CAPTAIN'S DINNER

PAUL PFLÜGER

teNeues

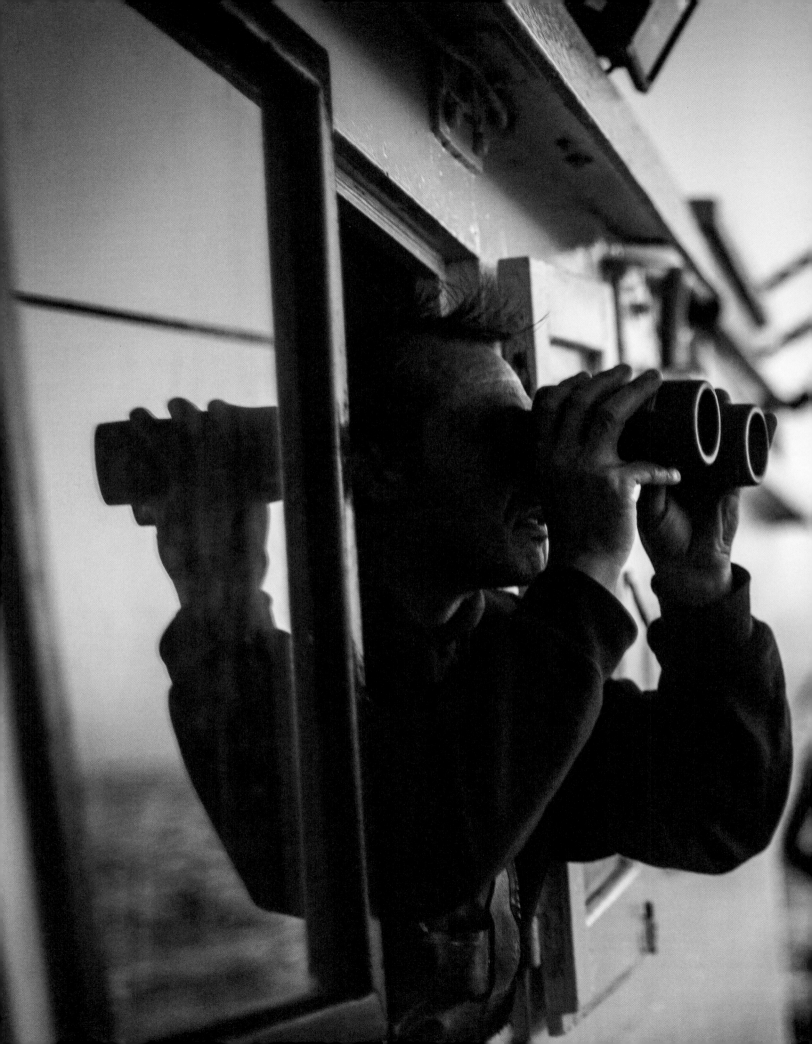

CONTENTS

PREFACE
7

NORTH SEA & ELBE
—

ANDRÉ JONGEJAN
IJmuiden, The Netherlands

**Baked Sole with Buttered
Potatoes and Broccoli**

Matjes Herring Tartar

10

JOHAN VANMASSENHOVE
Oostduinkerke, Belgium

Shrimp Croquettes

**North Sea Shrimp
with Scrambled Eggs
and Green Asparagus**

16

REINHARD SCHEEL
Hamburg (Elbe),
Germany

**Potato Cucumber Salad
with Smoked Eel**

Labskaus

22

DONALD LOW
Pittenweem, Scotland

Scottish Marinated Fish

Norway Lobster with Bacon

28

BALTIC SEA
—

KELD MOGENSEN
Torø Huse, Denmark

Fiskefrikadeller

**Salmon au Gratin
with Potatoes and Spinach**

36

JAROSLAV GLEBINSKI
Wladyslawowo, Poland

Fish Stock

Cured Salmon

42

ARVIS JANSONS
Roja, Latvia

**Smoked Fish
with Cream Cheese**

Pickled Fried Herring

48

JONNY EKHOLM
Grisslehamn, Sweden

**Fried Herring
with Young Potatoes**

**Potato Leek Soup
with Fried Salmon**

54

BLACK SEA
—

KENAN MAYK
Rumelifeneri, Turkey

Fried Whiting

**Fish Stew
with Lemon and Tomato**

62

DORU AGACHE
Sfântu Gheorghe, Romania

**Grilled Herbed Herring
with Polenta**

Storceag (Sturgeon Soup)

68

ATLANTIC OCEAN
—

ARNFINNUR THOMASSEN
Sørvágur, Faroe Islands

Arnfinnur's Fish Cakes

Faroese Fish Soup

76

ERWAN BRUNG
Camaret-sur-Mer
France

Sepia à l'armoricaine

Red Mullet

82

ORVAR MARTEINSSON
Ólafsvík, Iceland

Plokkfiskur

Pannfisch with Potatoes

88

AURÉLIEN SORIN
Capbreton, France

Mussels

Swordfish Steaks

94

ATLANTIC OCEAN

—

MATTHEW DEVONALD
St Davids, Wales
**Mackerel
Pembrokeshire Style**
**Crab Cakes
with Aioli Dip**
100

STEVEN FARREN
Howth, Ireland
Creamy Fish Chowder
Irish Surf & Turf
106

TOM & JEREMY BROWN
Port Isaac, England
Crab Meat Sandwiches
Fish & Chips
112

MARTIN HECHABE OSA
Zumaia, Basque Country
(Spain)
Octopus Salad
**Fried Octopus
with Potato-Parsnip Puree**
118

MIGUEL SILVA
Costa da Caparica,
Portugal
Sardinhas Alimadas
Cataplana
124

Tips for Buying Fish
130

MEDITERRANEAN SEA

—

ANTONIO RUSSO
Castellammare
del Golfo, Sicily
**Linguine with
Cuttlefish in Ink**
Fritto di Pesce
134

ROK DOMNIK
Piran, Slovenia
Mullet Carpaccio
**Mullet Fillets
with Beer Vanilla Sauce**
140

STAVROS KOUTSOUKOS
Aegina, Greece
Stavros' Calamari
Kakavia Fish Soup
146

SENAD HADŽIHALILOVIĆ
Biograd, Croatia
**Croatian
Fisherman's Breakfast**
Grilled Fish
152

MASSIMO TAGLIOPIETRO
Burano, Italy
**Oven-baked Gilthead Bream
with Vegetables**
Spaghetti Vongole
160

MARIO & VALENTINO ESPOSITO
Amalfi, Italy
Pasta Donna Clelia
**Neapolitan
Calamari Stew**
166

ANGÉLIQUE COLFORT
Cavalaire, France
Mackerel Rillettes
Gilthead Bream Tartar
172

JORDI & SALVADORE BESSON CASSELLAS
Costa Brava, Spain
Gambas a la Plancha
Catalan Fish Stew
178

INDEX
184

ABOUT THE AUTHOR
190

THANK YOU
191

IMPRINT
192

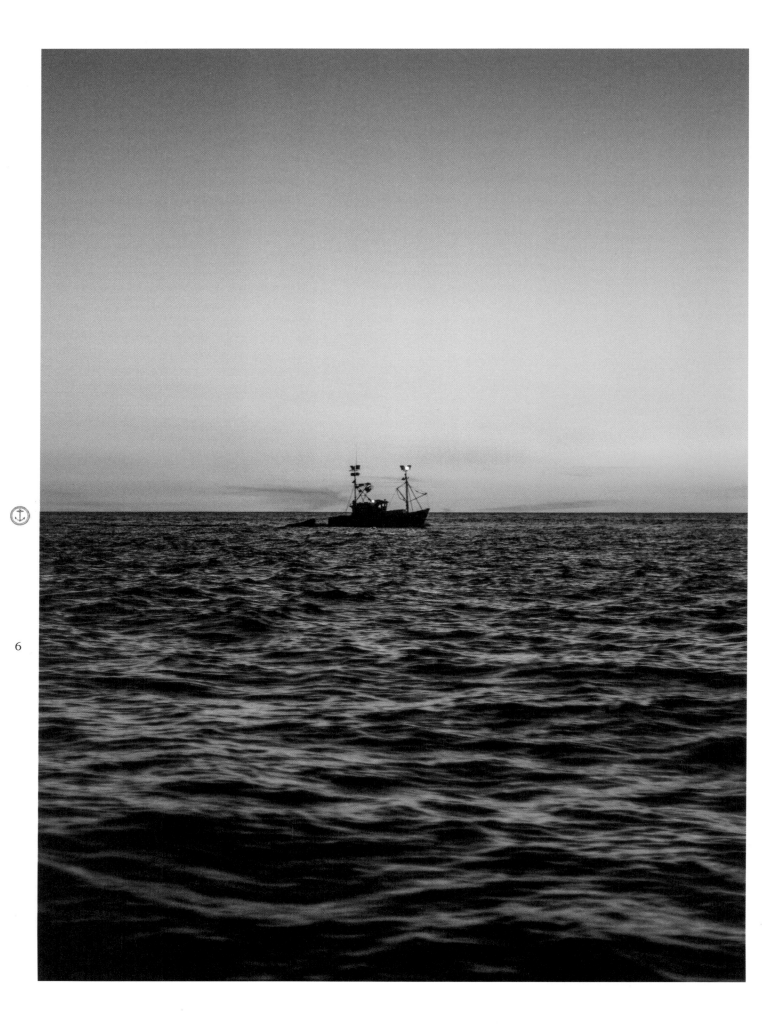

WELCOME ON BOARD!

Come along on an adventurous culinary journey across the seas of the old continent. Along the way you will encounter a wide variety of sailors on their cutters, draw in a deep breath of sea air, and get an exclusive look inside the cooking pots of traditional fishing families.

This journey will take you from fjords in the North Atlantic to the wide beaches of the North Sea, across Baltic ice floes and Mediterranean lagoons and on to the shores of the Black Sea. I was on the road for several months. In the course of numerous personal conversations, I had the unique opportunity to get to know people and photograph them—individuals whose history has often been closely connected to the sea for generations. The result is a book that provides an up-close look at the harsh working conditions on board fishing boats, honestly recounts the highs and lows of work at sea, and intersperses all this with the occasional culinary refreshment: Fishermen from all corners of the continent reveal how they prepare the freshly caught treasures of the sea at home and proudly disclose their own personal favorite recipes. In most cases, the recipes use local as well as regional types of fish, and the ingredients for the side dishes are wonderfully fresh and come from the respective region.

The characters on deck are as varied as the rich diversity found in the coastlines of Europe—and yet the crews of all small fishing boats seem to have one thing in common: They love the freedom. Being able to determine their own working rhythm combined with the expanse of the sea and the possibility of being self-sufficient are what makes fishing as a way of life so unique for them. Pursuing an occupation on shore would be unimaginable for many. Perhaps this is partly because they would no longer be right at the source: They always take part of the catch home with them, and for an astonishing number of sailors—men and women alike—cooking on their own stove is a matter of honor, even after an exhausting trip. After all, they themselves know especially delicious ways to prepare the catch of the day.

The recipes in this book are not ones that have been meticulously prepared by professional chefs—instead, they are the real deal and come straight from the kitchens of fishermen. The dishes introduced here are simple, original, and yet just as delicious—and the individual ingredients are that much more important. If you can't find a specific fish or another ingredient in the high quality you expect, be flexible and try out the recipe with a delicious alternative. Don't think of the recipes merely as instructions—above all, regard them as inspiration and don't be afraid to explore your own creativity.

Enjoy the journey, and bon appétit!

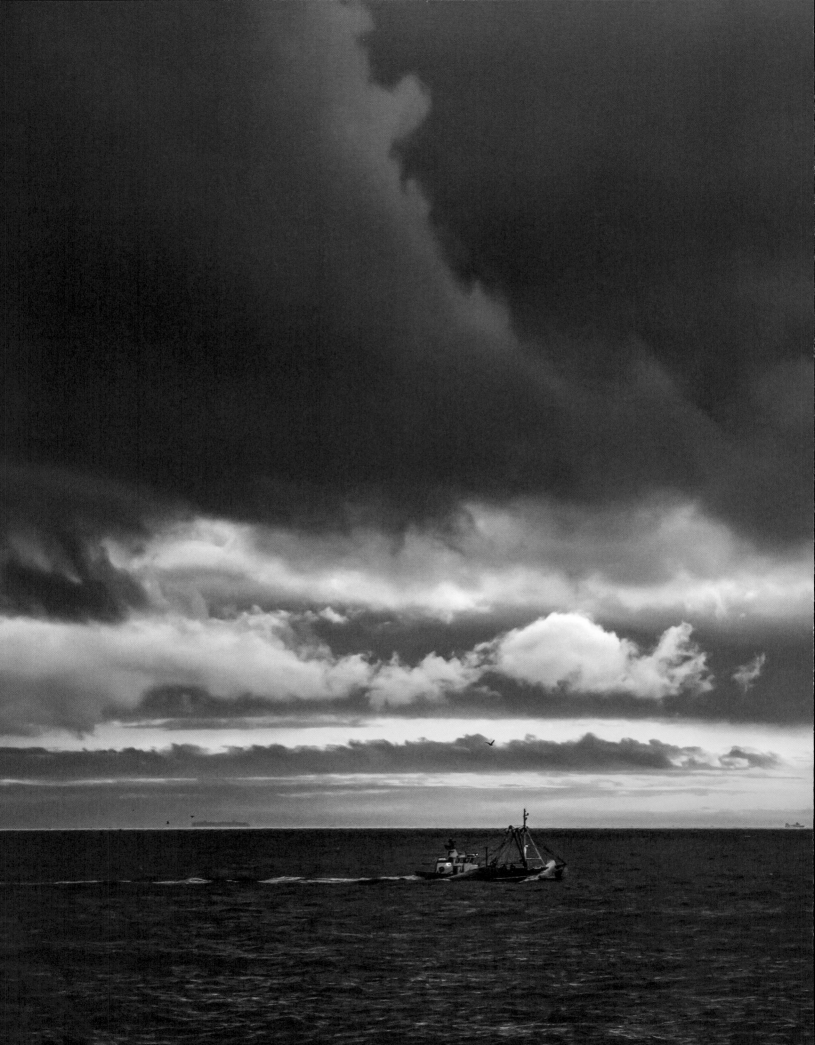

NORTH SEA & ELBE

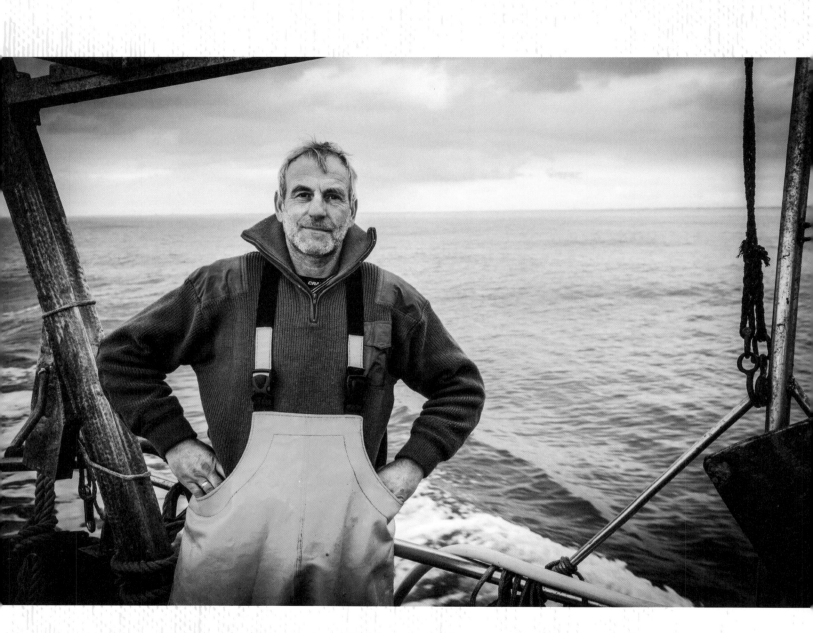

ANDRÉ JONGEJAN

IJmuiden, The Netherlands

André Jongejan has worked in the fishing industry since childhood. As a small boy, he would wander up and down the harbor walls in IJmuiden, clean the mackerel that the fishermen had just caught, and earn his first pocket money before he was even old enough to go to school. IJmuiden was a vibrant fishing port in those days. A great many small fishing boats bobbed about in the harbor basin. Every day, they brought their bountiful catch ashore, and the fishing docks teemed with activity. André grew up in this world, and after finishing school he instinctively knew what he wanted to do with his life: He took a job on a fishing boat in his home town. In those days, the ships had already grown in size, and the magnificent trawlers always put out to sea on Monday and returned Friday evening, right on time for the weekend. It was a well-regulated life, the young fisherman found: During the week, he worked hard, earned a good income, and when the weekend came around, he had plenty of time to spend his money hand over fist. However, the never-changing routine lost its charm over the years, and the tall Dutchman yearned for greater control over his own destiny.

André is now the captain of his own ship and a proud father. He enjoys the freedom afforded by being his own boss, with a schedule that allows him to come home to his family every evening. Although he is still very much attached to his native land, the North Sea is no longer what it used to be.

DECLINING FISH STOCKS, RESTRICTED ZONES AROUND THE INCREASING NUMBER OF WIND FARMS, AND ELECTROFISHING, IN PARTICULAR, ARE MAKING LIFE DIFFICULT FOR THE FISHERMEN OF IJMUIDEN.

Many of the impressive trawlers that ply the Dutch coast use electric nets to catch their fish as part of a large-scale experiment. The goal is to test the efficiency and sustainability of the new technology before giving it the final go-ahead. Instead of dragging heavy chains over the ocean floor, the new trawls are fitted with cables that flush out the fish from the bottom of the sea with electric pulses and drive them into the net. It is an effective and fuel-efficient method, but also one rife with controversy. An astonishingly large number of test ships are used, and it is almost impossible to monitor the intensity of the current, while very few fish manage to escape the trawlers. For these reasons, critics fear that the practice can potentially threaten fish stocks.

"Far fewer fish are left for small boats like mine," says André as he hauls his fishing gear onto the pitching quarterdeck. His narrow nets, one-and-a-half feet (half a meter) in height, rest vertically on the ocean floor, and they trap flatfish exclusively: André is on the lookout for European plaice, with their red spots, and the less conspicuous and yet all the more valuable sole.

He is alone on board the *Jongejan*. The size of his catches do not justify having a second man on deck, which means that he must be able to multitask. As he removes the fish from the nets, then cleans and sorts them, André must simultaneously keep an eye on the boat's bearing. On calm days like today, he performs the many tasks with a practiced hand, but when the seas are rough, this work is challenging even for such an experienced fisherman. Fortunately, he does not get lonely. A number of his friends and fellow fishermen are in sight, and André maintains a lively conversation with them by radio. The fishermen from IJmuiden have their own radio frequency, and they like to keep to themselves. Along with trading insider tips on the state of the fishing area, they joke around a lot, and from time to time the crackling loudspeaker blasts a classic rock number over the broad expanse of the North Sea.

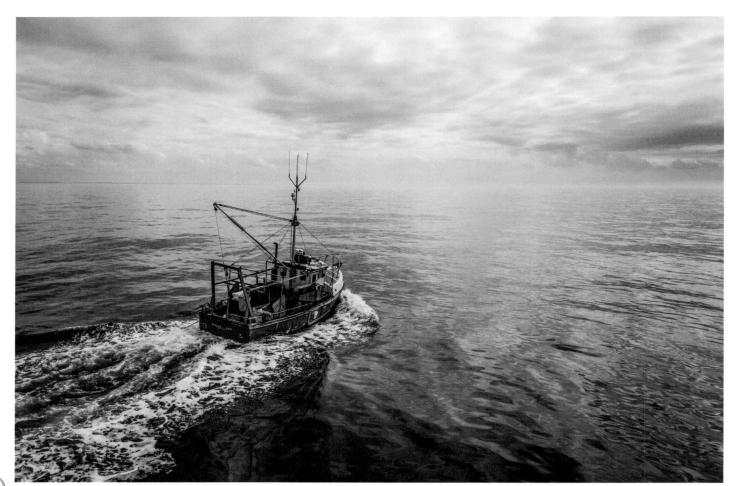

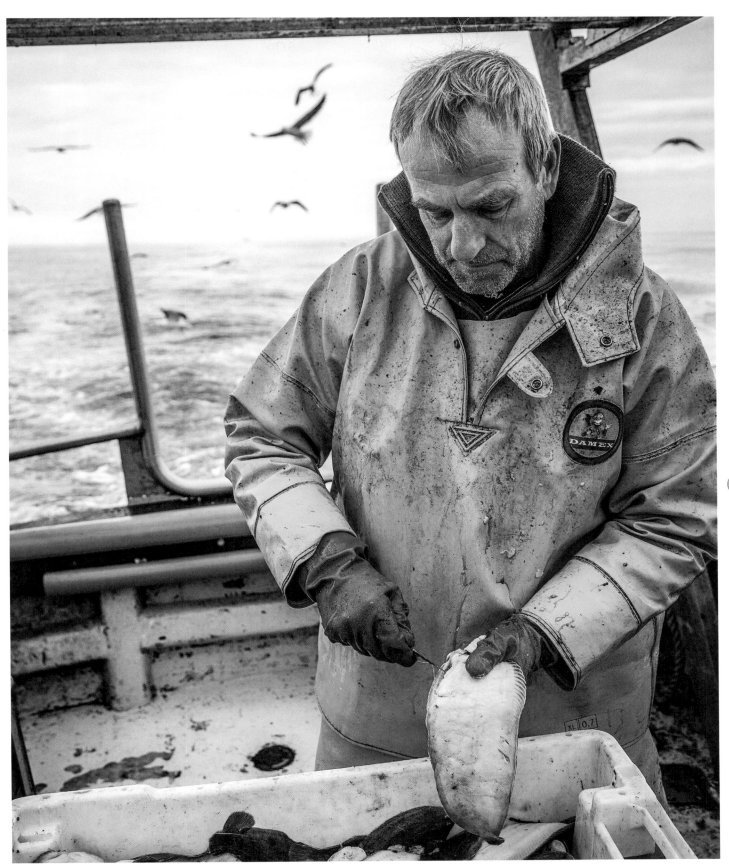

THE SIZE OF HIS CATCHES DO NOT JUSTIFY HAVING A SECOND MAN ON DECK, WHICH MEANS
THAT HE MUST BE ABLE TO MULTITASK. AS ANDRÉ REMOVES THE FISH FROM THE NETS,
THEN CLEANS AND SORTS THEM, HE MUST SIMULTANEOUSLY KEEP AN EYE ON THE
BOAT'S BEARING.

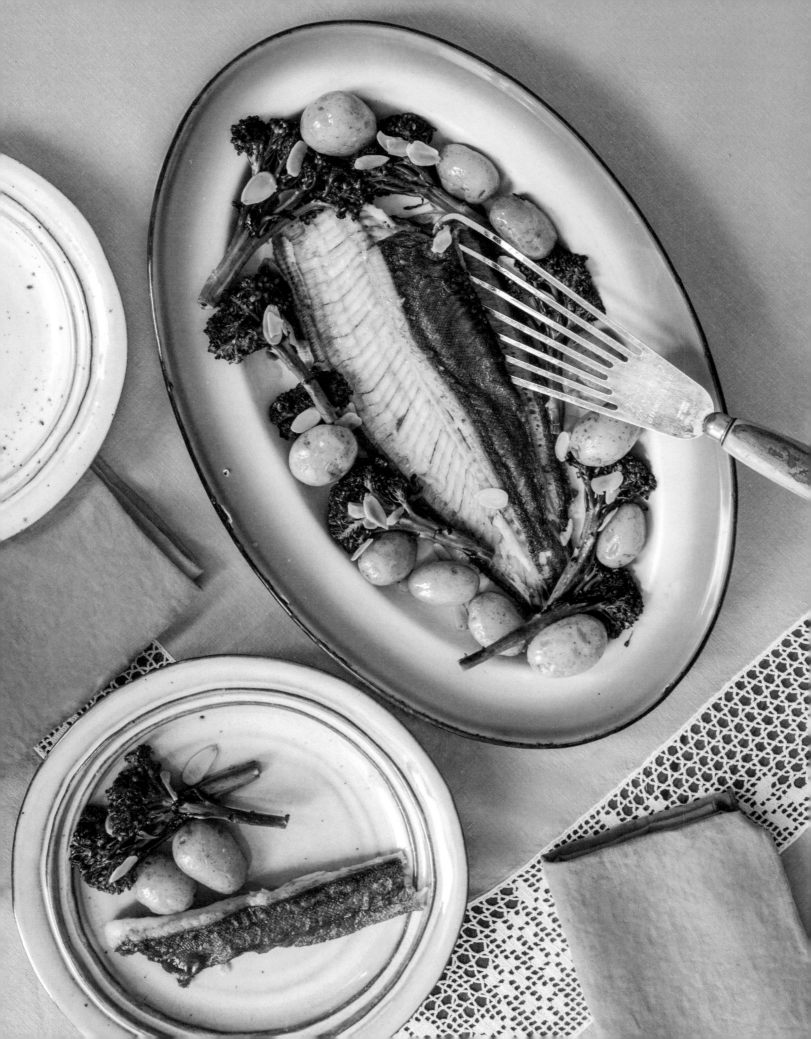

Baked Sole
with Buttered Potatoes and Broccoli

When there's fish at André's house, the captain himself heads to the kitchen to cook for his wife and daughters. Preferably sole, prepared in the traditional way.

SERVES 4

1¾ lb (800 g)	small baby potatoes
	Salt
1	head of broccoli
	Olive oil
	Pepper
1	handful of sliced almonds
4	small sole, cleaned and skinned
	Butter

PREPARATION

Wash the potatoes and cook in lightly salted water for about 15 minutes.

Cut the broccoli into small florets, then place in a freezer bag with a drizzle of olive oil, salt, and pepper. Seal the bag and shake well to evenly coat the florets with oil. Afterwards, spread the broccoli out on a baking sheet and roast for 30 minutes in a preheated oven at 350°F (180°C). Flip the broccoli about halfway through. Sprinkle with the sliced almonds about 5 minutes before the broccoli is done cooking.

Fry the sole in a little butter over medium heat for about 5 minutes per side until the fish easily separates from the bones.

Arrange the potatoes, broccoli, and sole on a plate and drizzle with a little sauce from the pan if desired.

Matjes Herring Tartar

This successful Dutch export is prepared from young, pre-pubescent herring with a high fat content. The name "Matjes" essentially means maiden or virgin herring and traces its origin to the Dutch word *Meisje* (girl).

SERVES 4

4	Matjes double fillets
1	red onion
4	gherkins
1	apple
2	small radishes
	Pepper
1	lemon

PREPARATION

Cut all the ingredients into a fine dice and mix thoroughly. Season to taste with pepper and lemon juice and refrigerate for at least 30 minutes.

Serve as an appetizer with salad, as a snack with a dark, hearty bread, or as a main course with fried potatoes, hash browns, or potato fritters.

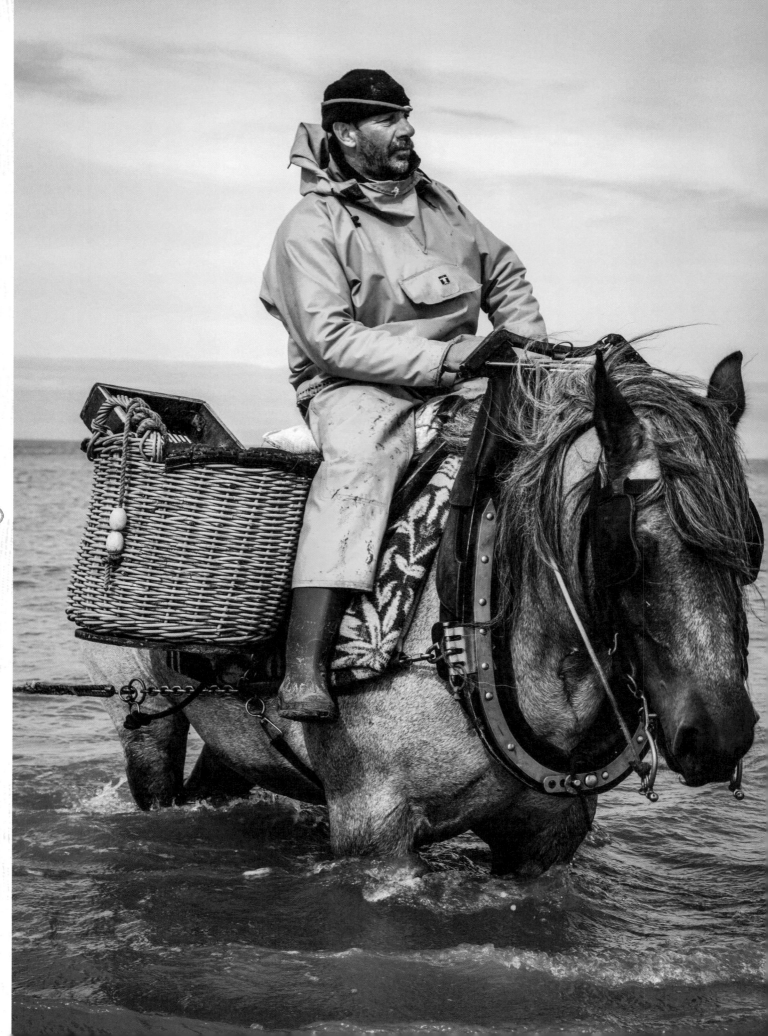

JOHAN VANMASSENHOVE

Oostduinkerke, Belgium

On the endlessly wide, sandy beach of Oostduinkerke, Johan Vanmassenhove sits up straight as he rides his faithful horse *Miss* through the water. The impressive Brabant mare drags a fine-meshed net through the hip-deep water of the North Sea, a process similar to a pulling plow across a field. In this case, the two are after shrimp. This traditional method has been used to catch these nondescript yet delicious shellfish here, on the coast of Flanders, for hundreds of years.

Not so long ago, the guild of local horse fishermen was threatened with extinction for a while: In the nineties, there were only three fishermen still practicing the art. Economically speaking, this method was simply no longer able to profitably compete against the trawlers off the coast. Since then, the love of the craft has inspired some of the locals to resume this traditional fishing method. At some point, the community of 8,500 recognized the marketing value of this unique craft. The fishermen received support, and in 2013 this art of horse fishing earned a spot on the UNESCO List of Intangible Cultural Heritage.

In the meantime, the number of fishermen and women who use this traditional shrimping method has grown to 15. None of them can earn a living doing this full-time, and some fishermen only practice it in the summer, during tourist season. Visitors buy the shrimp at a good price, and the fishermen are able to offer lucrative tours for school classes. In addition, on selected dates the community organizes a large-scale fishing demonstration featuring as many fishermen as possible: The community pays a fixed daily rate to everyone involved in the demonstration, while hundreds of spectators flock to this beach on the North Sea to experience the event in person.

The tremendous hustle and bustle and all the attention are not really Johan's thing. He usually tries to avoid the tourists, fishes when it suits him, and only takes part in tours when his mounted colleagues really need help.

JOHAN HAD WANTED TO BECOME A HORSE FISHERMAN EVER SINCE THE FIRST TIME HE SAW A NEIGHBOR SHRIMPING ON HORSEBACK WHEN HE WAS A CHILD. HE HAS ALWAYS BEEN CRAZY ABOUT HORSES, AND HE ENJOYS THE FOCUSED PEACEFULNESS WHILE FISHING.

His favorite time is in the early morning hours, when curious tourists with their cameras are still safely abed at their hotels and the beach is nearly deserted. On those mornings, like today, he can make his solitary way back and forth in the green-brown water, and he can sort the shrimp on the beach afterwards, undisturbed. After he has sorted out crabs, small fish, and algae, his catch on this particular morning weighs in at just over 15 pounds, or seven kilos, of North Sea shrimp.

He can't earn a living from fishing this way, but the sale of the shrimp will at least pay for the annual upkeep of his horses. For him, that is enough. Johan has a large number of regular customers who always eagerly await his shrimp. He sells the shrimp for the same price year-round—and to the same people. His loyal customers pay him nine euros per kilo (equivalent to about $4.75 per pound), even when the shrimp are so abundant in the high season that the big trawlers are letting a kilo go for two or three euros (about $1 to $1.60 per pound). His customers are repaid for their loyalty, however, by the time winter rolls around—when the sea is stormy before Christmas and the price per kilo soars to 50 euros ($26 per pound). Even then Johan charges his customers the same price as ever, and he declines with thanks all the other inquiries he receives before the holidays—even when he has shrimp leftover. Johan always remains true to himself. And to his beloved horses as well, of course.

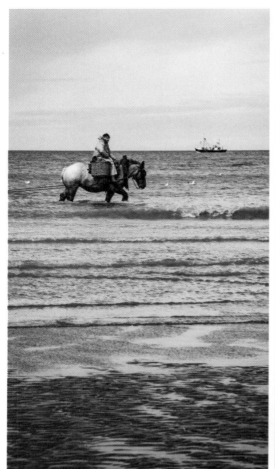

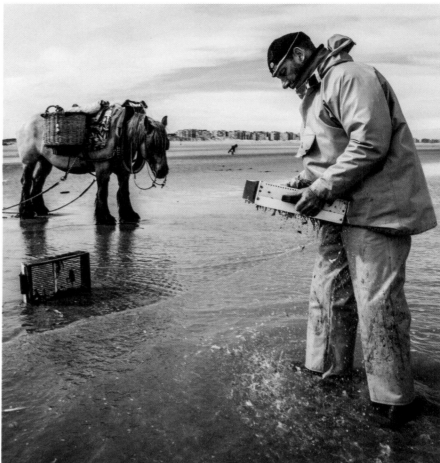

18

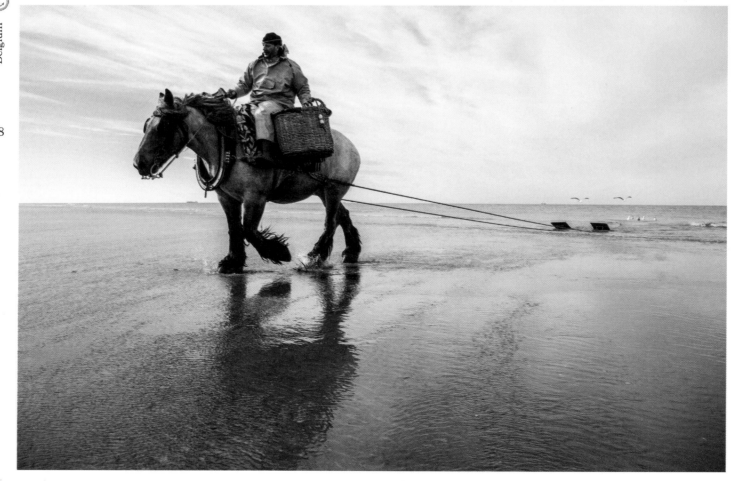

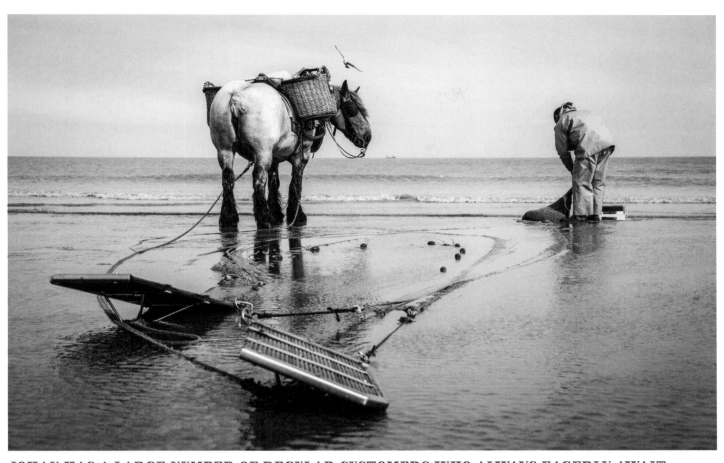

JOHAN HAS A LARGE NUMBER OF REGULAR CUSTOMERS WHO ALWAYS EAGERLY AWAIT HIS SHRIMP. HE SELLS THE SHRIMP FOR THE SAME PRICE YEAR-ROUND—AND TO THE SAME PEOPLE.

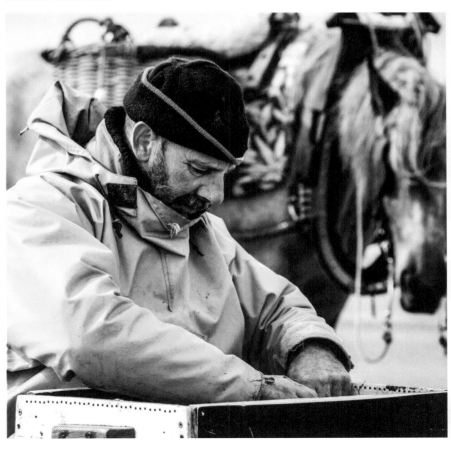

SHRIMP CROQUETTES

Fried delicacies and North Sea shrimp: This dish combines two typical elements of the Belgian coast on one plate.

SERVES 4

3½ Tbsp (50 g)	butter
6½ Tbsp (50 g)	flour
1 cup (250 ml)	whole milk
Scant ¼ cup (50 ml)	fish stock
	Salt, pepper
Scant ¼ cup (50 ml)	whipping cream
1	egg, separated
2 Tbsp	grated Edam cheese
9 oz (250 g)	North Sea shrimp meat
	Juice of ½ lemon
	Breadcrumbs
	Vegetable oil

PREPARATION

Melt the butter in a pot. Using a whisk, stir in the flour, then bring to a simmer. Stirring constantly, slowly pour the milk and fish stock into the roux. Cook over low heat for a little while to thicken, then season with salt and pepper.

Combine the cream and egg yolk in a separate bowl, then pour into the pot. Continue to simmer briefly over low heat, then remove from the stove. Mix in the grated cheese, shrimp meat, and lemon juice, scrape into a lidded container, seal, and refrigerate overnight.

Remove the mixture from the refrigerator and shape into croquettes. Roll the croquettes first in the flour, then in the egg whites, and then in the breadcrumbs. You can fry the croquettes immediately in a pot or in a deep fryer with plenty of oil until they are golden brown. Alternatively, you can choose to freeze them and fry the frozen croquettes later—with this option, the croquettes hold together better.

Serve with lemon slices as a hearty appetizer or with side dishes as a main course.

NORTH SEA SHRIMP WITH SCRAMBLED EGGS AND GREEN ASPARAGUS

If possible, Johan always processes the shrimp fresh, right after cooking. If they have already been refrigerated, he takes them out at least half an hour before working with them, because they have more flavor at room temperature.

SERVES 4

8	eggs
	Salt, pepper
2¼ lb (1 kg)	green asparagus
	Clarified butter
	North Sea shrimp, however much you like
2	green onions, thinly sliced

PREPARATION

Crack the eggs into a bowl, then whisk, season with salt and pepper, and set aside.

After washing the asparagus, use a sharp knife to trim the woody ends. If necessary, thinly peel the lower third of the very thick asparagus spears. Cook the asparagus in lightly salted water for about 8 to 10 minutes until al dente.

Shortly before the asparagus is done cooking, fry the beaten eggs in a bit of clarified butter in a pan and melt some clarified butter in a separate pot. Arrange the hot asparagus and the scrambled eggs on a serving dish with the shrimp. Sprinkle with the sliced green onions and drizzle with the melted clarified butter.

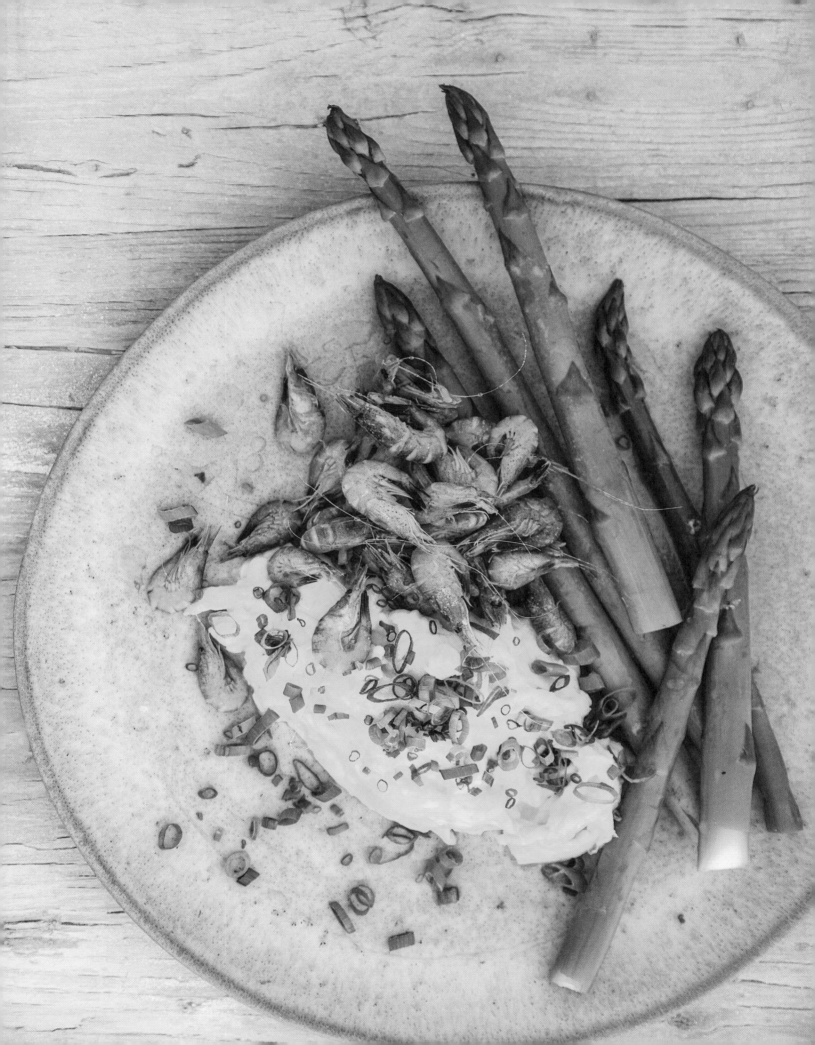

22

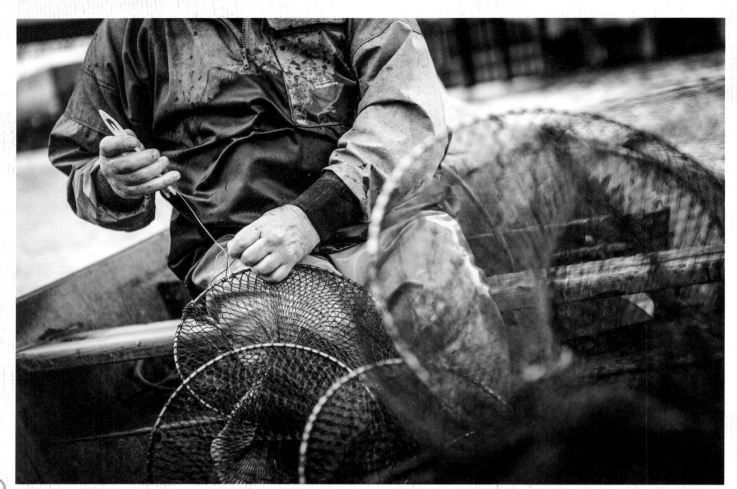

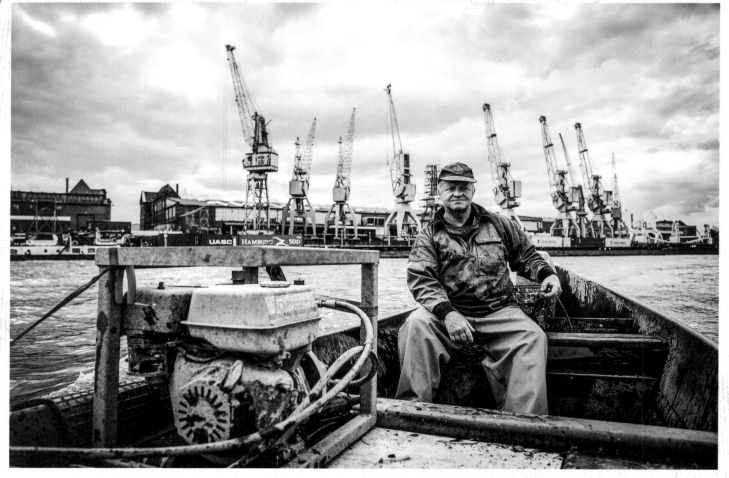

REINHARD SCHEEL

Hamburg (Elbe), Germany

"Damn anglers," swears Reinhard Scheel, throwing the torn-off flasher in a high arc toward the secluded promenade. Floating between the buildings of the Speicherstadt, Hamburg's historic warehouse district, he has just discovered another fishing lure in one of his fish traps. He angrily regards the damage to his fishing gear and then gets to work mending the holes with a net needle.

THIS ELBE FISHERMAN HAS SPENT THE PAST 20 YEARS PROWLING THE BRACKISH WATER OF THE PORT OF HAMBURG FOR EEL AND ZANDER. HE GAINED PROFESSIONAL FISH FARMING EXPERIENCE ON THE CALM WATERS OF LAKE MÜRITZ BEFORE HE WAS DRAWN TO THE OCEAN AND BEGAN CASTING HIS NETS ON THE BALTIC SEA.

After German reunification, he headed for the Hanseatic city of Hamburg at the mouth of the Elbe, where the inland fisherman faced completely new challenges. Given the rhythm of the tides and the tremendous hustle and bustle of an international port, he has to be very careful about where he sets his nets. Years of experience have taught Reinhard to stay far away from the deadly maelstrom of the ship propellers and to fish at a safe distance from thieving anglers.

After the net is repaired, he sets off to the next fish trap and his resentment toward the hobby fishermen is soon forgotten. When the first wriggling eels come into view at the end of the labyrinthine net, his expression suddenly brightens. So far it is the best fish trap of the fading day, and the overall results of his outing are gratifying: More than a dozen plump eels and three large zander have now landed in the fish tank in the center of the boat. And the next fish trap is also so full that Reinhard can call it a day.

In the blue hour after the sun drops below the horizon, he crosses the Elbe between huge container ships and sets course for home as the last light of dusk fades: In the middle of the waterfront, the staunch maverick lives on a houseboat. From this vantage point he can watch the sparkling city skyline from a safe distance.

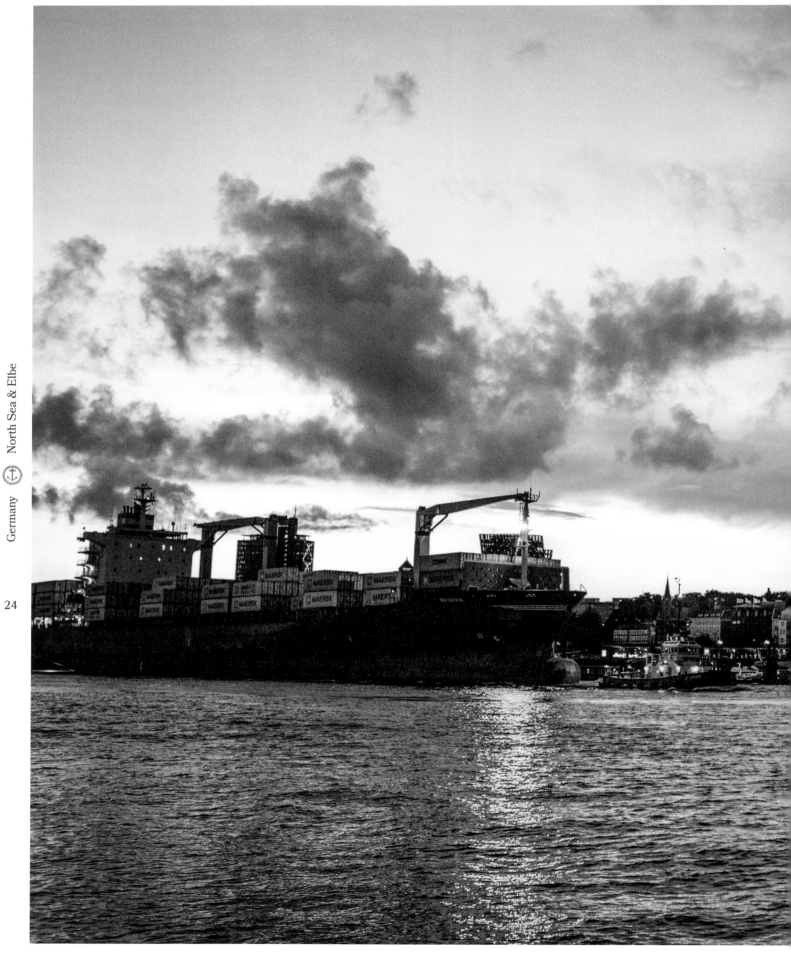

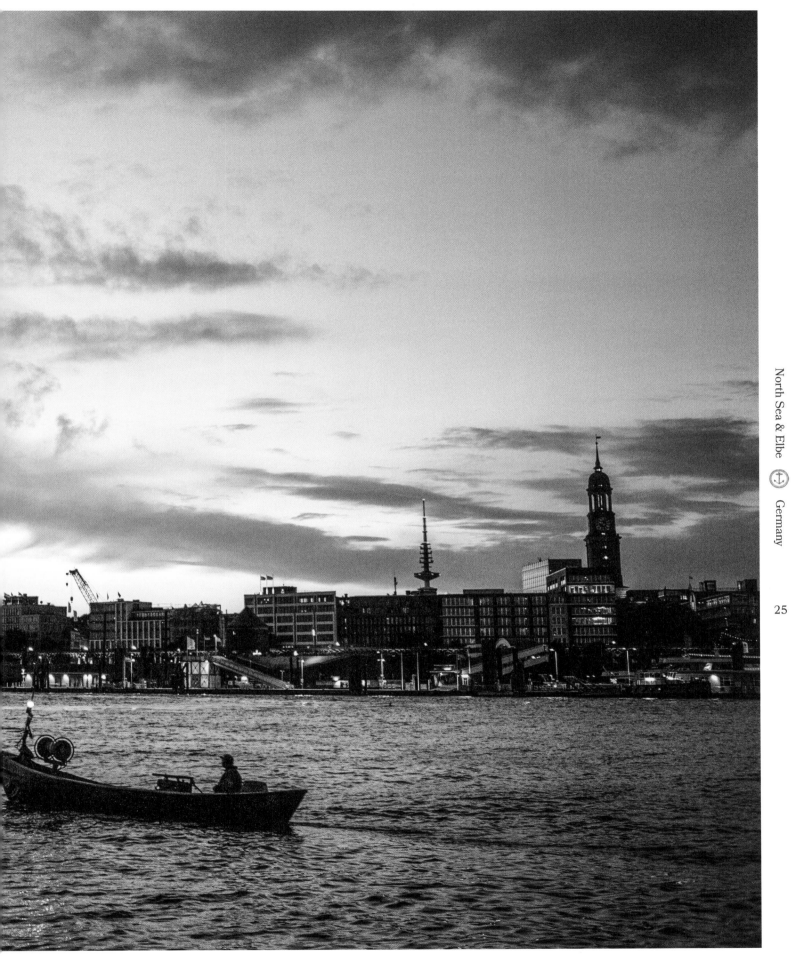

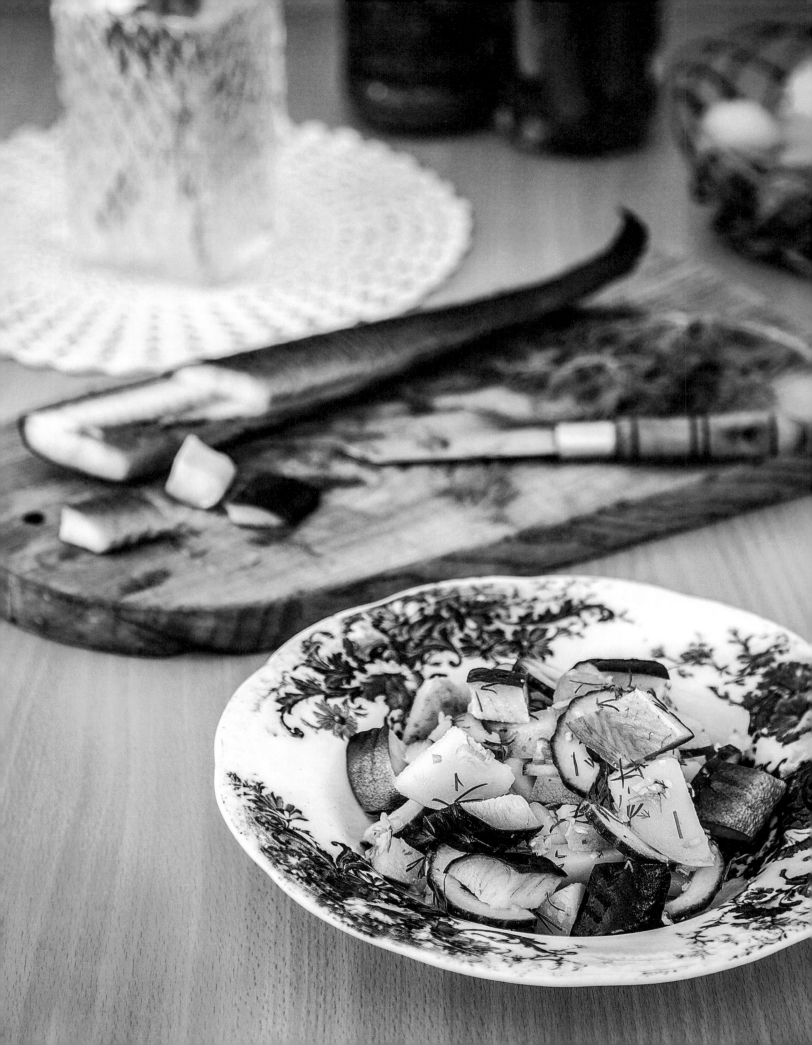

Potato Cucumber Salad with Smoked Eel

Reinhard smokes his eels himself before selling them. The fish are even more valuable when they are smoked, and he can always hold on to a few for his favorite dish.

Serves 4

2¼ lb (1 kg)	waxy potatoes
1 lb (500 g)	cucumbers
3–4	shallots, diced finely
4 Tbsp	sunflower oil
4 Tbsp	white wine vinegar
1 tsp	sugar
	Salt, pepper
11 oz (300 g)	smoked eel fillet
1	bunch of dill

Preparation

Cook the unpeeled potatoes for about 25 minutes, depending on the size. Afterwards peel and cut into bite-sized pieces.

Wash the cucumbers, cut into quarters lengthwise, then slice (not too thin). In a large bowl, combine the potatoes, cucumbers, and the finely diced shallots. Stir in the oil, vinegar, sugar, salt, and pepper, then set aside. (This salad tastes best when prepared in advance so it can sit for a few hours to allow the flavors to blend.)

Before serving, dice the smoked eel and sauté briefly in an unoiled pan. Finely chop the dill and mix into the salad along with the warm cubes of smoked eel.

Labskaus

This traditional sailor's dish from Northern Germany is far better than its reputation. You just have to try it.

Serves 4

1¾ lb (800 g)	potatoes, peeled
1⅓ lb (600 g)	beets, cooked and peeled
14 oz (400 g)	corned beef
10 oz (300 g)	pickles
5 oz (150 ml)	pickle juice
	Salt, pepper
4	eggs
	Vegetable oil
8	Bismarck herring, rollmops, or matjes

Preparation

Cook the potatoes in salted water for 20 to 30 minutes until just tender. Cut ⅔ of the beet into pieces and coarsely puree with the corned beef, pickles, and the pickle juice. Drain the cooked potatoes, then mash them in the pot. Stir in the beet puree, season with salt and pepper, and warm over low heat.

In a separate pan, fry the eggs in some vegetable oil. Serve the puree on a plate with the fish and the remaining beet cut into slices. To finish it off, top it with the fried egg and serve immediately.

Donald Low

Pittenweem, Scotland

The rocky harbor of Pittenweem with its protective wall reminiscent of a fortress is firmly in the hands of local fishermen. Large shrimp trawlers are moored side by side at the main quay while the smaller lobster boats cluster farther off in the distance and the shell divers' Zodiac inflatables bob in between. They are all waiting for the perfect water level. Here, on the east coast of Scotland with its numerous reefs, the North Sea's huge tidal range is the guiding factor. As soon as the tide brings in enough water underneath the keel of the ships, the docks suddenly spring to life. It is currently high season for the precious Norway lobster, and all the captains want to head out to sea as quickly as possible to cast their nets.

In all this hustle and bustle, Donald Low keeps a cool head. The man, who could give Captain Birdseye a run for his money, has spent much of his life at sea. He started out in Scotland as a young fisherman, and later he joined the merchant marines. As a first officer, he traveled around the world on container ships and tankers. Most recently he had returned to his native waters and worked on oil industry supply ships. After a brief detour inland—he had opened a pet store for his ex-wife's sake—he was ultimately drawn back to the diesel smell of the ships' engines and the clamor of seagulls.

He has been the harbor master of Pittenweem for a number of years now. In this tranquil harbor in the North Sea, Donald controls the departure times of the ships, pitches in to help unload their valuable catch when they return and is in constant motion. With his walkie-talkie in hand and a watchful eye, he strides up and down the quay walls—swiftly supplying a crate of ice here, quickly mooring an arriving cutter there—and along the way he collects the remnants of old nets for subsequent recycling.

THE FISHERMEN LIKE DONALD, AND NOT JUST BECAUSE HE STRIVES FOR CLEANLINESS AND ORDER, BUT ALSO BECAUSE HE IS A WELCOME CONSTANT IN THEIR DAILY ROUTINE. AS IN SO MANY FISHING VILLAGES ON THE COASTS OF EUROPE, EVEN PITTENWEEM HAS NOT GONE UNTOUCHED BY THE CHANGING TIMES.

The fishermen only come to work in the harbor, but they live in the Scottish hinterland. The old fishermen's houses have become prohibitively expensive, so the picturesque buildings surrounding the harbor are empty most of the year. Wealthy people from nearby Dundee and Edinburgh have established their weekend and vacation homes here. They all love the atmosphere of the fishing villages—at least superficially. In Pittenweem, where the tides govern the departure of the boats, complaints have been accumulating lately about the annoying engine noise of the trawlers when they have to leave in the middle of the night. Although the newcomers like the storybook charm of a small fishing harbor, they much prefer it without the annoying engine noises and fishy smells.

Gentrification has left its marks elsewhere as well: Last year the harbor pub changed hands and was completely renovated. The long-established sailor's pub was transformed into a bistro, which serves latte macchiato and where fancy convertibles are often parked out front. The tired fishermen used to step off their boats and head straight to the counter for a few pints and a game of billiards. Since the renovation, they have been avoiding what used to be their favorite pub. The traditional billiard table has disappeared from it as well—and with it a piece of Pittenweem harbor culture.

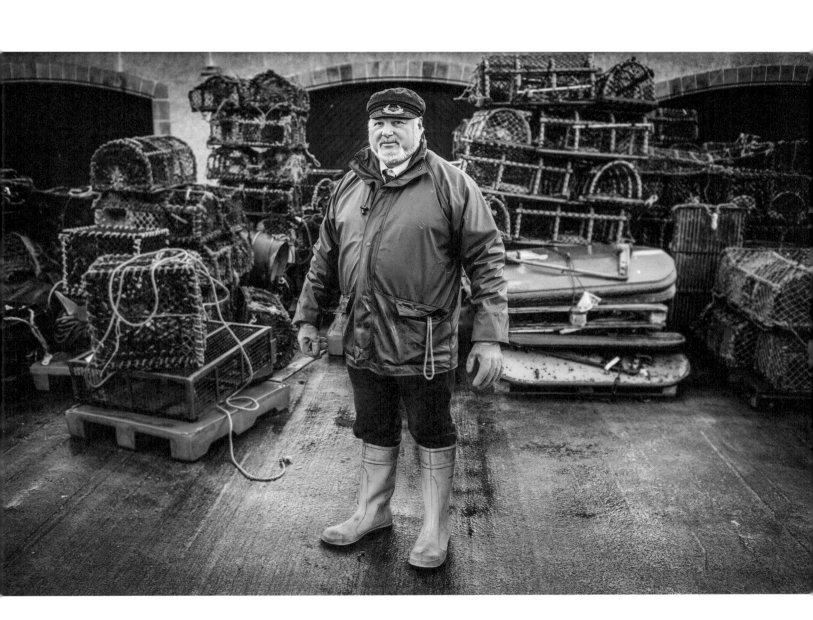

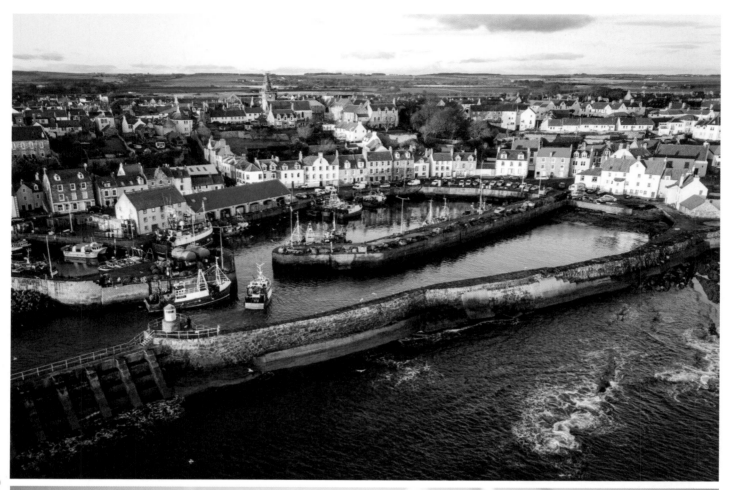

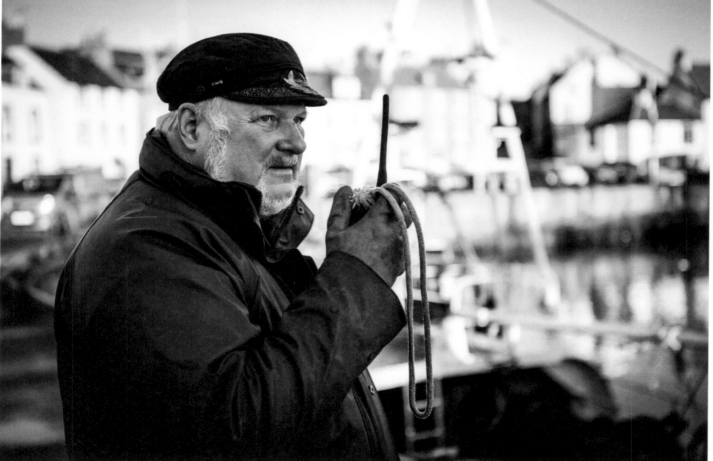

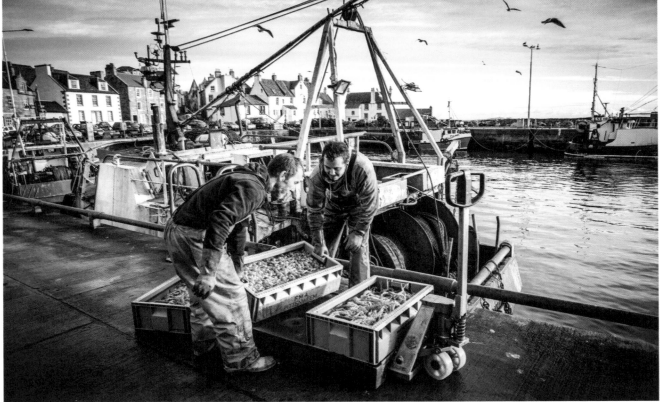

WITH HIS WALKIE-TALKIE IN HAND AND A WATCHFUL EYE, DONALD STRIDES UP AND
DOWN THE QUAY WALLS—SWIFTLY SUPPLYING A CRATE OF ICE HERE, QUICKLY
MOORING AN ARRIVING CUTTER THERE—AND ALONG THE WAY HE COLLECTS THE
REMNANTS OF OLD NETS FOR SUBSEQUENT RECYCLING.

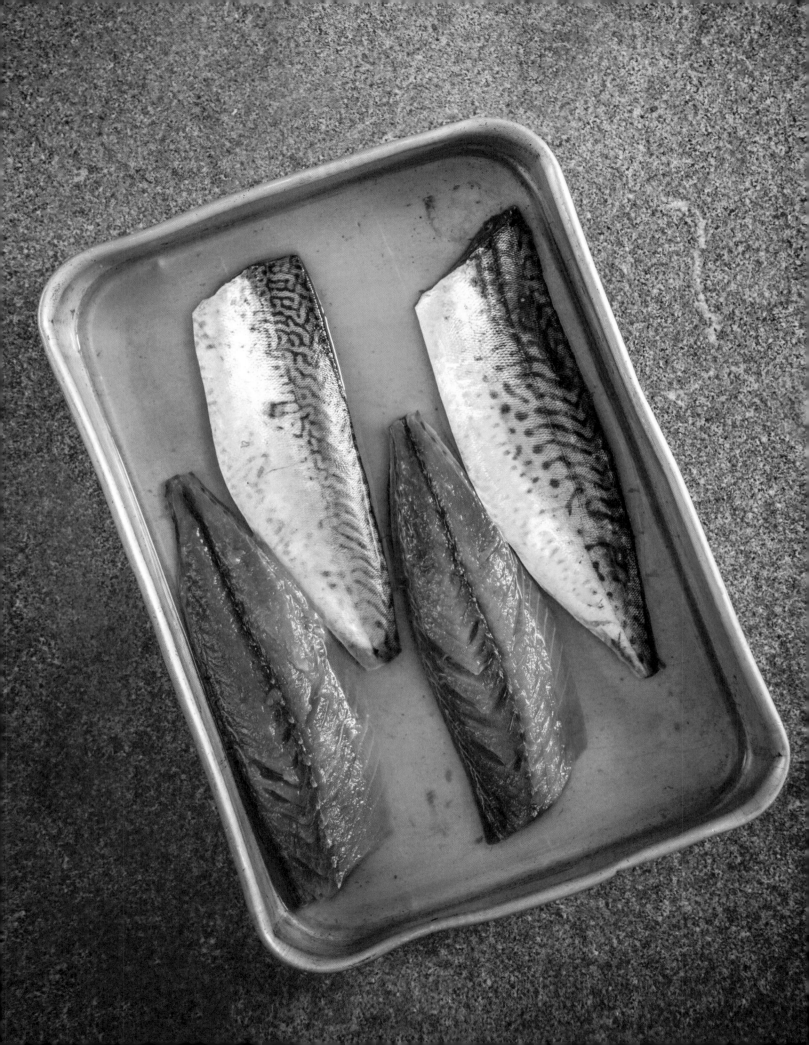

SCOTTISH MARINATED FISH

After a busy day at the harbor, Donald likes to treat himself to a whisky—even on his plate. He uses the typical Scottish drink to marinate the fresh fish and give it a typical Scottish flavor.

SERVES 4

2¼ lb (1 kg)	fish fillets (such as mackerel, salmon, herring, cod, or another type of fish)
1 tsp	salt
1 tsp	sugar
	Malt Whisky

PREPARATION

Place the fish fillets in a lidded container. Add the salt and sugar, then fill with whisky until the fish is at least half covered.

Close the lid, gently shake the container, and then refrigerate for at least 24 hours and up to a week. After several days, the bones in the fish will dissolve on their own.

If you were sparing with the whisky (or perhaps thirsty) and did not completely cover the fish, be sure to turn the fillets from time to time to ensure that they are evenly marinated.

The marinated fish can then be fried, baked, or grilled as usual.

NORWAY LOBSTER WITH BACON

Fish, shellfish, and seafood with bacon are a wonderfully hearty combination.

SERVES 4

12	Norway lobster
12	thin slices of smoked bacon
	Pepper
	Bread

PREPARATION

To butterfly the Norway lobster, slit the back from the eyes down to the tail, taking care not to cut it completely in half, then fold it open.

In a large pan (or on a plancha grill), fry the Norway lobster, shell side down, for about 4 minutes. Top each with a slice of bacon on the open butterflied side.

Season with pepper, carefully turn and fry the meat side, on top of the bacon, for another 4 minutes. Serve with some bread as a hot and hearty appetizer.

BALTIC SEA

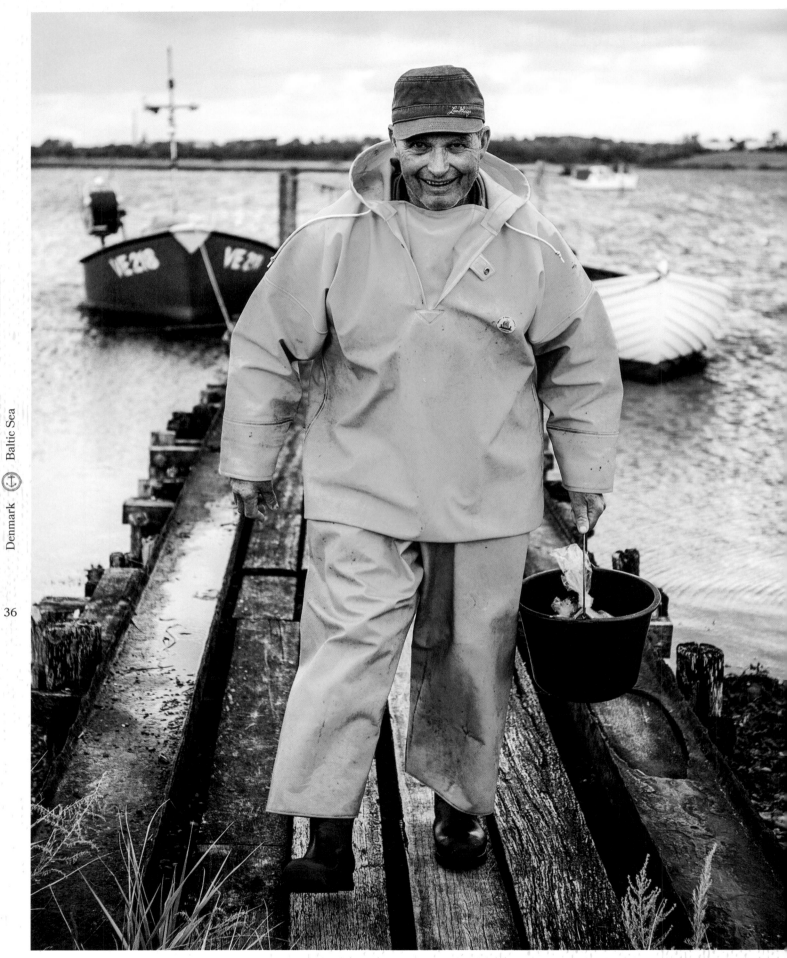

KELD MOGENSEN

Torø Huse, Denmark

Keld Mogensen does not look his age. His sparkling eyes and mischievous gaze belie his age of 74, six decades of which he has spent in the service of the fishing industry. Since the age of 14, he leaves the small harbor in all kinds of weather to empty gillnets situated off the coast. There, a piece of family history is firmly established as well. Keld's father and his cousin installed the construction of wooden pilings and nets south of Torø Huse almost 100 years ago. The fish trap is still owned by the Mogensen family today. It is a traditional and effective system in which the fish are guided through a barrier-like device near the shore and into a labyrinthine net in the deeper water. Attached at the end of the intricate installation is a fish trap from which there is no escape. Every day, Keld motors out to the end of the installation, hoists the fish trap out of the water, and empties the catch into the fish tank in the hull of his boat. He has a total of three traps in the area which he canvases every day, providing he is not thwarted by violent gusts of wind or fierce waves.

He usually does this on his own, but it has been extremely stormy in recent days, so he has a fellow fisherman on board to lend a hand. Given the harsh conditions, they need to exercise caution: While working together to empty the nets, one of them always makes sure they maintain a safe distance from the pilings, and the other keeps an eye on the ocean so they will have time to react to large waves. The small boat bobs violently up and down, at times coming dangerously close to the pilings—but the two are old hands, and they bring the catch on board without incident and steer the boat safely back into the harbor.

Today a few eels, young cod, and the first herring of the season have found their way into the net.

THE TYPES OF FISH CHANGE WITH THE SEASONS: WHILE SUMMER IS THE MAIN FISHING SEASON FOR PLAICE, KELD EXPLAINS THAT HE CATCHES PIKE PERCH, HERRING, AND VALUABLE EELS IN THE COLD MONTHS.

The volume of the catch also varies from day to day, and the sales strategy changes along with it. When the nets are well filled, he drives to the fish market in the next bigger town and sells his goods to wholesalers there. On less productive days, he sometimes makes a tour through the village, going door to door to offer his fish directly to the neighbors. Everyone knows each other in this small community of just a few hundred inhabitants, and the people there greatly appreciate the freshly caught delivery. Regardless of whether the day is good or bad: Part of the catch always lands in Keld's own refrigerator. And when it comes to preparation, the experienced fisherman always mans the stove himself.

It is not just the healthy fish and physical work that have kept Keld young, it is also his volunteer work. There is a youth hostel on the peninsula behind the harbor. The fisherman regularly takes groups of children on board to bring them closer to nature and to help give them an appreciation of fish as a foodstuff. "Fishing," he says, "is the perfect way to show that you can achieve something with work." He enthusiastically talks about these joint excursions and the reactions of the children. Experiencing the joy these children feel the first time they catch a fish is almost more fulfilling for the Danish fisherman than holding his own catch in his hands.

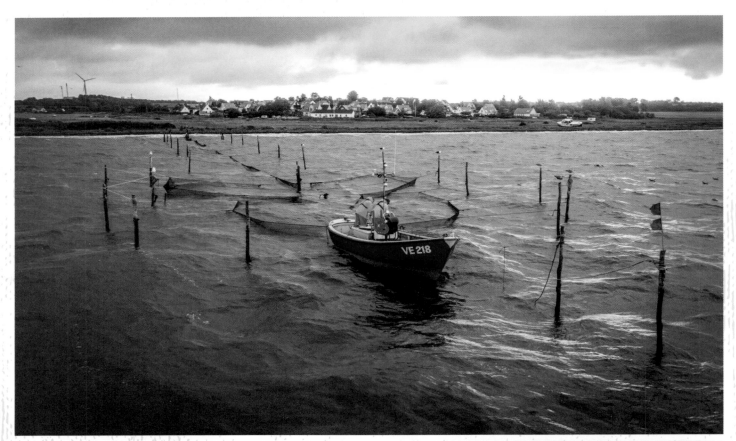

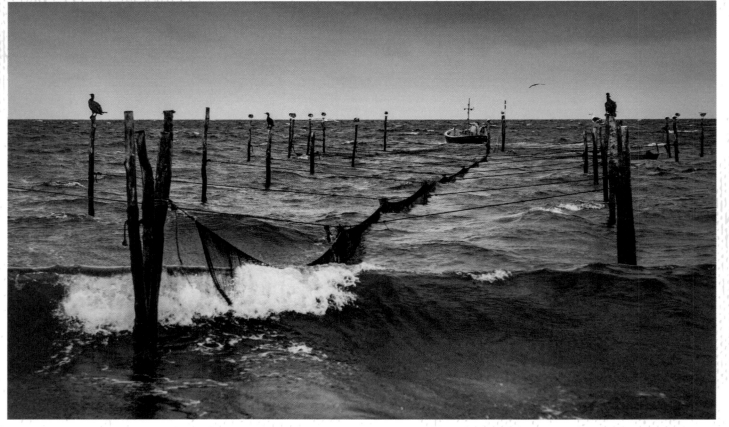

THE FISH TRAP IS STILL OWNED BY THE MOGENSEN FAMILY TODAY. IT IS A TRADITIONAL AND EFFECTIVE SYSTEM IN WHICH THE FISH ARE GUIDED THROUGH A BARRIER-LIKE DEVICE NEAR THE SHORE AND INTO A LABYRINTHINE NET IN THE DEEPER WATER.

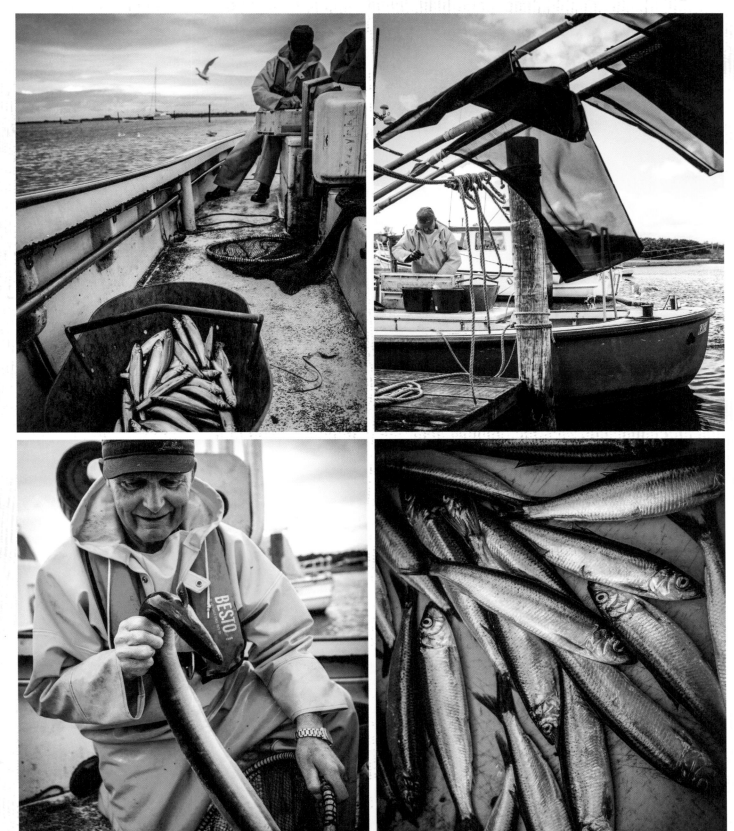

FISKEFRIKADELLER

Fish cakes, crisp on the outside and moist in the center, are popular all over Denmark. Keld usually prepares them when relatives come over for dinner—much to the delight of the children.

SERVES 4

For the remoulade sauce:

1	egg yolk
1 tsp	mustard
	Juice of ½ a lemon
5 oz (150 ml)	sunflower oil
1 tsp	capers, finely diced
4	small gherkins, finely diced
2	sprigs of tarragon, finely chopped
1	shallot, finely grated
1 Tbsp	heavy cream, lightly whipped
1	pinch curry powder
	Salt
	Brown sugar

For the fish cakes:

1½ lb (700 g)	cod fillets
3½ oz (100 ml)	heavy cream
	Zest of ½ a lemon
1	egg
¾ cup (100 g)	flour
	Salt, pepper
2 Tbsp	dill, finely chopped
	Butter

PREPARATION

To prepare the remoulade sauce, whisk together the egg yolk, mustard, and lemon juice until smooth. Slowly drizzle in the sunflower oil, whisking constantly, until the mayonnaise begins to turn thick and creamy. Fold the remaining ingredients into the mayonnaise and season to taste with salt and a pinch of sugar. Refrigerate for 2 hours and then let stand at room temperature for ½ hour before serving.

To prepare the fish cakes, place all ingredients except for the dill in a blender and process until coarsely chopped and a thick dough forms. Fold in the dill, flour your hands, and form into patties. Melt an ample amount of butter in a frying pan and fry the patties over medium heat until golden brown, 4 to 5 minutes on each side. Serve while hot and still crispy with a mixed salad or potatoes and a vegetable on the side.

SALMON AU GRATIN
WITH POTATOES AND SPINACH

"A feast for the eyes," says the Danish fisherman. What he likes the most about this casserole is the way its three main ingredients create a riot of colors—and, of course, it is absolutely delicious!

SERVES 4

2¼ lb (1 kg)	waxy potatoes
26 oz (750 g)	fresh spinach
2	onions, finely diced
1	clove of garlic, minced
	Olive oil
	Salt, pepper
3 Tbsp	butter
2 Tbsp	flour
½ cup (125 ml)	heavy cream
7 Tbsp (100 ml)	white wine
1 tsp	vegetable bouillon powder
	Juice and zest from one untreated lemon
4	salmon fillets (about 4½ oz or 130 g each)
	Breadcrumbs

PREPARATION

Cook the potatoes in boiling water for about 20 minutes, then peel and slice. Wash and clean the spinach, then coarsely chop.

Sauté the onions and garlic in some olive oil. Add in the spinach and cook until wilted. Season to taste with salt and pepper.

Melt the butter in a pot over low heat. Sprinkle in the flour and sauté to form a roux. Using a whisk, stir in 17 oz (500 ml) of water, the heavy cream, wine, and broth. Bring to a boil briefly and season to taste with salt, pepper, and the lemon zest. Layer the potato slices and spinach in a greased casserole pan. Season the salmon fillets with salt and pepper, drizzle with lemon juice, and then arrange on top of the potatoes and spinach. Pour the sauce evenly over the casserole, sprinkle with breadcrumbs, and then bake in a preheated oven (350°F/180°C) for about 25 minutes.

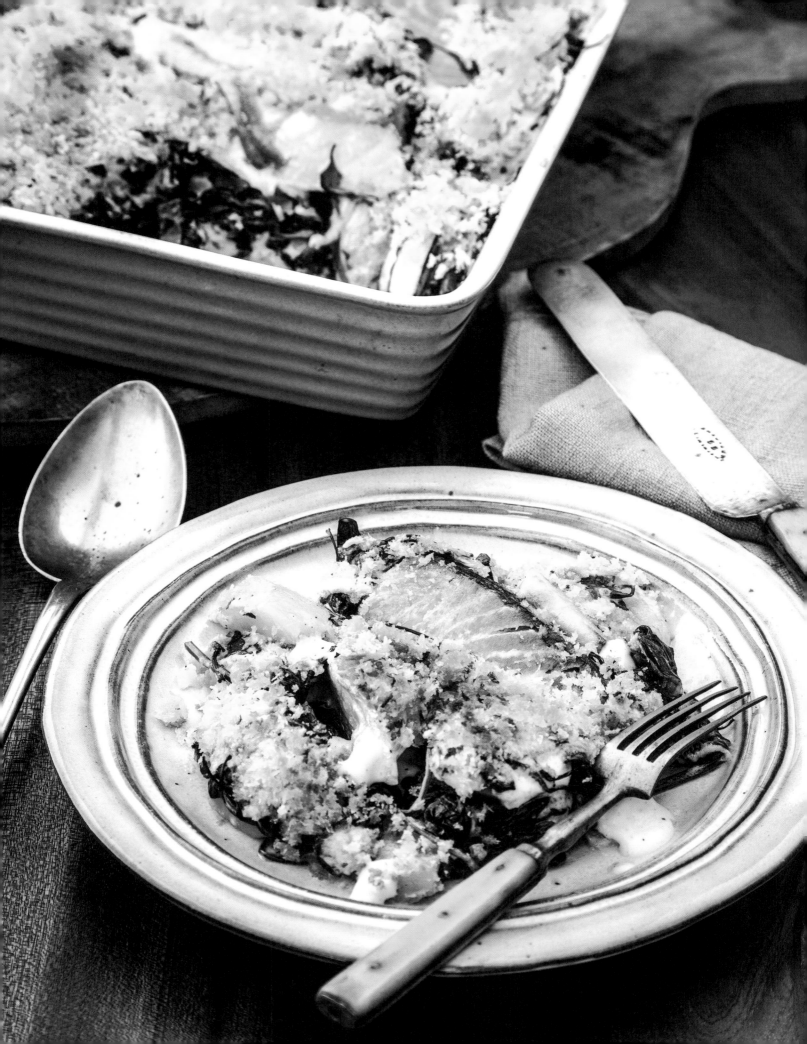

JAROSLAV GLEBINSKI

Wladyslawowo, Poland

The harbor in Wladyslawowo is completely full. The fishing boats are tightly packed, moored along all the quay walls of the harbor in rows up to four deep. Occasional noises can be heard here and there, otherwise there is no one to be seen far and wide. Work in Poland's largest fishing port has stopped, because beyond the wall the strongest storm of the year rages on the Baltic Sea. Even the largest ships cannot withstand the power of the Baltic Sea under these conditions and have taken shelter in the harbor.

Suddenly there is movement on one of the smaller boats. A hatch opens, squeaking, and a stocky older gentleman climbs onto the quay wall. When asked if he is a fisherman, he initially nods in the affirmative, then hesitates briefly before answering: "I used to be." However, Jaroslav Glebinski is always up for a walk around the harbor. After all, he knows his way around and he has plenty of time. "I enjoy my retirement, and I don't miss fishing at all," he announces cheerfully. He still likes to visit his old comrades on the jetty, especially on days like today.

ON MANY BOATS, THE CREW IS ON BOARD AND THEY TAKE ADVANTAGE OF THE FORCED BREAK DUE TO THE WEATHER TO CARRY OUT MAINTENANCE WORK ON THE SHIPS AND FISHING GEAR. THE SALT WATER CONSTANTLY EATS AWAY AT THE STEEL, AND THE NETS AND LINES ARE ALSO IN NEED OF REPAIR.

The more careful the preparations, the better the chances will be for a good catch on their next trip out.

Jaroslav seems to know every cutter, every fisherman, and every seagull in the harbor. Wherever there is life on board the moored ships, they greet each other and chat briefly. Here and there the spry pensioner climbs on deck with astonishing speed to have a look at the latest fishing gear. The modern boats in particular pique his curiosity, and he explores one ship after the other. Doubts are slowly beginning to set in as to whether he is really done with fishing. His former colleagues report with a smile that he regularly checks to see if everything is in order in the harbor—much to the delight of the other fishermen, because Jaroslav is a local legend and has many stories to tell.

Born in Wladyslawowo, he first learned his trade on the Baltic, then he spent 35 years sailing the seven seas of the world. His travels took him from the Bering Sea in the far north to the tropical waters around the equator and on to the Falkland Islands far down in the South Atlantic. He found jobs working on the largest ships of the Polish fishing fleet and was often at sea for months at a time. Only in the last year did he decide to take it a little easier before his retirement and fished from his home port in the coastal waters of the Baltic Sea. Although he retired a few weeks ago, he spends most of his time at the harbor, back where it all began. It remains to be seen whether the experienced sailor will actually stay on shore or whether he'll don his oilskins again and cast off the lines. One thing is for sure: He has no lack of energy or passion.

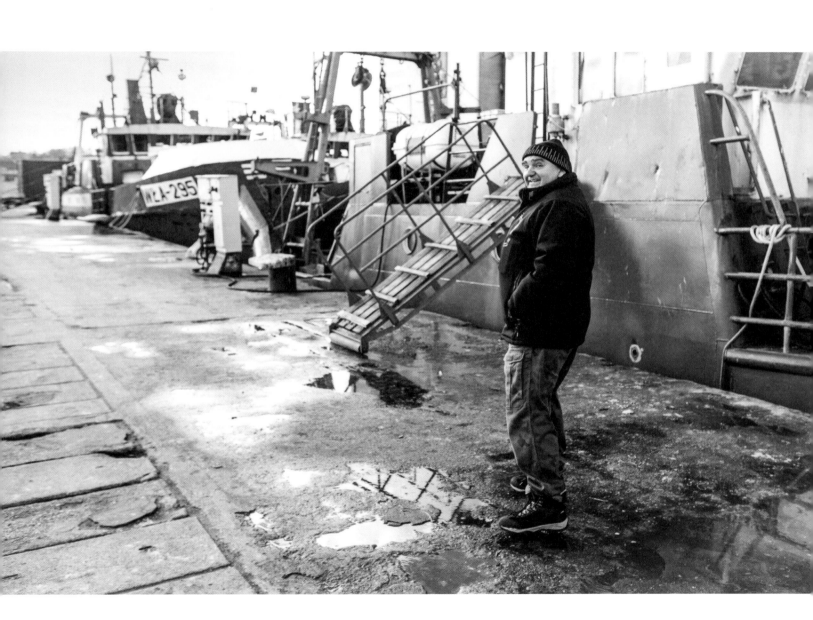

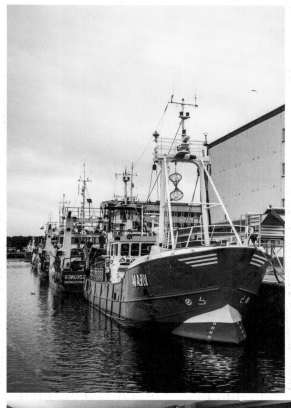

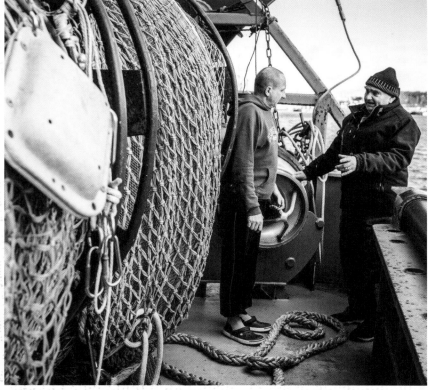

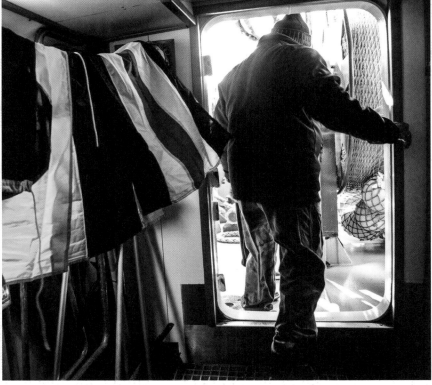

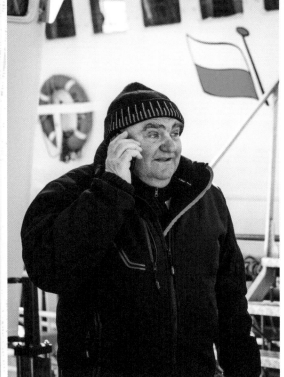

JAROSLAV SEEMS TO KNOW EVERY CUTTER, EVERY FISHERMAN, AND EVERY SEAGULL IN
THE HARBOR. WHEREVER THERE IS LIFE ON BOARD THE MOORED SHIPS, THEY GREET
EACH OTHER AND CHAT BRIEFLY. HERE AND THERE THE SPRY PENSIONER CLIMBS ON
DECK WITH ASTONISHING SPEED TO HAVE A LOOK AT THE LATEST FISHING GEAR.

Fish stock

Fish stock is used in a great many recipes, and it is very easy and economical to make at home. It is a good idea to plan ahead and ask your favorite fishmonger to set aside a few fish carcasses for you.

Serves 4

10½ oz (300 g)	fish carcasses or shellfish shells
2	leeks, cut into chunks
2	carrots, cut into chunks
1	handful parsley
5 oz (150 ml)	dry white wine

Preparation

Pick off any bits of blood clinging to the fish carcasses and rinse under running water. Place all ingredients in a pot filled with around 1 quart (1 liter) of water and bring to a boil. After 5 minutes, skim the foam off the surface and discard. Reduce the heat to medium and simmer for 30 minutes, skimming off more foam as needed.

Finally, strain the broth through a sieve. The finished stock can be used immediately, refrigerated for 2 or 3 days, or frozen. It is practical to freeze the broth in ice cube trays and simply defrost the amount you need for a particular recipe.

Cured Salmon

During his travels, Jaroslav was always eager to try the most exotic kinds of fish, which he thoroughly enjoyed. However, he prepares his favorite dish with wild salmon from his native Baltic Sea.

Serves 4

1	whole salmon fillet, with skin
2 Tbsp	sugar
1 tsp	allspice, roughly crushed in a mortar and pestle
1	bay leaf, ground into a powder
	Salt
1	red onion, finely sliced
1 Tbsp	capers
1 Tbsp	dill, finely chopped
	Olive oil

Preparation

Sprinkle the salmon fillet with the sugar, allspice, and ground bay leaf, cover everything with salt, and refrigerate overnight.

The next day, rinse off the fillet under running water, pat dry with a paper towel, and slice thinly. Arrange the slices on a plate and sprinkle with the onion, capers, and dill.

Finally, drizzle with olive oil, wrap in plastic, and marinate in the refrigerator for 3 to 4 hours before serving.

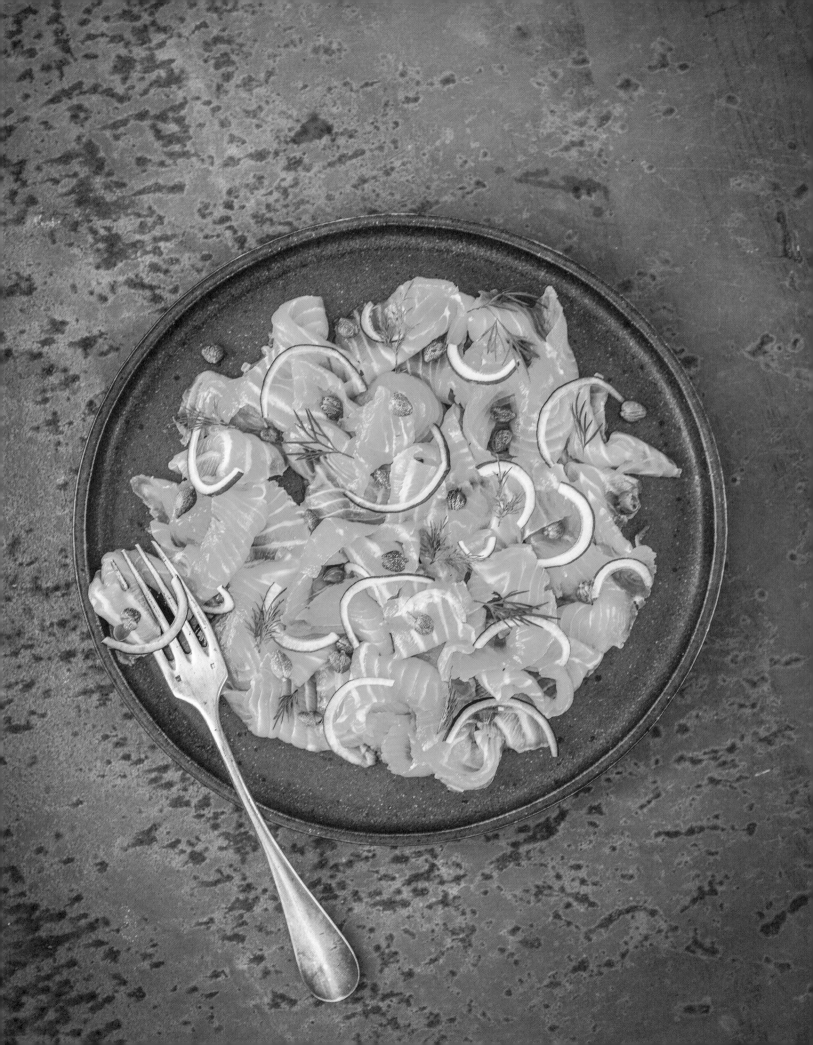

ARVIS JANSONS

Roja, Latvia

Latvia · Baltic Sea

Winter has a firm grip on Latvia. The coastal landscape is bathed in white beneath a silvery gray sky, and the temperatures have plunged to the double-digit subzero range. The cold doesn't bother Arvis Jansons, but the ice is slowly giving him some reason for concern. On his way back from the sea, he casts a critical eye over the growing ice sheet covering the breakwaters at the mouth of the harbor. The trawlers from Roja can still go out every day, but the ice floes in the harbor keep accumulating, and the next cold front is already advancing from Siberia. When the ice reaches a thickness of two inches (five centimeters), the conditions become too hazardous, and the entire harbor in the Gulf of Riga shuts down. When this happens, the ships remain moored along the quay wall, stranding Arvis and his crew on shore without any work prospects. Although they are all permanently employed by the fish factory in the harbor, they are nevertheless at the mercy of nature's whims. Their pay varies, depending on the catch: They earn more on good days that bring in a lot of fish, but when the ice forces the ships to remain in port, the fishermen are temporarily out of work.

HOWEVER, WHEN HIS NETS ARE EMPTY AND NO MONEY IS COMING IN, ARVIS HAS PLENTY OF TIME TO SPEND WITH HIS LOVED ONES. THE BALTIC SEA WOLF IS A FAMILY MAN, AND HIS WIFE AND KIDS WERE THE ONES WHO CONVINCED HIM TO TRY HIS HAND AT FISHING.

He used to work on the huge ships of the Latvian merchant marine, which traveled all over the Baltic Sea. As the captain of a tanker, he bore enormous responsibility and transported all kinds of raw materials to ports around the Baltic. On realizing that he was seeing far too little of his growing children, he switched to a different class of vessel and retrained as a fishing boat captain. Arvis did not find it particularly difficult to take this new career path. The size of his ship and his working hours may have changed, but he still spends his days in familiar waters. He has been a fisherman for 15 years now. When the elements permit, he maneuvers his ship into the Gulf of Riga every morning and returns home at dusk.

Today he arrives not only in time for dinner but also in fine spirits, despite the ominous ice sheet. It had been a good day for the crew of the *Sams:* Eight tons of herring, sprats, and whiting are stored for the time being in the ship's hold. The precious catch is brought ashore by crane in crates the size of bathtubs, where they are collected by the fastest forklift operator in Europe. Every move that Arvis, his crew, and the dockworkers make is perfectly orchestrated. Thirty minutes later, they have transferred all the fish to dry land, moored the *Sams* along the jetty, and Arvis can set out for home in good time just as he'd hoped.

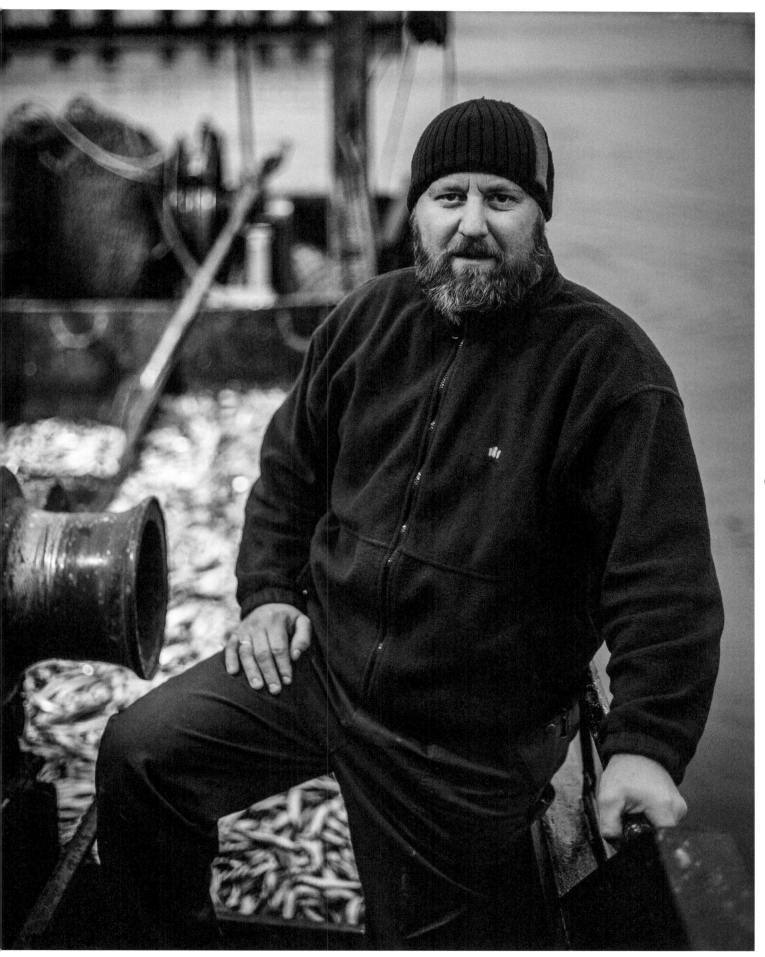

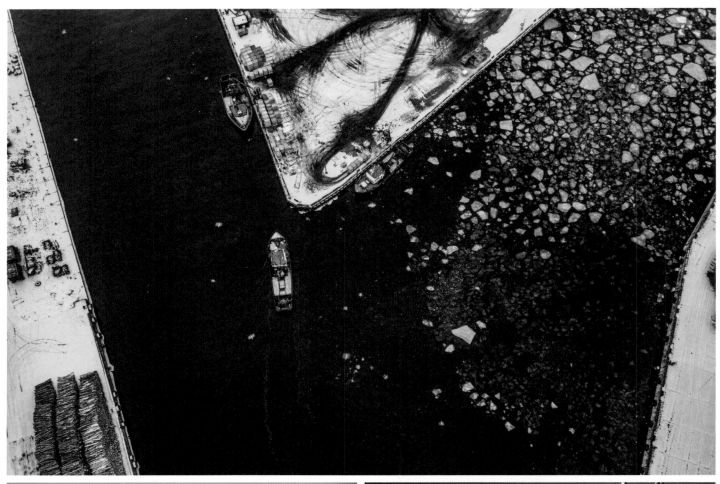

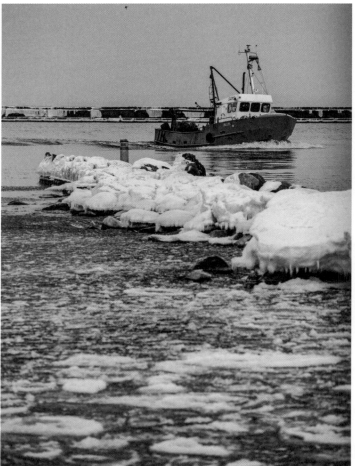

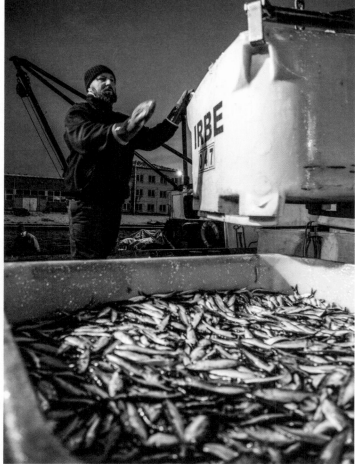

THE TRAWLERS FROM ROJA CAN STILL GO
OUT EVERY DAY, BUT THE ICE FLOES IN THE
HARBOR KEEP ACCUMULATING, AND THE
NEXT COLD FRONT IS ALREADY ADVANCING
FROM SIBERIA.

SMOKED FISH WITH CREAM CHEESE

Smoked fish is very popular in Latvia. Along the coast, there are numerous small smokehouses and sales stands that offer the golden shimmering delicacies fresh from the smoker.

SERVES 4

7 oz (200 g)	smoked fish (such as herring, salmon, sprats)
1	red onion, finely diced
2	cloves of garlic, minced
1 Tbsp	dill, chopped
1	pinch of chili powder (optional)
7 oz (200 g)	cream cheese
	Dark sourdough bread

PREPARATION

Remove any bones from the smoked fish, then shred with a fork. Combine it with the remaining ingredients and the cream cheese.

Spread the finished mixture onto the bread and serve as an appetizer or as a small snack for between meals.

PICKLED FRIED HERRING

Herring accounts for the majority of Arvis' catch. So it's a good thing that he enjoys eating it as well, preferably fried and marinated.

SERVES 4

Marinade:

3 cups (700 ml)	white wine vinegar
3 cups (700 ml)	water
2 Tbsp	mustard seeds
4 Tbsp	sugar
1 tsp	salt
½ tsp	dill
2	large onions, sliced into rings
8	herring
	Salt, pepper
	Flour
	Sunflower oil for frying

PREPARATION

Add all the ingredients for the marinade to a pot, bring to a boil, and then simmer for 5 minutes. Remove from the stove, add the onion rings, then let cool.

Gut the herring, cut off the head, rinse, and then pat dry. Next season with salt and pepper before coating the fish in flour. Fry for 3 to 4 minutes per side until golden brown, then let cool.

Place the fried herring in a sealable container along with the marinade and the onion rings. Refrigerate for at least 24 hours.

The pickled fried herring should be removed from the refrigerator ½ hour before eating and can be served either as an appetizer or as a main course (with fried potatoes, for instance).

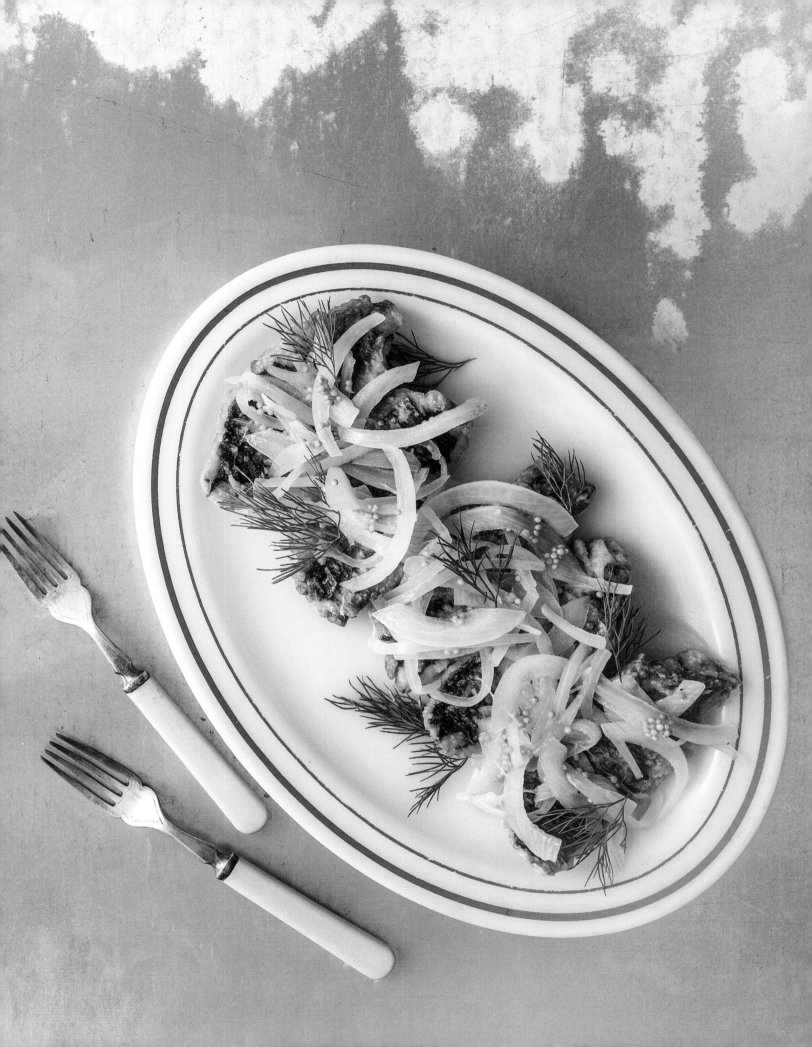

Jᴏɴɴʏ Eᴋʜᴏʟᴍ

Grisslehamn, Sweden

Grisslehamn is a traditional fishing port on the eastern coast of Sweden, which is known for its countless islands. Situated on the narrowest point of the Sea of Åland, from here the boats quickly reach the deep, nutrient-rich waters of the strait between Sweden and the Åland archipelago, an area with abundant fish. Fishermen have used this strategically good location for generations, and the small harbor with its red wooden houses even holds a record: The biggest Baltic cod ever caught weighed in here at an impressive 81 pounds (37 kilos).

At the moment, however, all this glory is of little use to the last remaining fishermen here. This season has seen one run of bad luck after another. Since ice finally disappeared from the harbor and the fishermen were able to cast out their nets again, the year has developed into an unmitigated disaster. Despite a picturesque sunrise, today has gotten off to a bad start for Jonny Ekholm. It is exasperating: His net is almost a mile long (1.5 kilometers), and he has already hauled half of it on board and has not yet found a single cod trapped inside. Jonny suspects that seals are behind this miserable turn of events. The fearless animals follow the ships, plucking the fish from the net at their leisure, and sometimes even damaging the fishing gear in the process. He has not yet spotted one today, but the intelligent creatures are extremely careful when the visibility is so good. Time and again, Jonny eyes the Baltic Sea skeptically; the water is as smooth as glass. He desperately hopes for the next fish but instead only discovers new holes in his net. He usually only patches the net in the winter, but if it continues like this, he'll soon need to stop to make repairs—and that would only further reduce his profit. Fortunately, there are no major investments on the horizon; Jonny had already completely upgraded his boat in better days.

When the mustached Swede started fishing in the eighties, good times prevailed for the captains of Grisslehamn. After his service in the navy, the trained car mechanic joined his father's fishing operation. The year before, his father had turned his passion for the sea into a career: On his old wooden ship named *Isabella,* he used to regularly return home with completely full nets. This appealed to Jonny far more than working under a vehicle lift, so he decided to follow in his father's footsteps. Together they earned a good living and were able to renovate the aging wooden boat. Apart from their economic success, most of all they really enjoyed the work.

ON ONE RECORD-SETTING DAY, THE TWO EKHOLMS RETURNED TO HARBOR WITH 110 FULL CRATES CONTAINING 3.3 TONS OF FISH. THAT WAS AN EXTRAORDINARY AMOUNT, EVEN BY THE STANDARDS OF THE TIME.

The fishing grounds are still home to enough fish. Today, however, Jonny has reached his lowest point so far: By the time he reaches the end of his net, he has not even filled an entire fish crate. Two cods are the meager result of all his hard work. The Swede is visibly saddened. He hesitates, wondering whether he should even set out his nets again. Resigned, he retreats to the cabin and radios his colleagues to consult with them. The situation is no better for them, and a general feeling of perplexity begins to spread. The entire time, Jonny tensely watches the sonar, sees numerous large fish, and ultimately decides to try again after all. To an extent, hope is always the last to die, and luckily when it comes to fishing, no two days are ever alike.

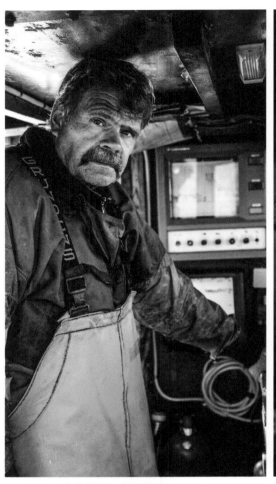

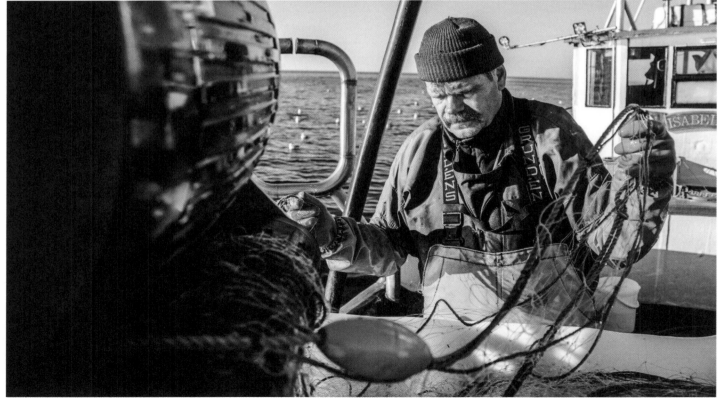

TIME AND AGAIN, JONNY EYES THE BALTIC SEA SKEPTICALLY; THE WATER IS AS SMOOTH AS GLASS. HE DESPERATELY HOPES FOR THE NEXT FISH BUT INSTEAD ONLY DISCOVERS NEW HOLES IN HIS NET.

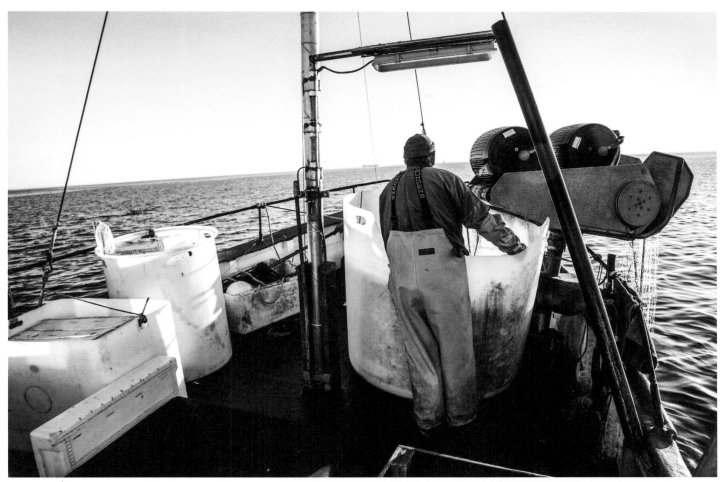

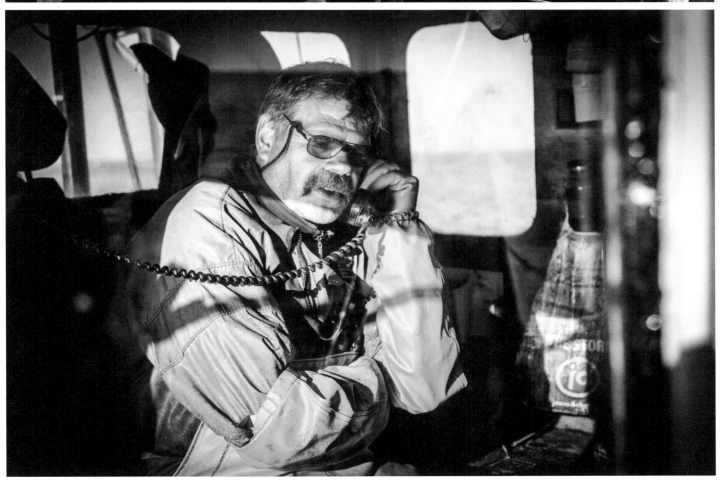

Fried Herring
with Young Potatoes

Breaded herring is a classic dish enjoyed throughout the Baltic region. This is how it is eaten along the Baltic coast of Sweden:

Serves 4

1¾ lb (800 g)	young potatoes with skin
	Salt
	Butter
8–12	herring double fillets
½	bunch of dill, finely chopped
	Pepper
1	egg
	Rye flour
	Vegetable oil

Preparation

Cook the potatoes in salted water until just tender. Drain the potatoes, then toss with some butter.

Sprinkle the meat side of the herring fillets with dill, salt, and pepper. Next fold the double fillets closed, first coating them in egg and then in rye flour. Fry the breaded fillets in hot vegetable oil for 3 to 4 minutes per side until they are brown and crispy. Serve along with the potatoes.

Potato Leek Soup
with Fried Salmon

Commercial fishing of wild salmon has almost entirely disappeared, and this fish has become difficult to find. The fisherman has this piece of advice: Use sustainably farmed rainbow trout instead of farmed salmon.

Serves 4

2¼ lb (1 kg)	potatoes, peeled and diced
14 oz (400 g)	leeks, cleaned and sliced
1	large onion, diced
	Butter
	Salt, pepper
2	cloves of garlic, minced
½ tsp	chopped ginger
4¼ cups (1 l)	vegetable stock
7 oz (200 g)	salmon fillet, with or without skin
	Vegetable oil
1 Tbsp	fresh dill

Preparation

In a large pot, brown the diced potatoes, sliced leeks, and chopped onion in some butter. Season with salt and pepper. Once the onions and leeks become translucent, add in the garlic and ginger. Continue to sauté for another minute, then deglaze the pot with the vegetable stock. Give everything a good stir, then simmer over medium heat for 25 minutes. Remove the soup from the stove, puree with an immersion blender, and set aside.

In the meantime, cut the salmon fillet into strips about 1½ inches (4 cm) in width. Sauté in some vegetable oil for about 2 to 3 minutes on each side. Serve the hot soup in bowls. Cut the salmon into bite-sized pieces and arrange on top of the soup. Finish it off by garnishing with sprigs of dill.

ABOUT THE INGREDIENTS:
It's actually a shame to let any removed **salmon skin** go to waste. When it's fried until very crispy, it becomes a sophisticated delicacy. You can cut the skin into crispy flakes, for instance, and use them to garnish a salad, or you can combine them with cream cheese and herbs to make a spread.

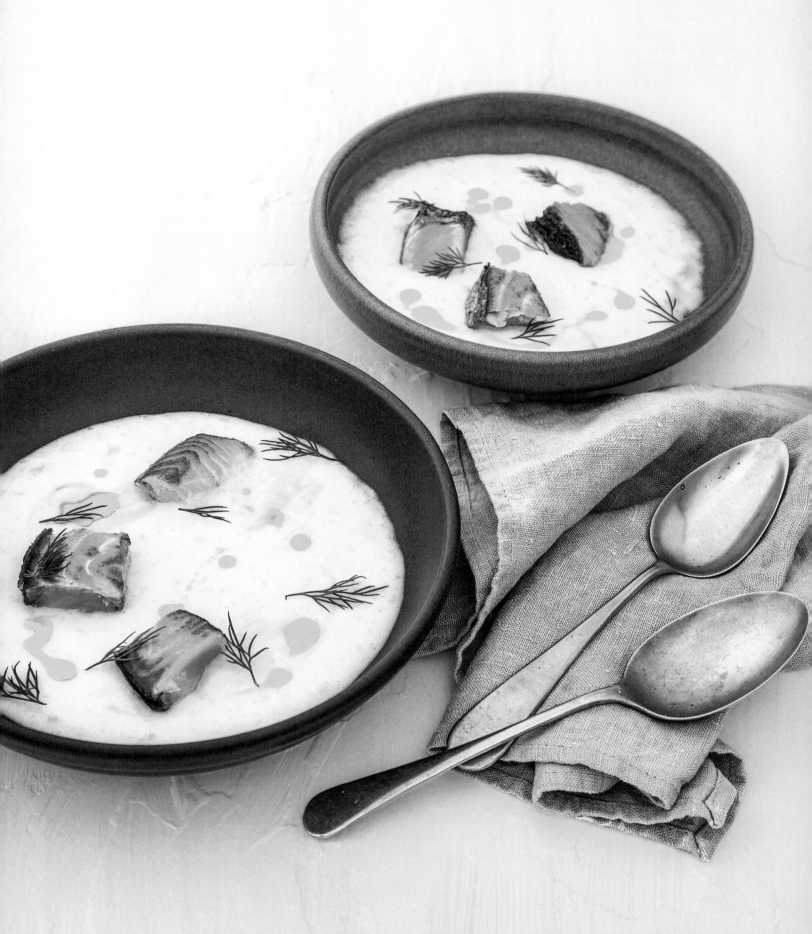

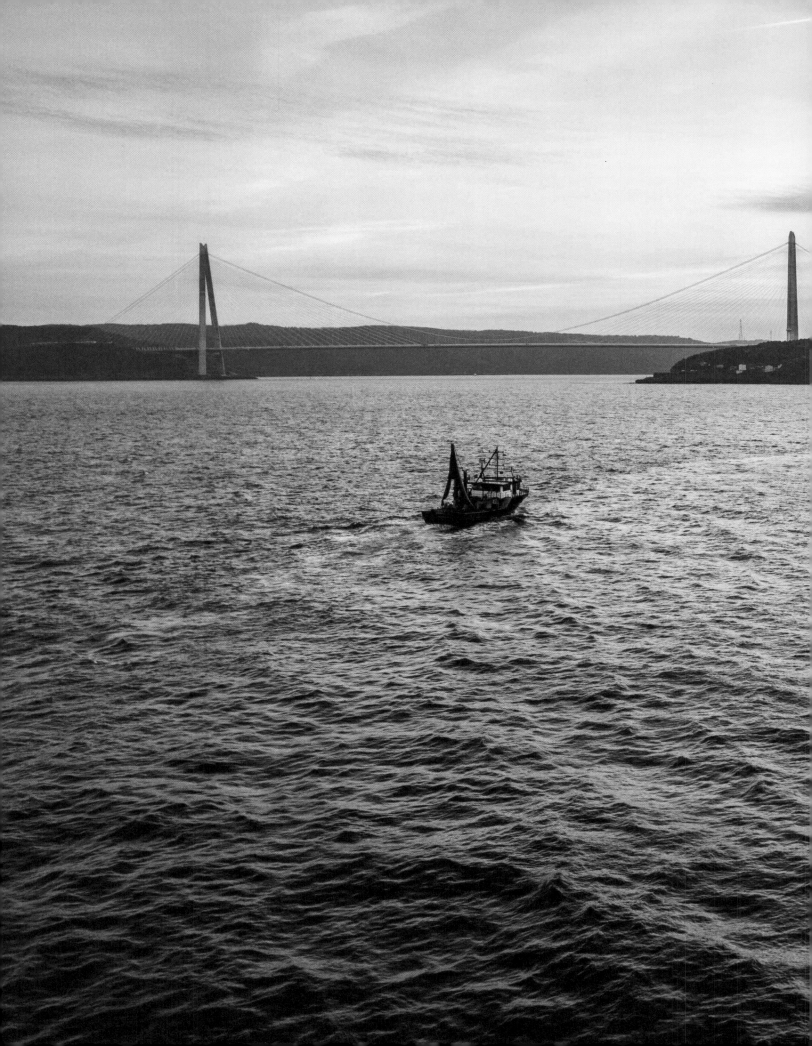

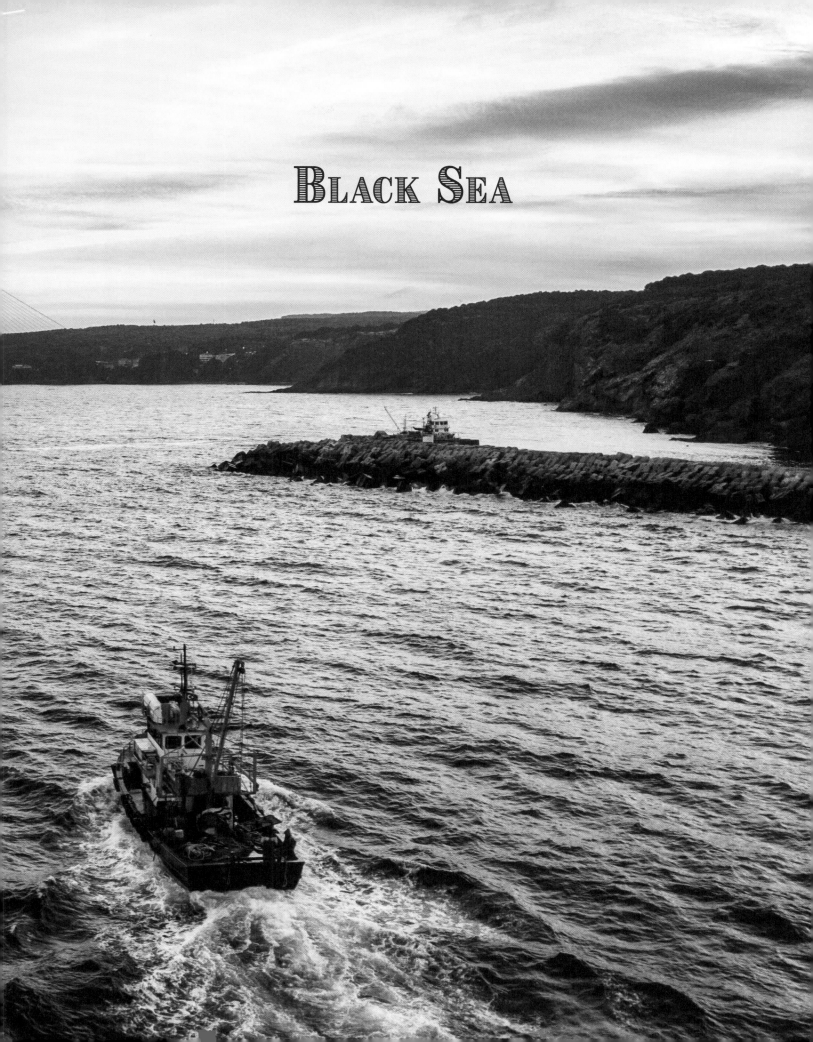

BLACK SEA

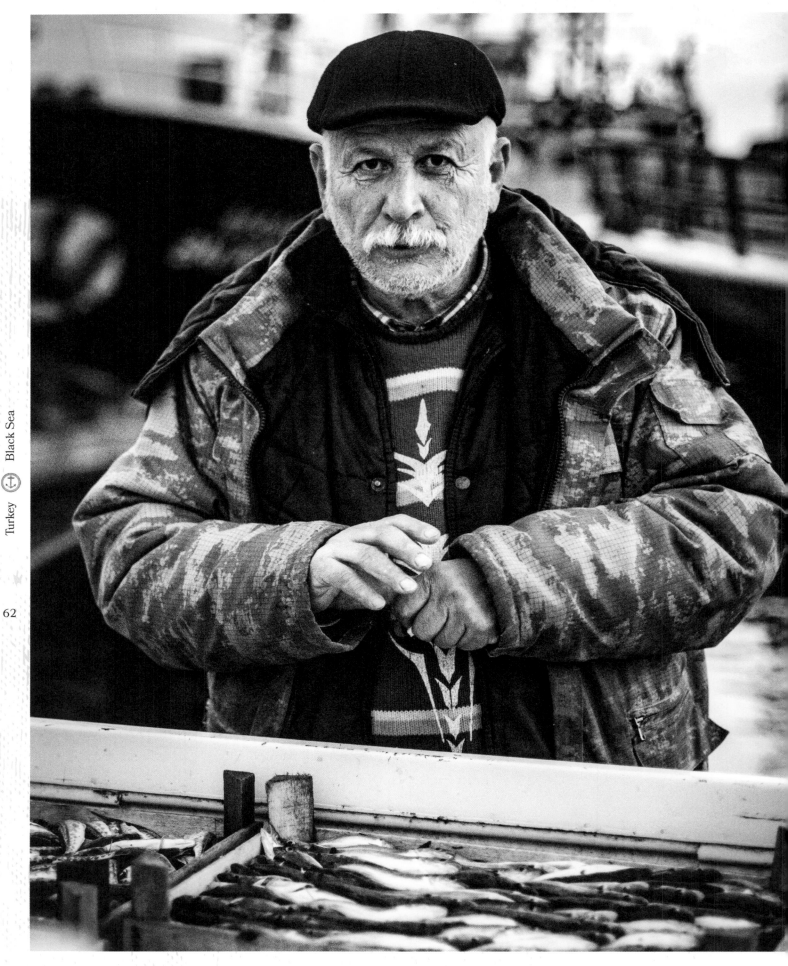

KENAN MAYK

Rumelifeneri, Turkey

As the sun sinks behind the European bank of the Bosporus, a whole flock of fishermen returns from the fishing grounds in the Black Sea. The only creatures more numerous than the towering cutters are the strident seagulls. Hundreds of them circle the boats and greedily dive for every scrap of fish tossed overboard, no matter how small. As the insatiable seabirds cry overhead, one ship after the other passes the breakwaters at the mouth of the harbor. One by one, they fill the moorings along the Rumelifeneri jetty, and signs of life also begin to emerge on shore. As soon as the first fishermen arrive, Kenan Mayk steers his small truck down the steep road leading to the harbor.

The old fishmonger makes a beeline for the quay wall and boards one of the boats before the crews have finished mooring their vessels. They all know him. Kenan makes daily visits to the harbor, situated on the northern bank of the Bosporus, where the river meets the sea. The fishermen hold their loyal buyer in high regard, in part because he is an experienced sailor in his own right and understands the challenges of the fishing industry better than anyone. These days, he sticks to land but remains as skilled as ever in applying his expertise. He carefully examines the catch in the refrigerated hold with the critical eye of an expert and then the negotiations get underway. The fish are terribly small, Kenan points out with a theatrical flair. The fishermen shake their heads sadly and blame it on the bad weather. Then, after a brief back and forth, money and goods change hands. Now that they have concluded their business, the fishermen form a human chain and help Kenan load his purchases.

Once the fish have been safely stowed, the fishmonger immediately covers them with a tarp—after all, the hungry seagulls are still on the lookout for scraps—and then it's on to the next ship. Time is money, since other buyers are also out and about in the harbor, ready to snatch the goods out from under Kenan's nose. He rushes from ship to ship, and crate after crate fills up in the back of his truck.

AT EACH STOP, THE STREET VENDOR SKILLFULLY REPEATS HIS PERFORMANCE: AFTER ADOPTING A POINTEDLY CRITICAL EXPRESSION, HE REMARKS ON THE QUALITY AND SIZE OF THE CATCH WITH A HEAVY SIGH, ONLY IN MOST CASES TO BUY THE ENTIRE HAUL IN THE END.

He briskly repeats this performance until night has fallen over Rumelifeneri and the final trawler has arrived in port. Kenan is now approaching the end of his workday, but like his seafaring colleagues, he will start again bright and early the next morning. As the fishing fleet sets out to the north at the break of day, the enterprising vendor makes his way south. His customers in Istanbul's suburbs wait impatiently for fresh fish from the Black Sea. Kenan is welcomed warmly all along his regular route, and his merchandise is in high demand. The back of his truck is often picked clean by midday, and he indulges in a hard-earned break before heading back to the shore. On returning to Rumelifeneri Harbor, the vendor, fishermen, and seagulls celebrate a happy reunion, and the daily ritual begins all over again.

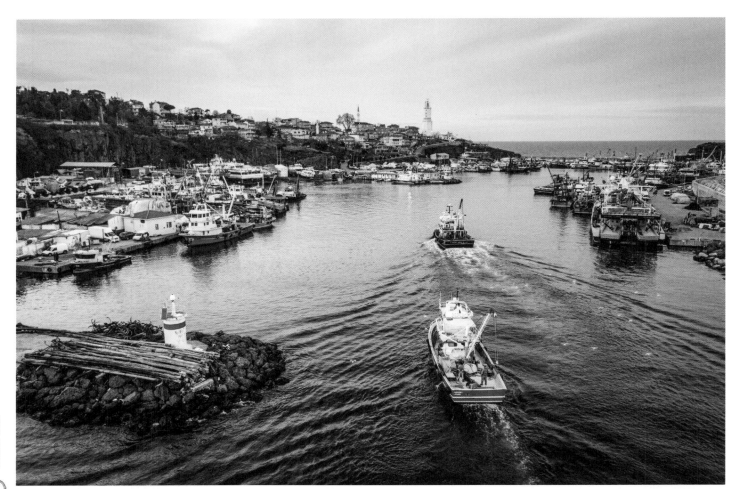

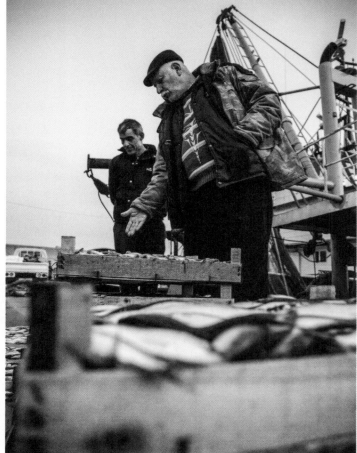

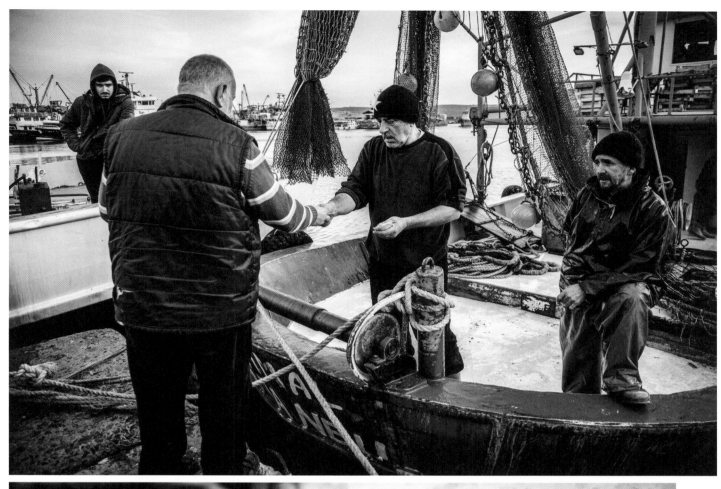

KENAN CAREFULLY EXAMINES THE CATCH IN THE REFRIGERATED HOLD WITH
THE CRITICAL EYE OF AN EXPERT AND THEN THE NEGOTIATIONS GET UNDERWAY.

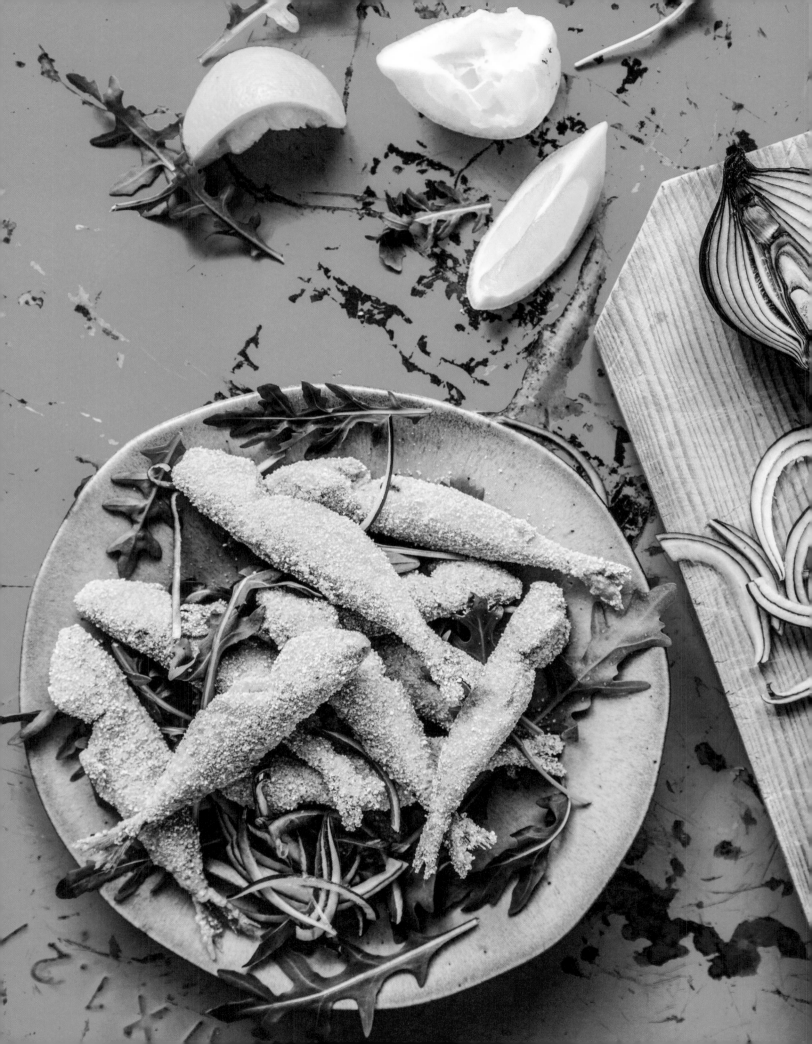

Fried Whiting

Kenan's favorite dish is more of an appetizer or a snack for between meals. This is the perfect dish for the traveling dealer who is always on the go.

SERVES 4

	Flour
2	eggs
	Cornmeal
1¾ lb (800 g)	small whiting (the large fish are often sold as fillets; when they are small, whiting can be fried whole, but you should be sure to scale and gut them first)
	Olive oil
1	handful of arugula, washed
1	red onion, thinly sliced
1	lemon

PREPARATION

Place the flour, the beaten egg, and the cornmeal on separate plates. First coat the fish in flour, then the egg, then the cornmeal.

Heat an ample amount of olive oil in a large pan over medium heat. Fry the breaded fish for about 2 to 3 minutes per side until golden brown. On a plate, arrange the freshly fried fish along with the arugula and the onion slices and drizzle with the lemon.

Best eaten with your fingers!

Fish Stew
with Lemon and Tomato

Fishermen love their stews, and Turkey is no exception. This version from the Bosporus is wonderfully fresh with plenty of citrus aromas.

SERVES 4

	Olive oil
2	onions, sliced into rings
2	medium-sized sea bass, ready to cook
8	ripe tomatoes
4	cloves of garlic, coarsely chopped
2 Tbsp	parsley, chopped
3	lemons
	Salt
	Pita bread

PREPARATION

Pour some olive oil into a large pot with a lid. Spread out the onion rings inside, then arrange the fish on top of the onions. To peel the tomatoes: Score the tomatoes crosswise, then pour boiling water over them. Wait a minute and then you will be able to easily peel off the skin. Dice the tomatoes, then spread the tomatoes over the fish along with the garlic and parsley. Peel two lemons, slice, then arrange on top of the other ingredients. Squeeze the juice from the last lemon over everything. Season with salt and drizzle generously with olive oil.

Place the lid on the pot, then simmer the stew over medium heat for about 40 minutes. Serve hot with toasted pita bread.

Doru Agache

Sfântu Gheorghe, Romania

Sfântu Gheorghe is located on the far eastern edge of Romania. It is situated in Europe's second-largest river delta, where the waters of the Danube pour into the Black Sea. The tranquil fishing village is nearly surrounded by water: From the east, the waves from the Black Sea crash onto shore and the endless floodplains of the delta stretch out in every direction. The small village can only be reached by boat. If you want to come here, you have to park your car in the district town of Tulcea and take a three-hour ferry ride through the meandering foothills of the Danube.

Doru was born and raised in Sfântu Gheorghe and has spent his entire life here. He never entertained the idea of becoming anything other than a fisherman. Even as a child, he would go to sea with his father. He grew up exploring the lagoons of the delta and becoming familiar with different fishing methods along with the peculiarities of the local wildlife. The fishermen of the region were once rich people.

THE STURGEON OF THE BLACK SEA—AND ESPECIALLY THEIR EXTREMELY VALUABLE EGGS—BROUGHT FAME AND A HIGH STANDARD OF LIVING TO THE SMALL VILLAGE. THE LARGEST STURGEON COULD WEIGH MORE THAN A TON AND CATCHING SUCH A SPECIMEN WOULD FEED SEVERAL FAMILIES FOR WEEKS.

Then, twelve years ago, all sturgeon fishing was banned, and fishermen were forced to fundamentally change their fishing methods and habits. Since then, they have come to terms with it, but they have to work more—for less money.

As if all that weren't enough, the fuel ran out today. A snowstorm cut the power line to the mainland the day before, and there is no electricity in the entire village. Although there is plenty of fuel stored for the boats, the only fuel pump in the harbor cannot be operated without electricity. Fortunately, Doru still has a small amount of reserve fuel in his tank. It is not enough for fishing, but at least it is enough for the crossing to his cabin on the other bank of the Danube. This is where the fishermen store their nets, which take a lot of time to maintain. Last week, a log floated into Doru's main net and seriously damaged his most important fishing gear. He gets to work with needle and thread and mends the net stitch by stitch.

Around noon his colleague Lucian stops by and delivers good news: A generator was shipped in from the mainland so that the fuel pump in the harbor can finally be operated again. Unfortunately, it is too late to head out to sea today. The two use the remaining daylight to repair their nets and traps, the task is easier and more entertaining when the two work together. Doru and Lucian have fished together for ages, and they used to go to school together in the small village school. While they talk about the glorious days of sturgeon fishing and their adventures at sea, they go through one spool of thread after another. Several hours later, they have whipped their entire arsenal into shape and the two look forward to being able to make a concerted effort to fish again the next day. And maybe someday they will even be allowed to fish for their beloved sturgeon again. In two years, the EU will decide whether to lift the fishing ban ...

THE SMALL VILLAGE CAN ONLY BE REACHED BY BOAT. IF YOU WANT TO COME HERE, YOU HAVE TO PARK YOUR CAR IN THE DISTRICT TOWN OF TULCEA AND TAKE A THREE-HOUR FERRY RIDE THROUGH THE MEANDERING FOOTHILLS OF THE DANUBE.

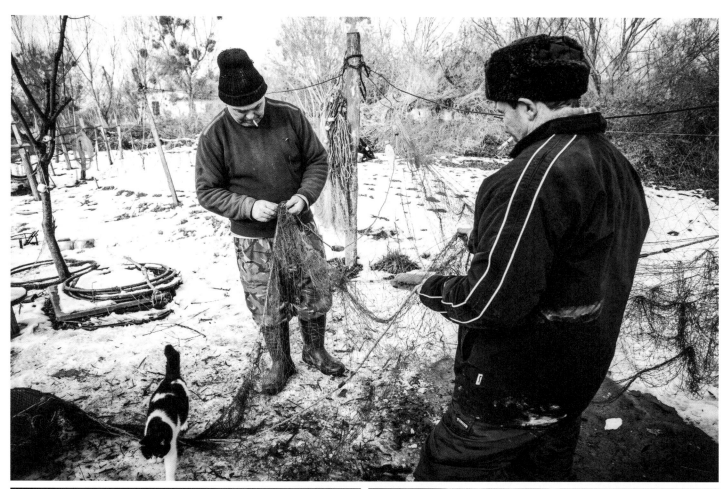

GRILLED HERBED HERRING WITH POLENTA

Since sturgeon fishing has been banned, herring has become the most important fish in the Danube estuary.

SERVES 4

2 Tbsp	fresh herbs (such as parsley, dill, thyme, and oregano), finely chopped
2 Tbsp	olive oil
2¼ lb (1 kg)	herring, gutted and scaled
	Salt
3 cups (750 ml)	water
Scant ¾ cup (150 g)	polenta
1 Tbsp + 1 tsp (20 g)	butter

PREPARATION

Mix the finely chopped herbs with the oil. Carefully score the herring with numerous small diagonal cuts and liberally apply the herbed oil.

Bring the salted water to a boil and pour in the polenta, stirring constantly. Simmer the polenta over low heat for 20 minutes, continuing to stir constantly. Finally, mix in the butter. Scrape the polenta into a flat dish and allow it to cool for at least 15 minutes.

In the meantime, grill the herring on the grill over medium heat for 3 to 4 minutes per side until crisp. Cut the cooled polenta into pieces and serve with the herring, hot from the grill.

STORCEAG (STURGEON SOUP)

Doru does not hesitate for a second when asked about his favorite recipe: "Storceag," a traditional fish soup from the delta. Although this recipe is traditionally prepared with Doru's beloved sturgeon, today catfish is usually used as a substitute.

SERVES 4

17 oz (500 g)	sturgeon or catfish
	Salt
14 oz (400 g)	potatoes, peeled, cut into medium sized pieces
1	onion
1	green onion
1	parsley root
1	bell pepper
1	egg yolk
7 oz (100 g)	sour cream
1 Tbsp	dill, finely chopped
1 Tbsp	parsley, finely chopped
1	hot pointed pepper, cut into slices

PREPARATION

Cut the fish fillets into pieces about ¾ to 1¼ inches (2 to 3 cm) in size, then season with salt. Add the potatoes, the diced vegetables, and the fish to a pot with a generous three quarts (three liters) of water and simmer over medium heat for 20 minutes.

Stir the egg yolk into the sour cream, pour into the soup, and simmer for an additional 2 to 3 minutes over low heat.

Remove the pot from the stove and stir in the dill and parsley. Garnish with the slices of pointed pepper and serve hot.

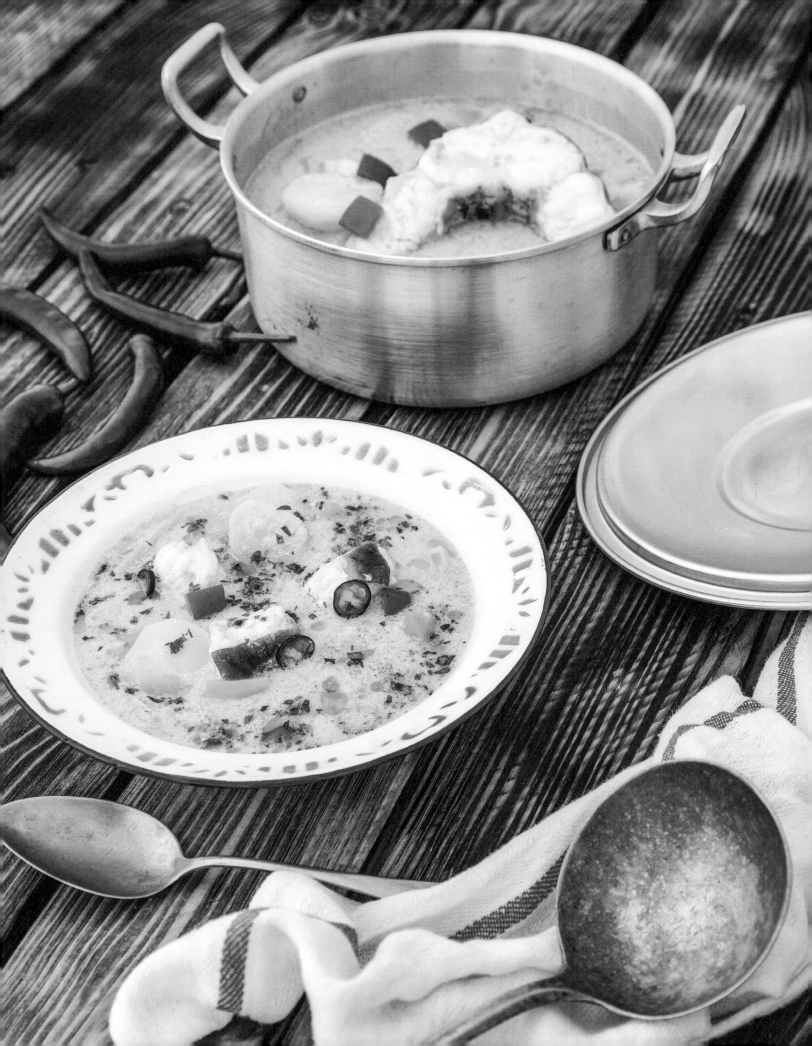

Arnfinnur Thomassen

Sørvágur, Faroe Islands

As the *Nestangi* glides through the calm, dark water heading for the fishing grounds, lush green mountainsides rise up on both sides of Sørvágsfjørður fjord. The weather is unusually good for the Faroe Islands and the sea is showing its tame side. Only occasionally do a few swells from far distant storms gently lift the boat. These conditions are a rarity here on the extreme western tip of this North Atlantic archipelago, where the surf usually thunders at the foot of the towering cliffs. Typically, you have to stay far away from the rocks, but today Arnfinnur Thomassen can take a shortcut.

He knows the hidden dangers of the Faroe Islands because he has spent his entire life fishing here. His father taught him the basics of fishing when he was a child. As a young man, he went to Greenland to find work on the big trawlers there. After several years in the rough waters bordering the Arctic, he was drawn home again. Back in Sørvágur, on the third largest island in the Faroe Islands, he bought his own boat and started a family. Nowadays his four children are grown and have left home. He is a grandfather several times over, and he still goes fishing nearly every day when the winds and waves of the North Atlantic permit.

Nature is benign today, and Arnfinnur skillfully steers his boat through the spectacular rock formations of Tindhólmur and on out to the open sea. In the middle of the jagged rocky islands, the fishing boat suddenly seems tiny.

WITH ITS TRADITIONAL DESIGN AND STATE-OF-THE-ART EQUIPMENT, THE NESTANGI IS ALSO A REFLECTION OF SOCIETY ON THE FAROE ISLANDS. ALTHOUGH THE WOODEN HULL AND POINTED BOW HAVE THE MILLENNIA-OLD SHAPE OF THE VIKING VESSELS, THE FISHING GEAR MOUNTED ON DECK IS PURE HIGH-TECH:

Three fully automated lines, each with two hooks on the end, dangle the bait, dancing up and down, at a depth of 80 feet (25 meters). As soon as a fish bites and tugs on the line, it is automatically reeled in by computer control. The electrical winch on deck then emits a warning signal, and the fish is pulled to the surface of the water. There Arnfinnur is waiting with his fishhook to bring the catch on board and to ensure that it doesn't escape at the last second. And even if a fish does happen to slip through his fingers, there is always plenty more to be found in these fish-filled waters.

In the cold, nutrient-rich waters of the Faroe Islands, the fish population is intact and fishing is traditionally considered to be a very stable source of income. As long as the weather plays along, the yield is always big enough. On each trip it is impossible for Arnfinnur to know how long it will take him to fill the fish crates before he can call it a day. There are usually enough golden shimmering cod teeming in the plastic containers after just a few hours—and then, like today, the Faroese fisherman can steer his boat into the fjord and head back toward Sørvágur in the evening light, accompanied by the cries of hungry seagulls.

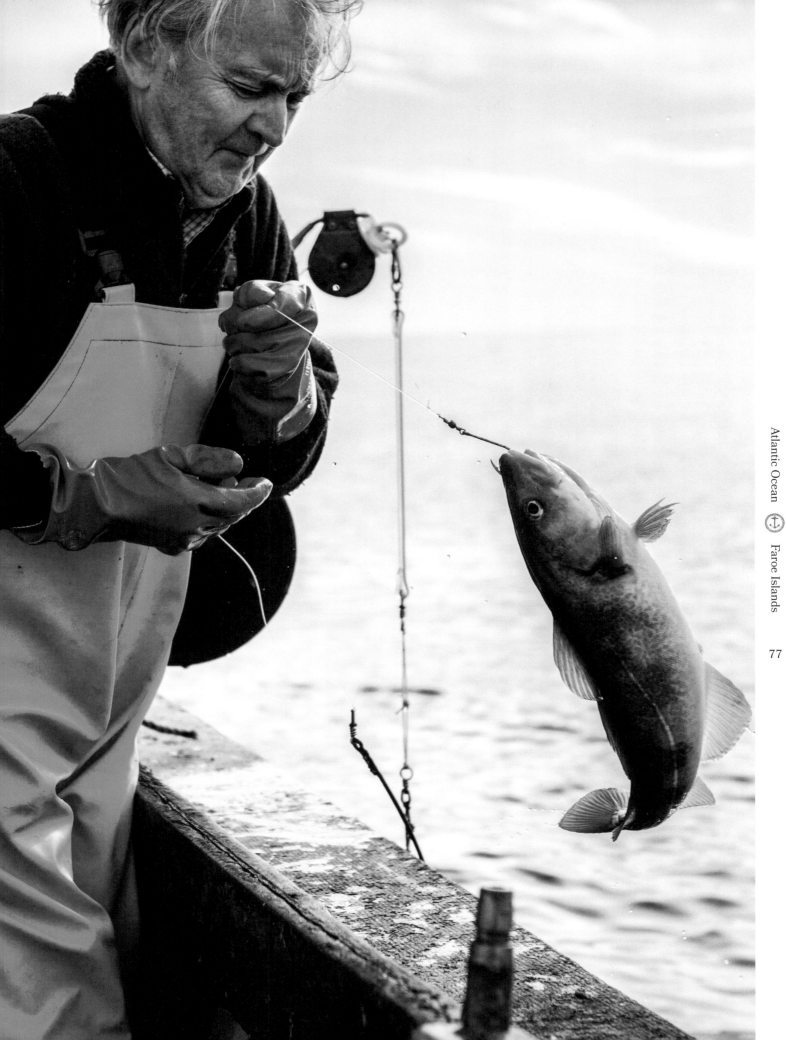

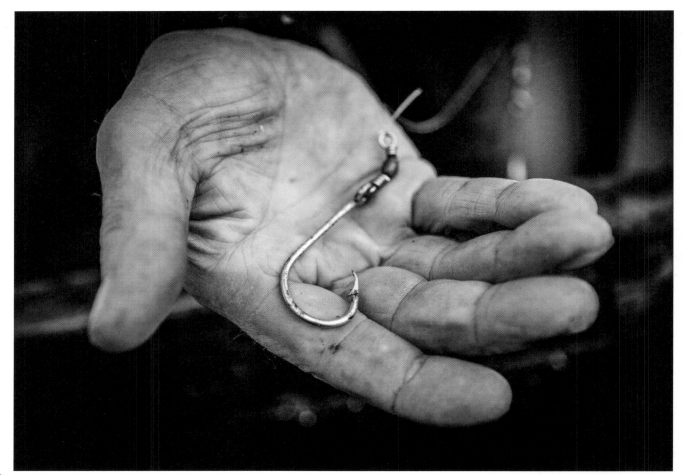

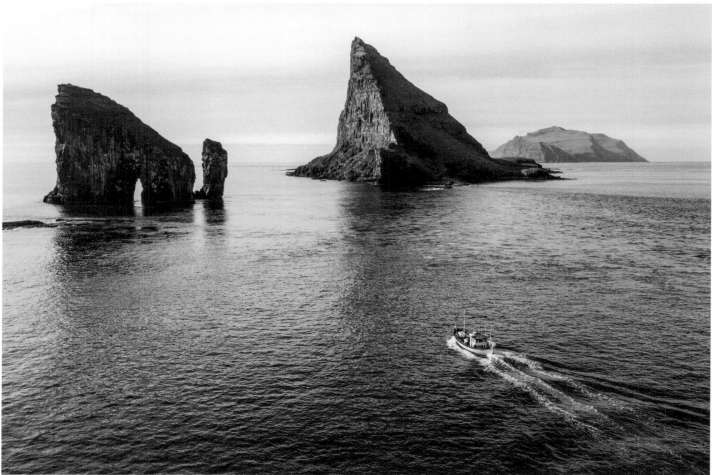

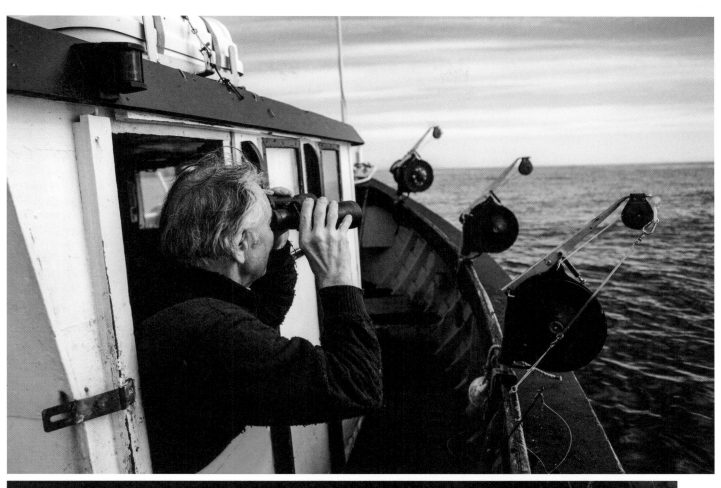

IN THE COLD, NUTRIENT-RICH WATERS OF THE FAROE ISLANDS, THE FISH POPULATION
IS INTACT AND FISHING IS TRADITIONALLY CONSIDERED TO BE A VERY STABLE SOURCE
OF INCOME.

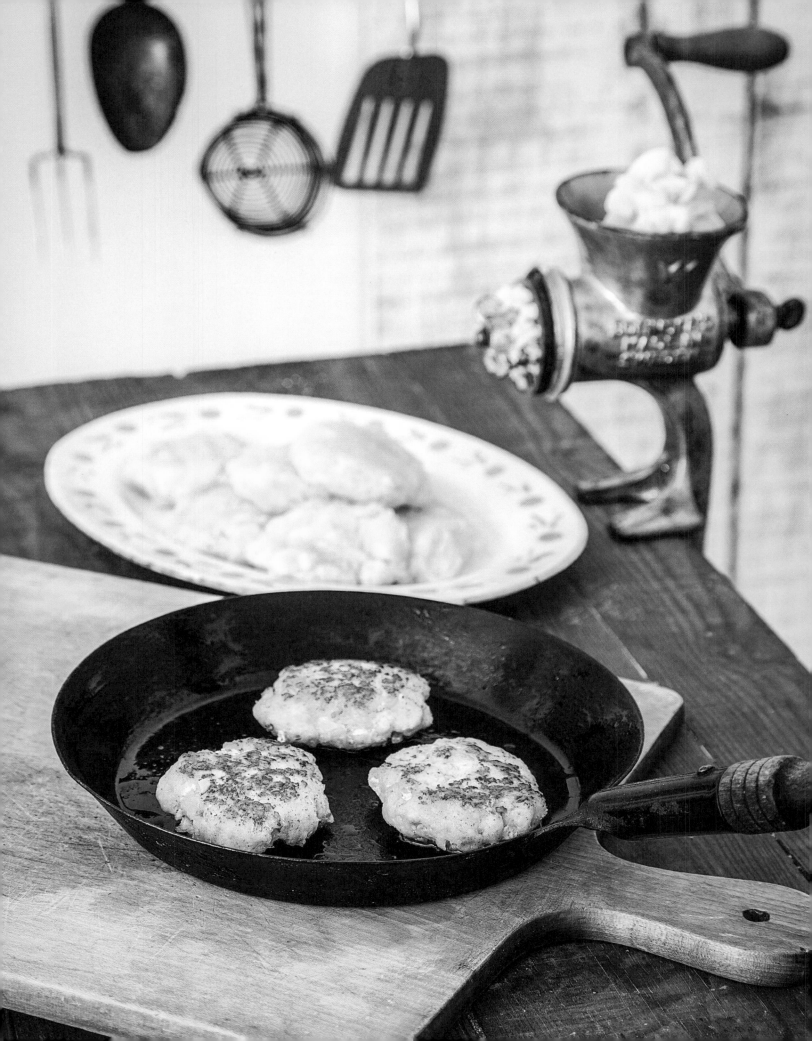

Arnfinnur's Fish Cakes

Cod and lamb: When it comes to putting the Faroe Islands on a plate, it would be difficult to top this recipe. Whenever Arnfinnur makes his beloved fish cakes, he always prepares a large batch so he can use some to restock his freezer.

SERVES 4

1¾ lb (800 g)	cod, filleted
½ lb (250 g)	lamb tallow (pre-order from butcher)
1	onion
	Salt, pepper
2¼ lb (1 kg)	potatoes

PREPARATION

Cut the cod and lamb tallow into pieces and coarsely dice the onion. Place all the ingredients in a blender and process until finely chopped. Season with salt and pepper, then form into fish cakes of whatever size you like.

Heat an ample amount of oil in a pan and fry the fish cakes until they are golden brown. Peel the potatoes, then cook them in lightly salted water for about 20 minutes. Serve with the fish cakes.

Faroese Fish Soup

It is usually cold and windy on the Faroe Islands. A warming soup is just the thing after an exhausting day at sea.

SERVES 4

1	large onion, diced
3	carrots, peeled and julienned
	Butter
3 Tbsp	curry powder
3	cloves of garlic, minced
	Chili powder (optional)
3⅓ cups (800 ml)	fish stock
7 oz (200 g)	canned peaches, diced
Scant ½ cup (100 ml)	heavy cream
	Salt
	Sugar
1⅓ lb (600 g)	cod fillet, diced
	Bread

PREPARATION

Sauté the onions and carrots in plenty of butter until translucent. Add in the curry powder, garlic, and chili powder. Sauté briefly, then pour in the fish stock and the diced peaches. Bring to a boil briefly, then reduce the heat and simmer for 15 minutes. Reduce the temperature again, then stir in the heavy cream. Season to taste with salt as well as a small pinch of sugar.

Add the fish to the soup, close the lid, and boil for another 3 to 4 minutes until the fish is done. Serve hot with bread.

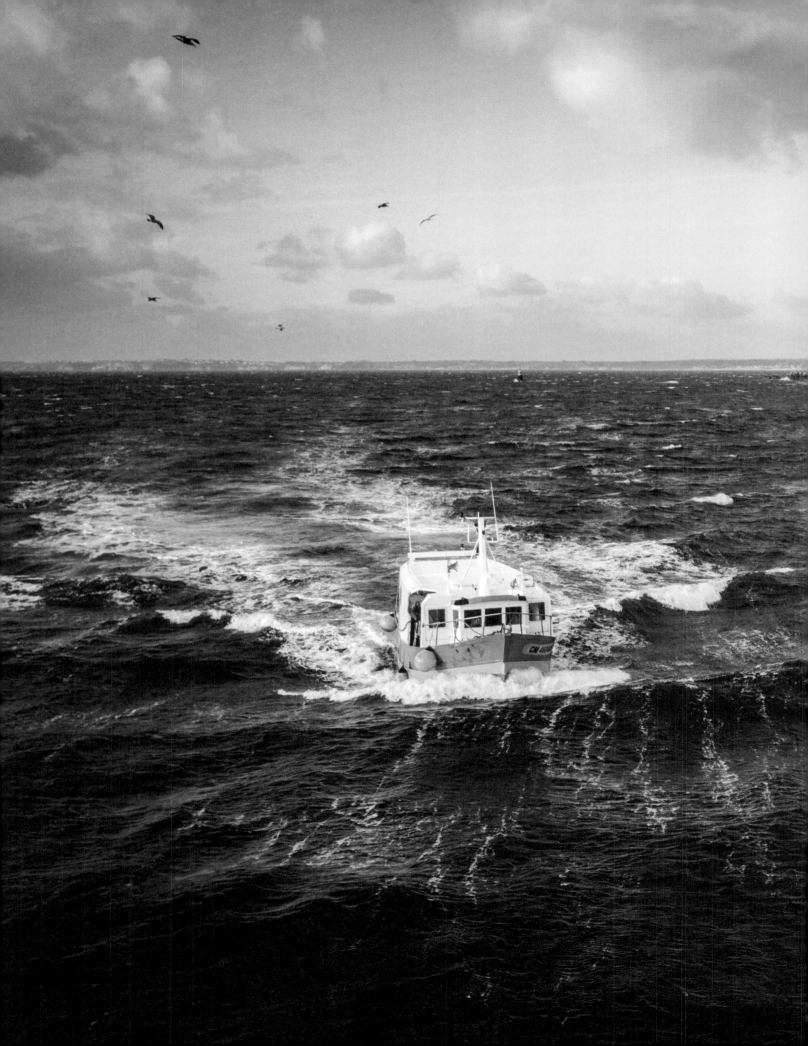

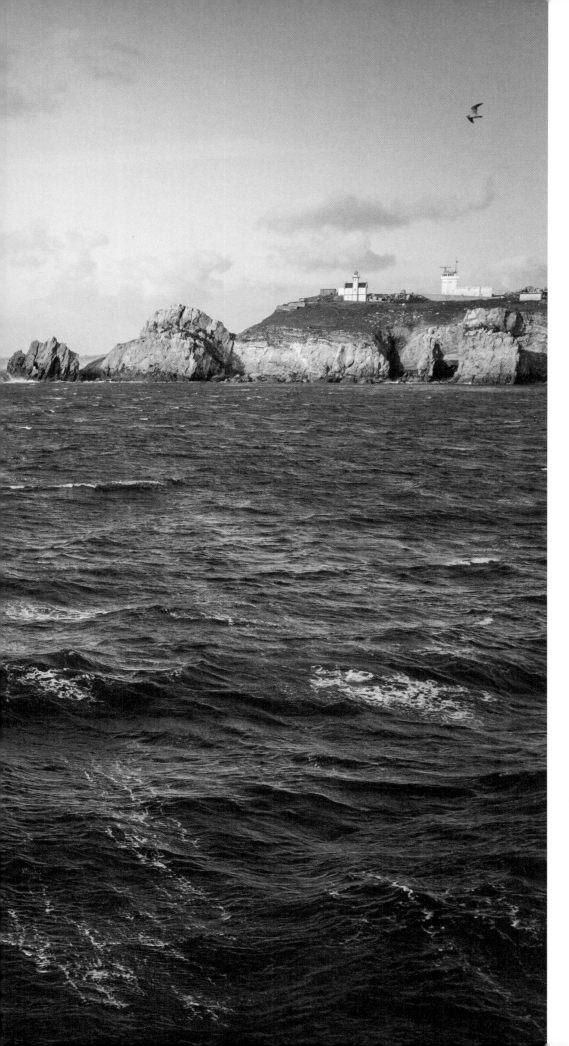

ERWAN BRUNG

Camaret-sur-Mer
France

The *Arbikez* is built like a floating fortress. Atop the compact wooden hull sits a steel shell which completely encloses the quarterdeck. Apart from small viewing windows, this shell has only two somewhat larger openings: on the side to haul the nets on board and on the stern to cast them out again. After leaving the harbor, the stout construction of the boat immediately makes sense. With a swell of 8 feet (2.5 meters) and a wind force of 7, the force of the Atlantic collides against the *Arbikez*. Accompanied by a loud droning, the diesel engine battles against the wind and waves, heaving as it makes its way out to the open ocean.

While the fish crates are flung from left to right in the loading area, matching the rhythm of the waves, Erwan Brung taps the course for today's fishing area into the GPS. Rain clouds still conceal the first rays of daylight; only a few sparkling lights on the horizon manage to penetrate the black of the night. In the darkness, navigation assistance is essential for survival in these treacherous waters.

BRITTANY'S SHALLOWS AND ROCKY REEFS HAVE BEEN THE DOWNFALL OF MANY SAILORS—AS EVIDENCED BY COUNTLESS WRECKS ALONG THE RUGGED COAST.

After reaching the destination, a shallow spot off the infamous "Pointe de Penhir," the nets are cast. Now it is time to wait and hope that plenty of fish swim into the nets. As we eat breakfast together, the boat rocks so hard that drinking tea is a feat in and of itself. Erwan recounts how he eventually got into the fishing industry.

The ardent fisherman spent his childhood by the sea, and even back then he loved all the fishing boats. After his schooling, he initially trained as an accountant. Later he ended up inland, in Burgundy, where he worked as the chief accountant managing the balance sheets for a supermarket chain. Far away from the sea. Although the work paid well, it did not fulfill him. He returned to Brittany on a regular basis and would wistfully watch the fishing boats as they headed out to sea. Without him.

During one of his visits home, he met the woman who would become his wife. The daughter of a fisherman, she finally convinced him to follow his passion. Erwan moved back to the coast, married, got his fishing license, and got a job on a cutter. He has been fishing for ten years now, is captain of his own boat, and is intimately familiar with the challenging waters around the Crozon peninsula. He has long since mastered a wide variety of fishing techniques. Depending on the time of year and the weather conditions, he changes his fishing gear and his hunting ground.

On stormy days like today he uses simple gillnets. They are relatively small and less susceptible to waves and current. Two hours after they are cast out, the nets are pulled back in before other sea dwellers start nibbling on the fish in the net. There is no such thing as routine at sea. The wind has picked up again and the waves have grown so large that Erwan pulls the first net back on board early. Pulling in the nets is like a dance. Unfortunately, the first three are only somewhat full. The mood threatens to mirror the weather, but thankfully the last net saves the day: Magnificent pollacks, bonitos, and a few valuable red mullets of impressive size finally make Erwan smile after all.

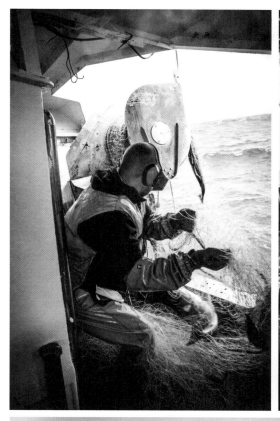
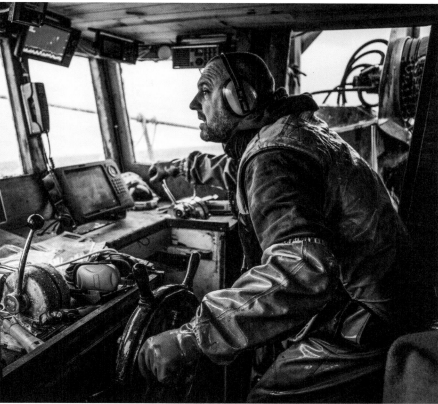
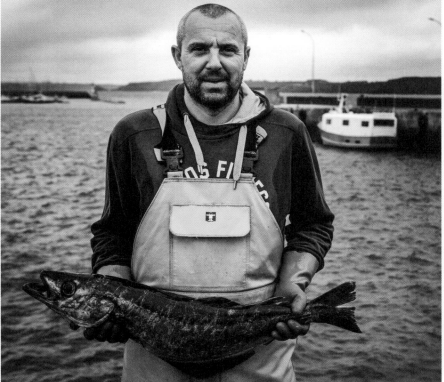

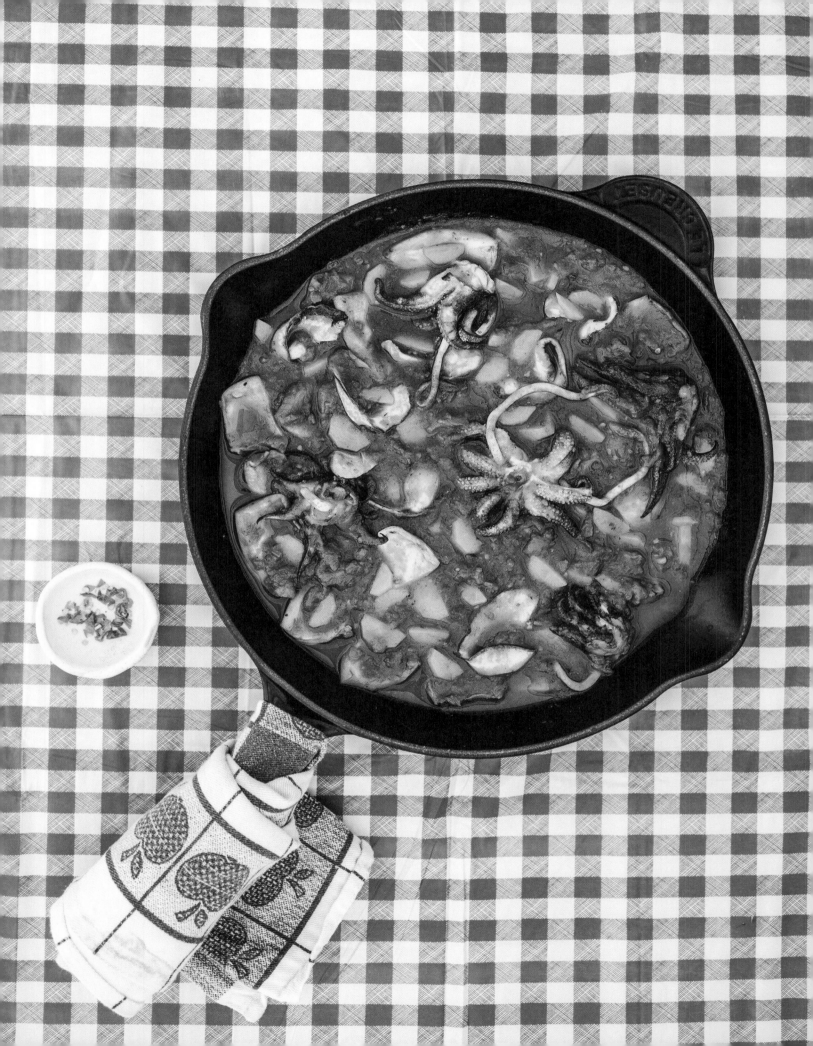

Sepia à l'armoricaine

As much as Erwan loves the ocean and fishing, he is actually not that much of a fish eater. He does like cuttlefish a lot, however—at least they don't have bones.

SERVES 4

2¼ lb (1 kg)	cleaned cuttlefish
	Rice
2¼ lb (1 kg)	carrots
4	shallots
	Salted butter
½	glass of whisky
1	glass of dry white wine
1	small can of tomato paste
	Salt, pepper

PREPARATION

Cook the cuttlefish in salted water for 20 minutes, then cut into bite-sized pieces. Cook the rice according to the package instructions. Peel the carrots and cut them into slices just under ½ inch thick (1 cm).

Slice the shallots into rings, then add to a pot and sauté in some butter along with the cuttlefish. As soon as the shallots become translucent, deglaze the pot with the whisky and then flambé. Next add the carrots, white wine, and tomato paste to the pot. Mix everything well, then season to taste with salt and pepper.

Simmer for another 20 minutes, then serve with the rice.

ABOUT THE INGREDIENTS:
Even if you can find very fresh cuttlefish, it is still a good idea to freeze them for a short time before preparing them. This process breaks up the cell structure and makes the meat more tender—especially with large specimens.

Red mullet

A classic of Breton cuisine that is prepared with many local ingredients.

SERVES 4

7 oz (0.2 l)	dry white wine
2¼ lb (1 kg)	potatoes (waxy), peeled and sliced
8–10	shallots, diced
1 cup (250 g)	salted butter
	Salt, pepper
2	sprigs of thyme
1	bay leaf
4	whole red mullet (about 11 oz/300 g each), ready to cook
2 tsp	chopped parsley

PREPARATION

Preheat oven to 350°F (180°C). Evenly distribute the wine, potato slices, diced shallots, and ⅔ of the butter (in small pieces) in a baking dish. Season with salt and pepper, the sprigs of thyme, and top with the bay leaf before putting the dish in the oven.

After baking for 45 minutes, arrange the whole fish on top of the potatoes and garnish with the remaining pieces of butter.

Bake for another 10 to 15 minutes and sprinkle with the parsley before serving.

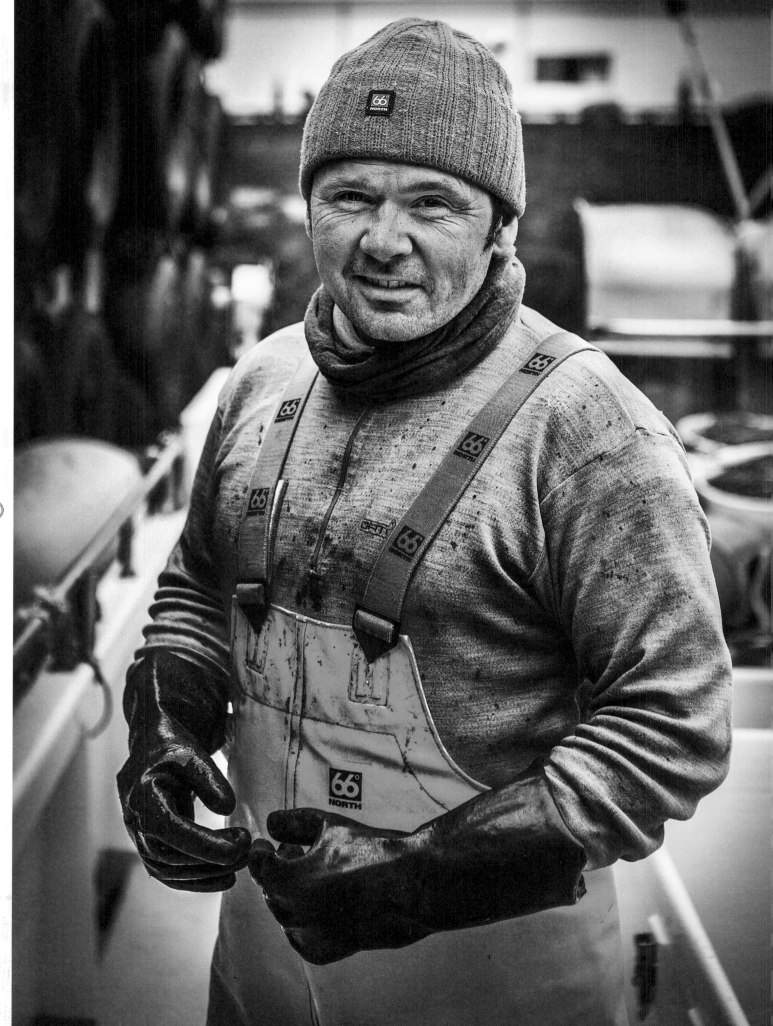

ORVAR MARTEINSSON

Ólafsvík, Iceland

The weather in Iceland lives up to its reputation. The original plan was to travel by ferry to the Westman Islands, but the connection is canceled an hour before departure due to a brewing storm. It is necessary to quickly come up with an alternative plan. The weather forecasts and maps do not bode well, however. Iceland is literally in the eye of the storm: A circular low-pressure area with strong winds rotates around the island, causing high swells on all coasts.

The only hope is located just under 186 miles (300 kilometers) away in the northwest of the island. There the glaciers have etched deep fjords into the landmasses, and their steeply sloping cliffs may offer sufficient protection from the capricious weather conditions. The route goes overland through dark volcanic landscapes in horizontal rain to the Snæfellsnes peninsula. Several small fishing ports are tucked away on the peninsula's northern coast. Even in the first two ports, however, shipping traffic is at a standstill and the sea is churning and looks menacing. The first glimmer of hope appears in Ólafsvík, a small town whose tuya volcano Ólafsvíkurenni is already submerged in the rain and mist. A small boat just off the cliffs battles its way through the breakers toward the entrance to the harbor. Orvar and Dodi, the two fishermen on board, are worried about their hook lines in the turbulent sea. After lunch, they plan to head back out immediately to retrieve their fishing gear. An hour later they cast off their lines, and the *Sverrir SH 126* ventures back out onto the restless sea.

WHEN THEY ARE NOT BEING SURPRISED BY A STORM, ICELANDIC FISHERMEN ARE ACTUALLY DOING QUITE WELL: THEY EARN A DECENT INCOME, THEY ARE TRADITIONALLY REGARDED AS RESPECTED PILLARS OF SOCIETY, AND ABOVE ALL THE VOLCANIC ISLAND STILL BOASTS ABUNDANT FISH STOCKS.

In the shallow waters directly off the cliffs of Ólafsvík, fishermen can expect a good catch even on stormy days. Due to the harsh conditions, Orvar and his first mate Dodi have set their baited lines right outside the harbor. While Orvar monitors the lines being hauled in and stands ready with his hook to prevent any cod from escaping overboard at the last moment, Dodi slaughters the fish with a practiced cut to the throat as soon as they are on board. Both men have drawn the hoods of their protective oilskins over their faces. Despite the bad weather, everything runs smoothly on board because the two are an experienced team: Dodi, the first mate, used to go to sea with Orvar's father and has known his captain since he was born. Although Orvar's father now remains on shore, his son and Dodi keep up the family tradition.

Orvar, who now has his own family to care for, has never bought a fish in his life. Even when he orders fish in a restaurant out of curiosity while on vacation, it is very unusual for him—after all, the fish he catches himself is hard to beat. He takes some fresh fish home with him three or four times a week and prepares them in his own kitchen. To his children's dismay. "They don't know what's good. They would rather eat hot dogs from the gas station than the fried fish prepared by their father," remarks Orvar with a smile. At the jetty, he is already working on filleting dinner for his children.

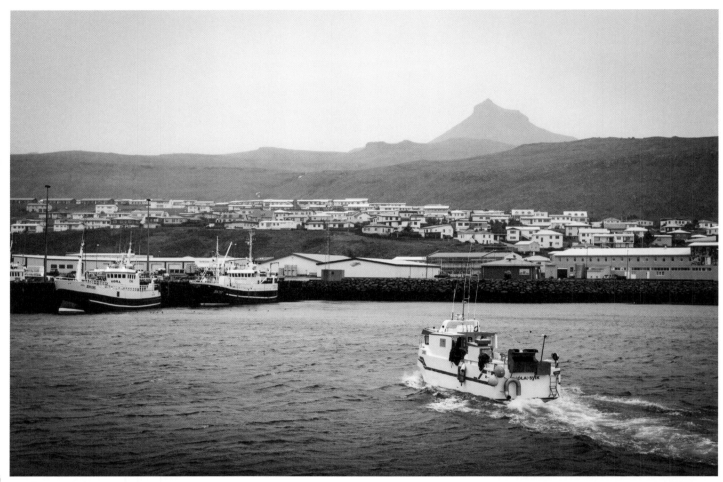

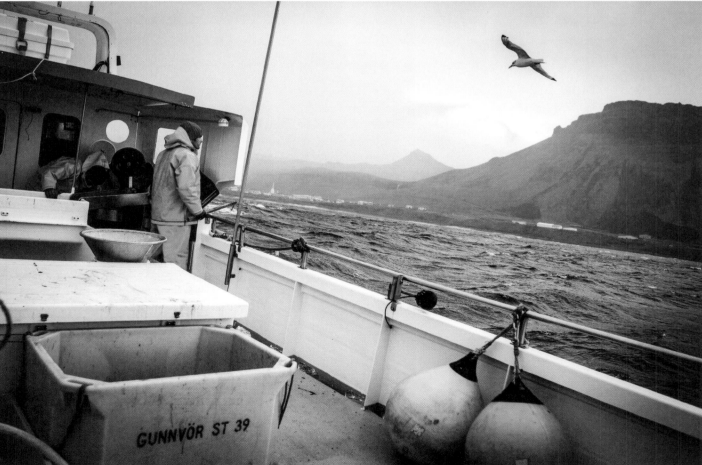

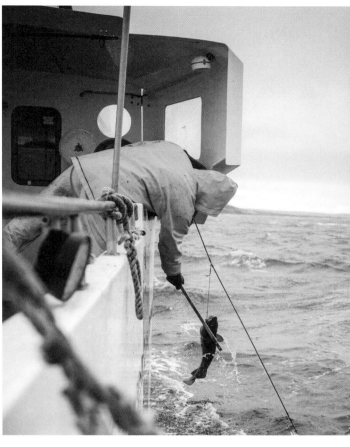

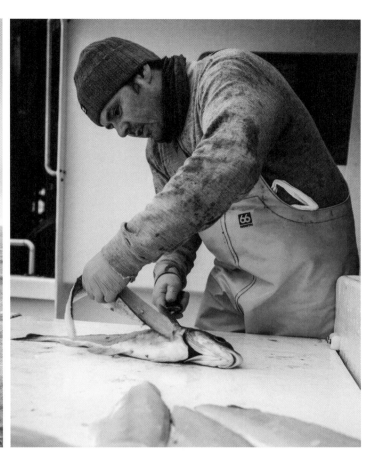

WHILE ORVAR MONITORS THE LINES BEING HAULED IN AND STANDS READY WITH HIS HOOK TO PREVENT ANY COD FROM ESCAPING OVERBOARD AT THE LAST MOMENT, DODI SLAUGHTERS THE FISH WITH A PRACTICED CUT TO THE THROAT AS SOON AS THEY ARE ON BOARD.

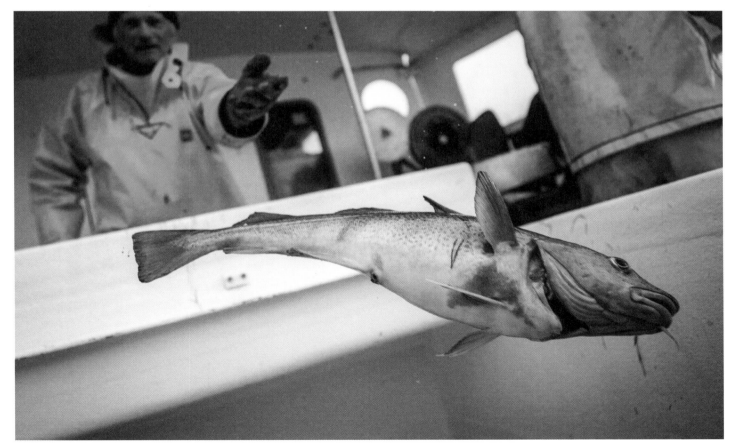

PLOKKFISKUR

This is a traditional hot and hearty Icelandic fish stew. Perfect for the harsh weather conditions in the North Atlantic.

SERVES 4

1	shallot, finely diced
2	stalks of celery, sliced
1	carrot, finely diced
	Butter
5 oz (150 ml)	white wine
14 oz (400 g)	potatoes, peeled and quartered
4¼ cups (1 l)	vegetable broth
1⅓ lb (600 g)	cod or halibut, cut into bite-sized pieces
1	tomato, diced
9 oz (250 g)	heavy cream
	Salt, pepper
2 tsp	chives, finely chopped
4	thick slices of wholegrain bread

PREPARATION

Fry the shallots, celery, and diced carrots in some butter until they turn translucent. Deglaze the pan with the wine and simmer until the liquid is reduced by half. Add the potatoes and vegetable broth and cook for 20 minutes.

Next add the fish and the diced tomato and simmer for another 5 minutes over low heat. Finally stir in the heavy cream and season with salt and pepper. Sprinkle with chives and serve steaming hot along with buttered slices of bread.

PANNFISCH WITH POTATOES

In a manner of speaking, this dish is the daily bread of the Marteinsson family and always comes to the table freshly caught.

SERVES 4

2¼ lb (1 kg)	potatoes
	Salt
1¾ lb (800 g)	cod fillet
	Flour
	Egg
	Breadcrumbs
1 cup (250 g)	skyr
1	bunch of chives, chopped
	Pepper
1	lemon
	Sunflower oil

PREPARATION

Cook the potatoes in salted, boiling water for about 30 minutes, depending on their size.

Dredge the cod fillets in flour, then dip them in the egg, and finally coat them in the breadcrumbs. Stir the chopped chives into the skyr, then season to taste with salt, pepper, and freshly squeezed lemon juice.

Heat some oil in a pan and fry the breaded fish fillets over medium heat until both sides are golden brown. Briefly drain the fried fish on paper towels.

On a plate, arrange the steaming potatoes with a large spoonful of skyr and the crispy fish fillets, then serve.

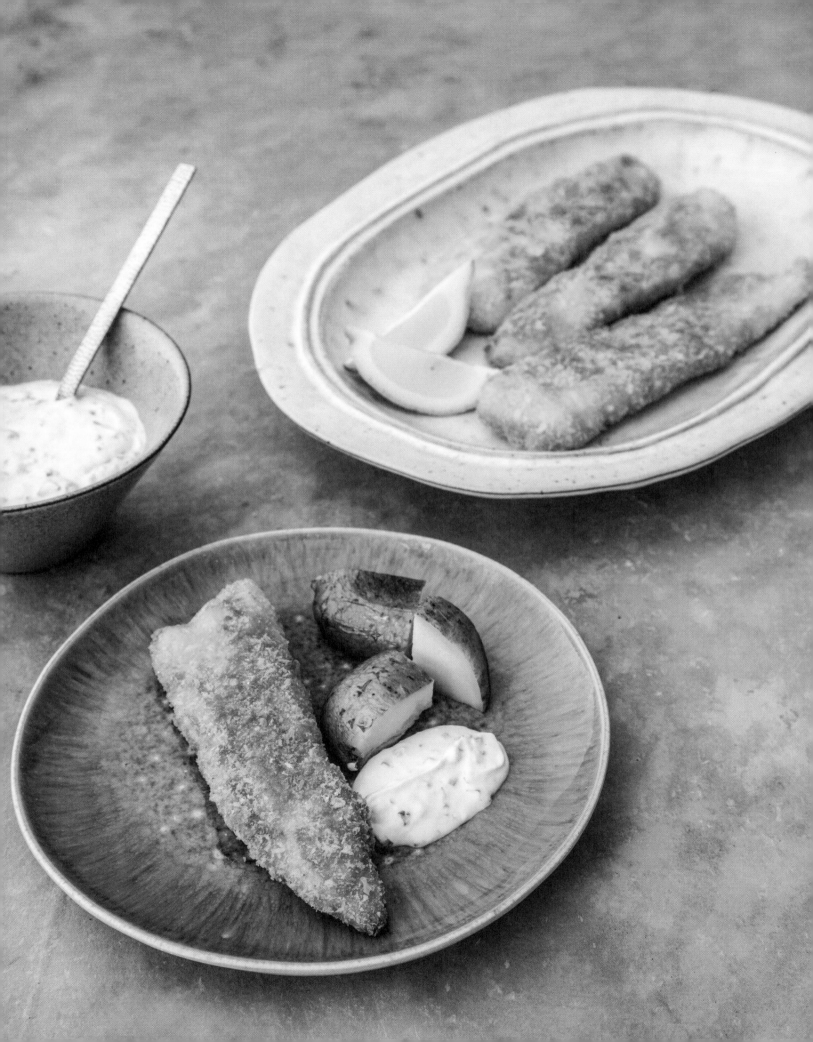

AURÉLIEN SORIN

Capbreton, France

A boisterous mood prevails on board the *Joker 2*. The roar of the nearby surf, off-color jokes, and laughter fill the sea air as Aurélien, Joanice, and the two Christophes haul the first nets on board at the crack of dawn. As accompaniment, the ship radio blares a mix of the summer's latest techno hits, while the crew join in on the English chorus at the top of their lungs. Their dedication to the effort more than makes up for a tendency to improvise when they miss some of the lyrics. A ventured dance step or two on the slippery deck can even be seen at this early hour of the day. Not only the music but also the size of the haul so far are responsible for the high spirits. The still new day is off to a good start, and a number of fish crates are already full by the time the first rays of sunshine poke out from behind the dunes. A sizeable quantity of glistening, silvery bonitos along with gilthead and common bream flop about in the blue crates on the quarterdeck.

Once the crew has emptied the short gillnets that were set in the shallows, they move on to the larger nets in the deep-sea trench off the coast of Capbreton. Along this section of coastline, known as a surfer's paradise, the ocean floor drops sharply into a deep submarine canyon. Two tectonic plates meet in this spot, the sailors explain over breakfast consisting of homemade pork pâté and pickled fish, which we eat in the cabin. A crack in the earth's crust formed a deep trench, known as the "Gouf de Capbreton," in the otherwise shallow Bay of Biscay. The variable ocean depths and nutrient-rich waters are responsible for a rich biodiversity and good fishing grounds.

By the time breakfast is over, the *Joker 2* has reached the underwater escarpment, and the men must get back to work. However, the hearty repast seems to have left the crew feeling somewhat lethargic. While David Guetta & co. continue to give the musical entertainment their best effort, the mood on board has settled down a bit. Everyone does his part with a practiced hand in hauling the long fishing gear on board, while the sun keeps climbing higher into the sky.

A SUDDEN CLAMOR ARISES. "SWORDFISH! SWORDFISH! SWORDFISH!," AURÉLIEN CALLS OUT EXCITEDLY FROM HIS POSITION AT THE WINCH, AND CHRISTOPHE HURRIES OVER TO HELP. WORKING AS ONE, THE TWO MEN HEAVE THE MAGNIFICENT FISH ON BOARD, AND THE SECOND CHRISTOPHE LENDS A HAND.

Once the fine specimen has landed safely on deck, the entire crew executes a little dance of joy, with high fives and hugs all around. They've hauled in an extremely rare catch, the first swordfish that the *Joker 2* has landed since Aurélien bought the boat three years ago. The crew's spirits are at least as high as they were at the start of the day, and the mood remains euphoric until the remaining nets have been emptied and the large catch is delivered to the fish market in Capbreton.

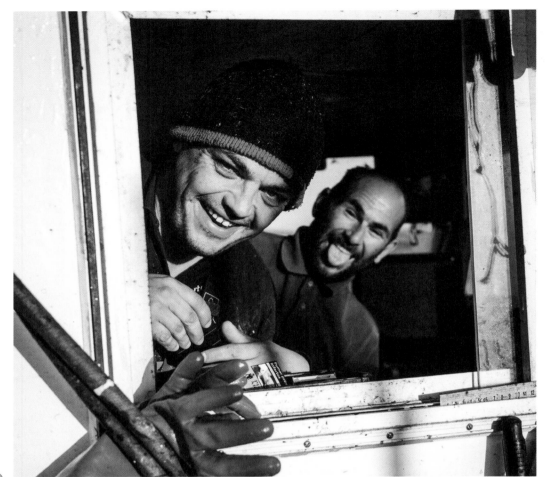

A BOISTEROUS MOOD PREVAILS ON BOARD THE *JOKER 2*. THE ROAR OF THE NEARBY SURF, OFF-COLOR JOKES, AND LAUGHTER FILL THE SEA AIR AS AURÉLIEN, JOANICE, AND THE TWO CHRISTOPHES HAUL THE FIRST NETS ON BOARD AT THE CRACK OF DAWN.

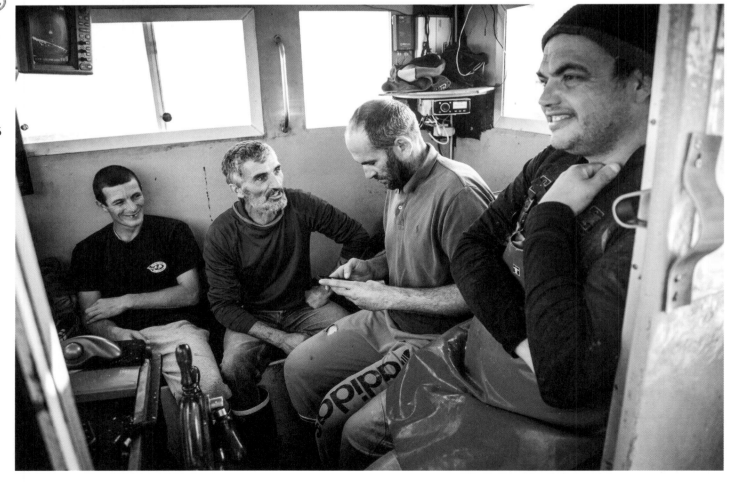

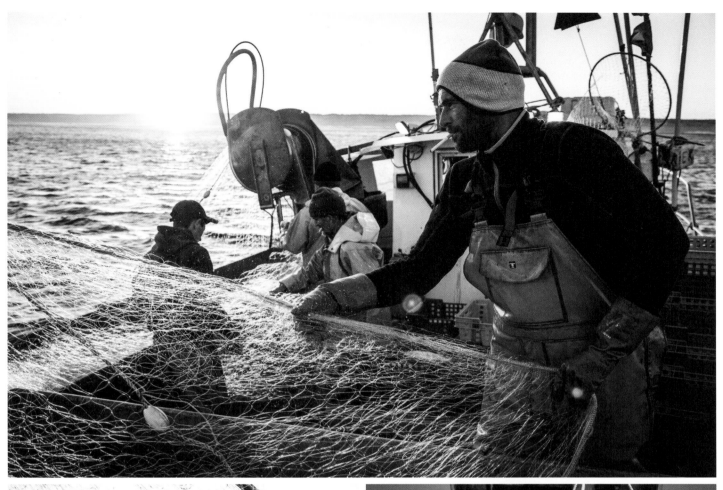

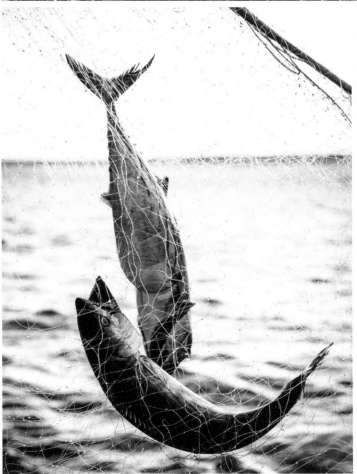

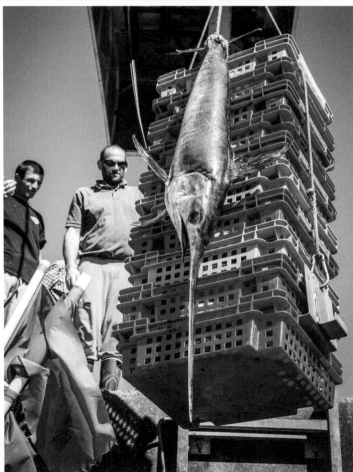

MUSSELS

Mussels are cheap and easy to prepare.
This is the classic recipe. It is also easy
to modify, for instance by adding pieces
of fried chorizo or by trying an Asian
version with ginger, green onions, cilantro,
sesame oil, and soy sauce.

SERVES 4

2¼ lb (2 kg)	mussels
3	large shallots, diced
	Olive oil
3	cloves of garlic, minced
1 cup (¼ l)	dry white wine
1	bunch of parsley
	Bread

PREPARATION

Clean and wash the mussels, discarding any that
are damaged or open. In a large pot with a lid,
lightly sauté the diced shallots in olive oil. As
soon as the onions start to turn a bit translucent,
add in the garlic and sauté briefly. Pour the
mussels into the pot, cover with white wine, and
give them a stir. Put the lid on the pot and steam
for about 4 minutes until all the mussels have
opened. Sort out any mussels that are still firmly
closed after cooking. Using a large ladle, scoop
the steamed mussels into a bowl, pour some of
the broth over them, then sprinkle with parsley
and serve with bread.

SWORDFISH STEAKS

After returning to port, there is a simple but
delicious dish to mark the occasion. The
recipe relies primarily on the quality of
all the ingredients. The fresh swordfish,
straight from the boat, simply can't be beat.

SERVES 4

4	swordfish steaks (7 oz/200 g each)
	Olive oil
2	lemons
1 lb (500 g)	tomatoes
	Brandy vinegar
	Sea salt flakes
1 lb (500 g)	pimiento peppers
	Piment d'Espelette (red chili
	pepper powder from France)
	or any other mild chili powder
	White bread

PREPARATION

Marinate the swordfish steaks in some olive oil and
lemon juice on a large plate.

Cut the tomatoes into bite-sized pieces and toss with
olive oil, a drizzle of brandy vinegar, and salt flakes.

Fry the pimiento peppers in plenty of oil over medium
heat until they have softened a bit and the skin starts
to bubble. Sprinkle with sea salt flakes, turn again,
and remove the pan from the stove.

Fry the swordfish steaks over high heat for about
2 to 3 minutes per side. After turning, sprinkle with
some sea salt and Piment d'Espelette. The cooking
time will vary depending on the thickness of the
steaks: The swordfish should still be a bit translucent
in the middle, because it dries out quickly.

Arrange the tomatoes, pimiento peppers, and last
of all the fish on plates and serve. Don't forget to use
some white bread to soak up the flavored olive oil
on your plate!

ABOUT THE INGREDIENTS:
Some fish can be grilled and roasted similar to
beef—from rare to well done, according to personal
taste. Particularly firm types of fish such as <u>tuna</u>,
<u>swordfish</u>, <u>salmon</u>, <u>bonito</u>, or <u>mullet</u> are delicious
when they are seared so they form a nice crust on the
outside and are still juicy and rare on the inside.

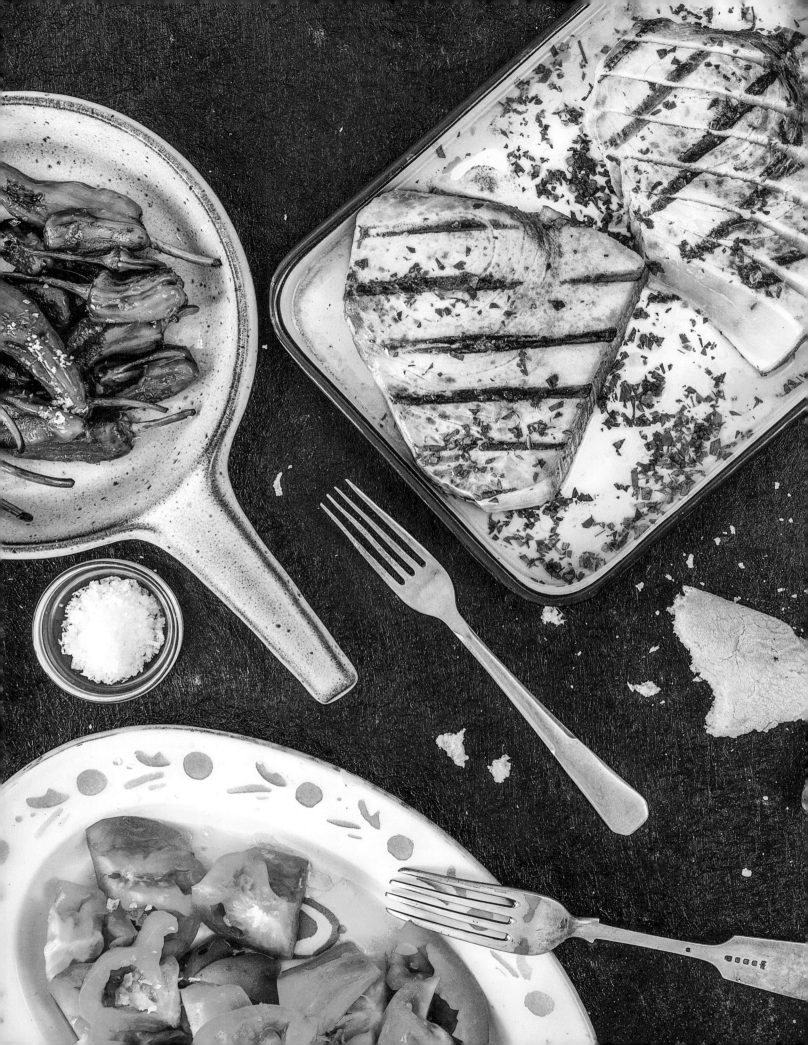

Matthew Devonald

St Davids, Wales

Atlantic Ocean

⚓

Wales

Matthew Devonald is a part-time sailor. Apart from fishing, the Welshman also works in a restaurant, where he turns fresh-caught spider crabs into the very best crab cakes in Pembrokeshire. But only a small portion of his haul ends up in his kitchen and those of several other nearby restaurants. Most of his catch is shipped abroad. After all crabbing in Wales would no longer be worth the trouble if it weren't for the export trade, Matthew explains. Many British consumers prefer to buy their fish, seafood, and crustaceans frozen—in the form of convenient, white rectangles that look very little like sea creatures, the fisherman says. Fortunately, things are different in France, Spain, and Portugal, where the spider crabs are sold whole and considered a delicacy, commanding far higher prices than in the British Isles.

Once a week, a truck stops in St Davids to pick up the export goods. Matthew prepared for this day ahead of time and transferred the spider crabs from his traps to big collecting nets last week. The nets are now full to bursting with the precious crustaceans and are waiting to be picked up. Marked by a buoy, the net traps are anchored a mere quarter of a nautical mile beyond the harbor, and it doesn't take long to reach them. Matthew retrieves the buoy with a grappling hook, after which he must use all his physical strength to drag the valuable haul on board. En masse, the spider crabs are incredibly heavy and also quite rebellious. Several of the long-legged creatures try to escape right at the last moment. In vain. Matthew reacts quickly, resolutely grabs the troublemakers, and secures every last one of them.

He hauls up a total of three traps and then it's time to head back to shore. However, it's nowhere near time to call it a day because the catch must first be sorted. The crustaceans are distributed among various crates according to size and then hoisted up onto the quay for transport. Matthew also has lobsters and brown crabs on board, and in the end an impressive stack of crates has accumulated next to his mooring. As a productive yet strenuous day draws to a close, the fisherman feels the effects of his labors right in his bones.

FISHING MAY BE MORE PHYSICALLY DEMANDING THAN HIS WORK IN THE RESTAURANT KITCHEN, BUT MATTHEW LOVES THE CHANGE OF PACE BETWEEN SOLITARY HOURS UNDER THE OPEN SKY AND THE FRANTIC PACE OF HIS ROUTINE IN THE RESTAURANT BUSINESS.

While everything is orchestrated down to the last minute in the restaurant, his daily routine at sea depends on the tides and the crustacean migratory routes. St Davids' rugged coastline is known for its enormous tidal range, where the difference between high and low tide can be as much as 20 feet (6 meters).

When the sea level and his cooking schedule permit, the Welsh fisherman tries to collect his traps early in the morning so as to experience the sunrise at sea. In that early hour, he enjoys the calm before the storm, after which he makes his way to the restaurant with the best specimens he's caught that day and starts the second, hectic half of his workday.

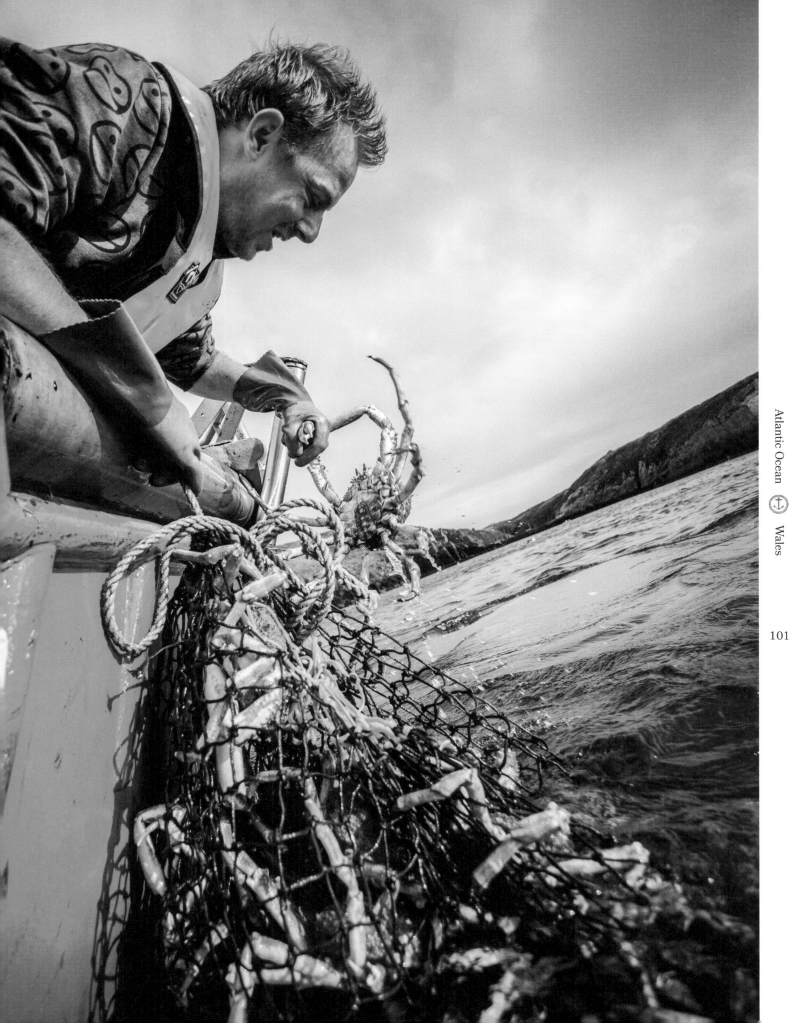

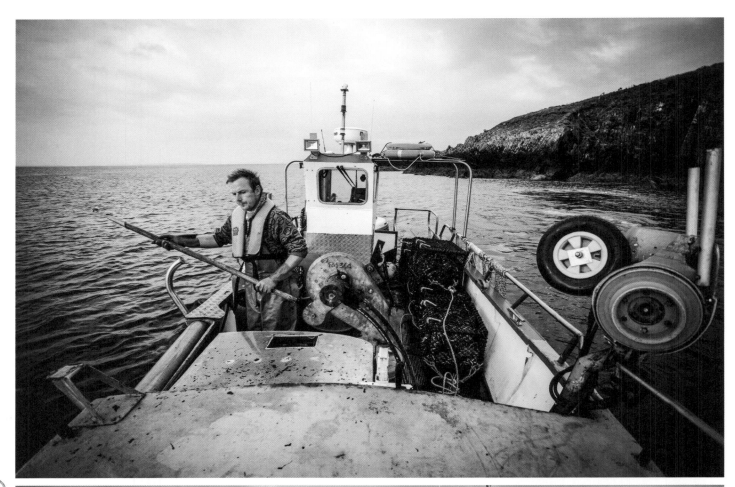

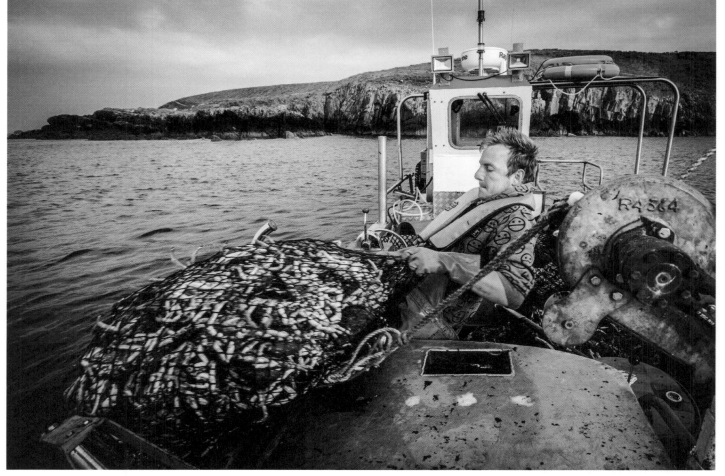

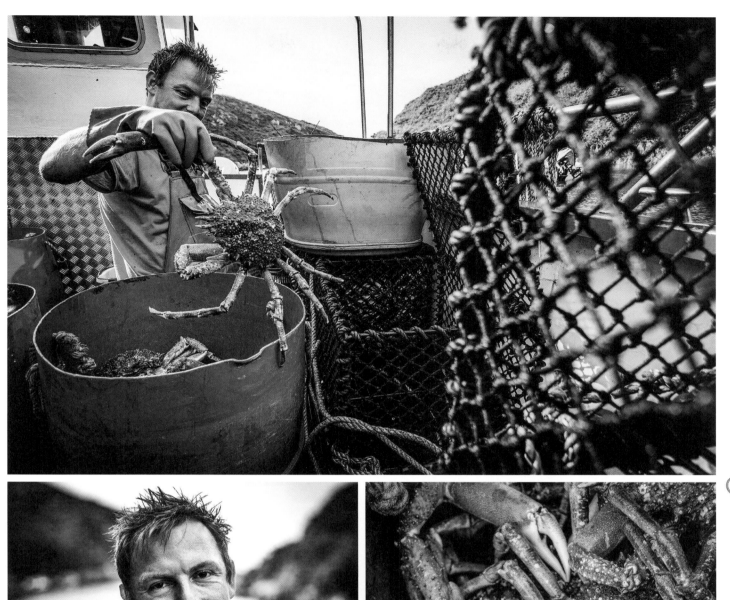

APART FROM FISHING, THE WELSHMAN ALSO WORKS IN A RESTAURANT, WHERE
HE TURNS FRESH-CAUGHT SPIDER CRABS INTO THE VERY BEST CRAB CAKES
IN PEMBROKESHIRE.

MACKEREL
PEMBROKESHIRE STYLE

Mackerel season starts every summer in Pembrokeshire, a region in western Wales. The arrival of these tasty, juicy fish coincides precisely with the first young potatoes of the season as well as the best harvest time for marsh samphire—also referred to as sea asparagus.

SERVES 4

2¼ lb (1 kg)	small, new potatoes, washed and unpeeled
1	sprig of mint
	Salt
1 lb (500 g)	marsh samphire, cleaned (alternatively you can use young, green asparagus)
8–12	mackerel fillets (about 1¾ lb/800 g)
	Vegetable oil
	Butter

PREPARATION

Cook the potatoes along with the sprig of mint in salted water for about 20 minutes until just tender. Use a large, deep pot that is filled only halfway.

A few minutes before the potatoes are done cooking, position the marsh samphire in a sieve at the top of the pot and cook in the steam from the potatoes until al dente.

In the meantime, fry the mackerel fillets in a pan with some vegetable oil. Fry for 2 to 3 minutes with the skin down, then flip and cook for another 1 to 2 minutes on the other side. Melt some butter over the cooked vegetables. Season with salt and serve with the potatoes and the fried fillets.

104

CRAB CAKES
WITH AIOLI DIP

Although spider crabs as a whole are mainly exported, Matt also uses the juicy meat in his kitchen for this local classic.

SERVES 4

Aioli dip:

2	egg yolks
1	clove of garlic
	Juice and zest from one untreated lemon
4 tsp	olive oil
4 tsp	vegetable oil
	Salt
3	green onions, finely sliced
1 Tbsp	celery, chopped
	Butter
7 oz (200 g)	white fish
1 lb (450 g)	spider crab meat
1	egg
1 tsp	parsley, finely chopped
1 tsp	mustard
7 oz (200 g)	breadcrumbs
	Salt, pepper
	Vegetable oil

PREPARATION

To make the dip, mix the egg yolks, garlic, some lemon juice, and the lemon zest in a blender. While mixing constantly, add the oil. Season to taste with salt, the remaining lemon juice, and then set aside.

For the crab cakes, sauté the green onions and the chopped celery with some butter in a pan, then scrape into a bowl and set aside to cool. Next finely chop everything with the white fish and the crab meat on a board. Add the chopped ingredients to the bowl along with the egg, parsley, mustard, and half the breadcrumbs. Mix everything thoroughly and season to taste with salt and pepper.

Form crab cakes from the finished mixture, then sprinkle with the remaining breadcrumbs. Heat some oil and butter in a pan and fry the crab cakes over medium heat until golden brown on both sides.

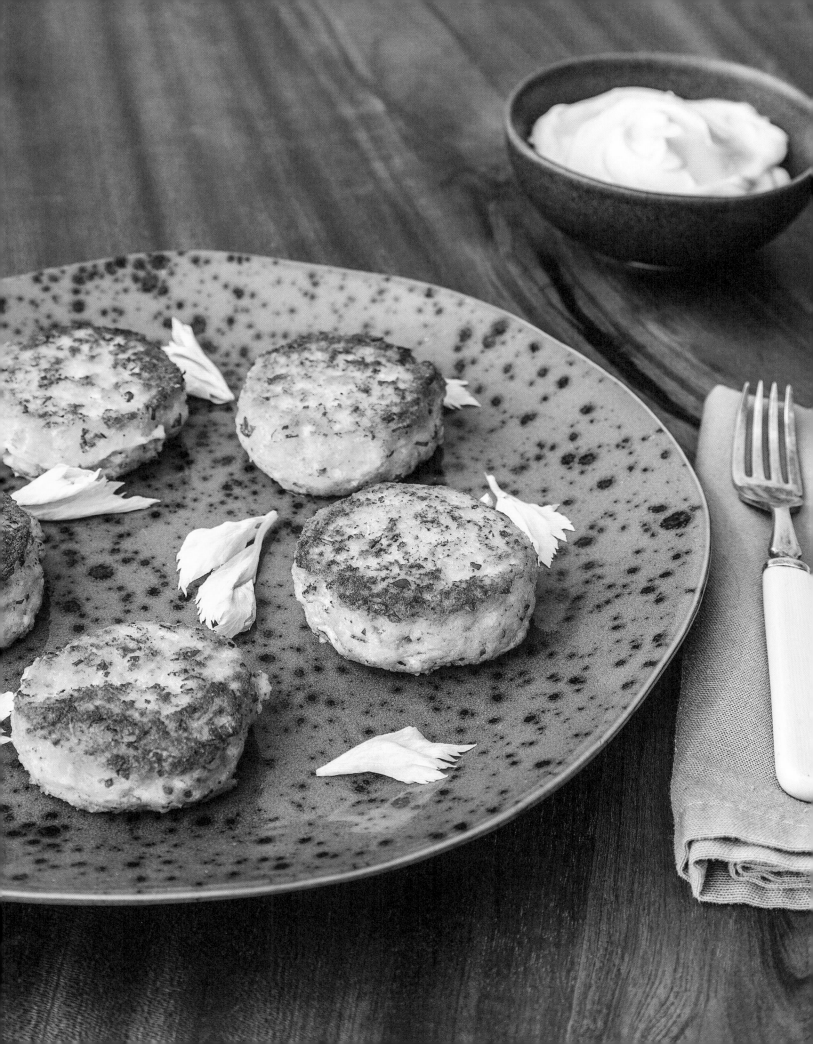

Steven Farren

Howth, Ireland

The day begins with blood-red clouds on the eastern horizon as Steven Farren steers his small boat out onto the unusually calm sea. It is a blaze of color that enthralls the untrained eye, but which makes the man at the wheel grumpy. "A red sky in the morning means bad weather," explains Steven. The words are barely out of his mouth when his phone rings. His father, a retired fisherman himself, sees the red sky from his garden in Howth and urges caution. After a look at the weather map—the forecasts are still good—the boat once again picks up speed. Two days ago, Steven had set crab traps on the sandy bottom 1.5 nautical miles north of Howth. It's Christmas time: peak season for crustaceans. Crab, shrimp, and lobster bring premium prices on the European mainland. On this icy December morning, he is hoping for velvet crabs. Apart from the holiday business, commercial fishing of this type of crab is hardly worthwhile because the prices are too low. Right before Christmas, however, the sea creatures are extremely lucrative, and a box is worth around 100 euros ($115). The traps are well filled, and it doesn't take long until the first box on board is full. As the seagulls cry overhead, the Irishman hauls one trap after another onto the deck and rebaits the traps. By midday all the traps have been emptied, and Steven can head home to warm up a bit. In the distance, the tops of the gently rolling hills disappear beneath the first snow of the year.

Against all expectations, the weather continues to be good even after lunch. The sun makes an appearance, the sea is still calm, and Steven decides to head out again. A few lobster traps are waiting right outside the harbor, and the lobster prices will rise again in the next few days. Steven would like to be well prepared: He not only catches the creatures, he also sells them together with some of his fishing colleagues from the jetty in Howth. At home, he stores the live lobsters in tanks until the prices reach a peak. Once that happens, Steven empties the tanks, loads the precious crustaceans into his transporter, and drives to the wholesaler in Dublin.

When the *Celtic Spirit* makes its second run of the day, Steven's father is also on board. Steven learned how to fish from him. Although the senior citizen has been retired for several years, he still keeps busy. If the weather is not too rough and the fishing area is not too far away, he regularly rides along and helps out his son. Sometimes the two get competition from the sea: One of the seals from the harbor has followed them and will not leave their side. He begs loudly for a treat. Although the begging works well with tourists, the two experienced fishermen initially ignore the seal.

SEALS ARE NOT VERY POPULAR WITH FISHERMEN: THE INTELLIGENT ANIMALS DEVOUR THE FISH, OCCASIONALLY DESTROY NETS, AND ARE EVEN ABLE TO OPEN AND EMPTY LOBSTER TRAPS.

Nevertheless, at some point Steven relents, and after he demonstrates the seal lock on one of the traps, he tosses a treat to the big-eyed beggar. The father and son fill the lobster crates on board with practiced motions. It promises to be a good day for all, even for their insatiable companion: By the time the last lobster trap has been emptied and they head back to shore, the seal has polished off nearly an entire school of bait fish.

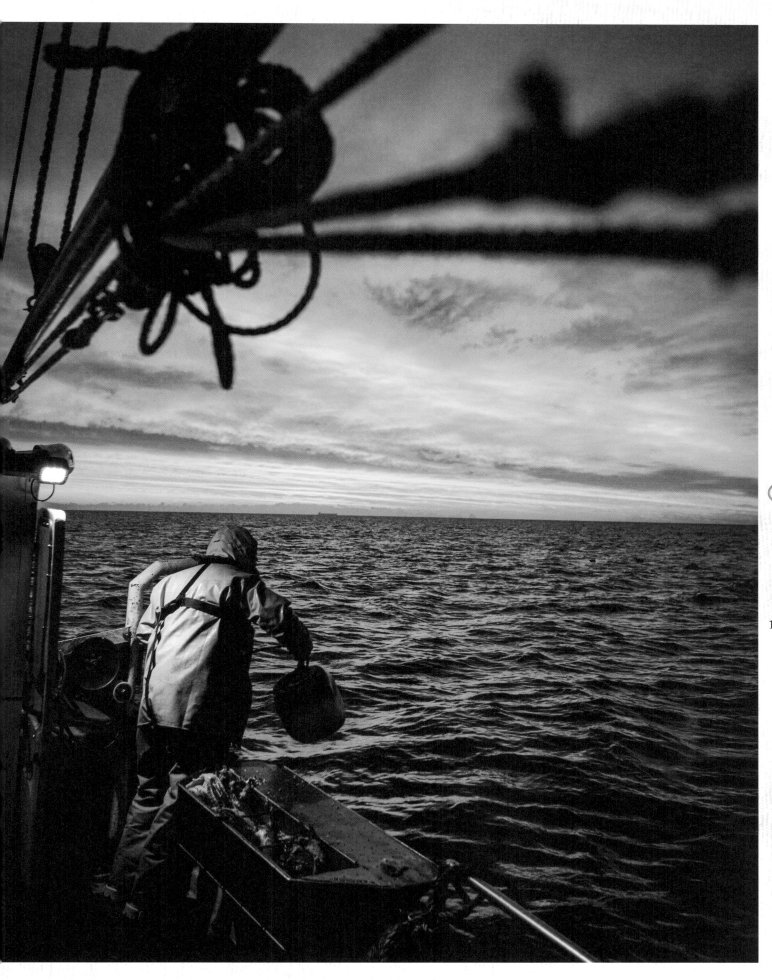

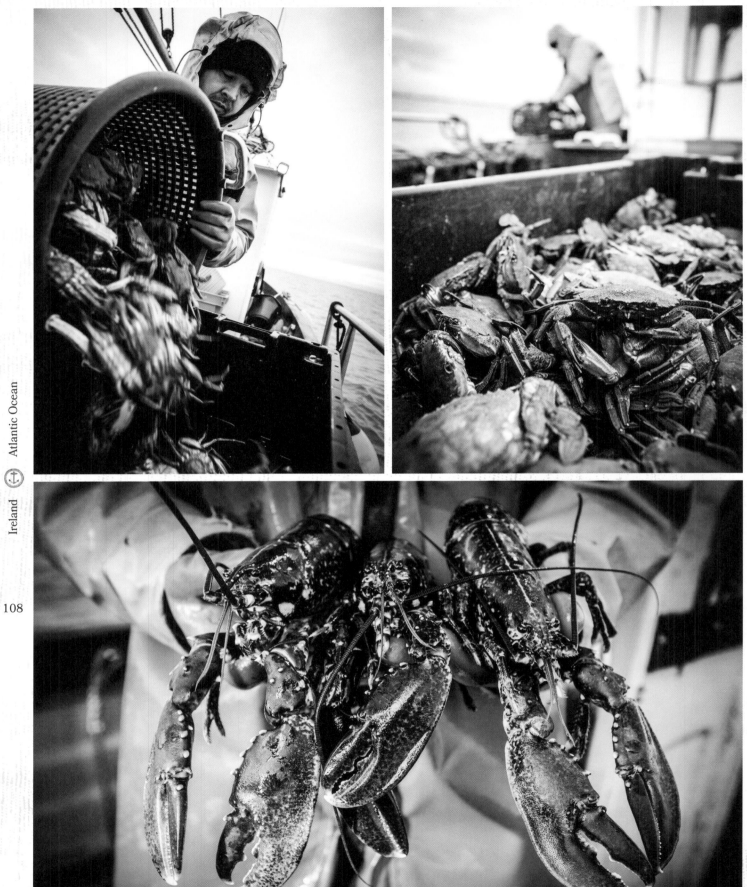

IT'S CHRISTMAS TIME: PEAK SEASON FOR CRUSTACEANS. CRAB, SHRIMP, AND LOBSTER BRING
PREMIUM PRICES ON THE EUROPEAN MAINLAND.

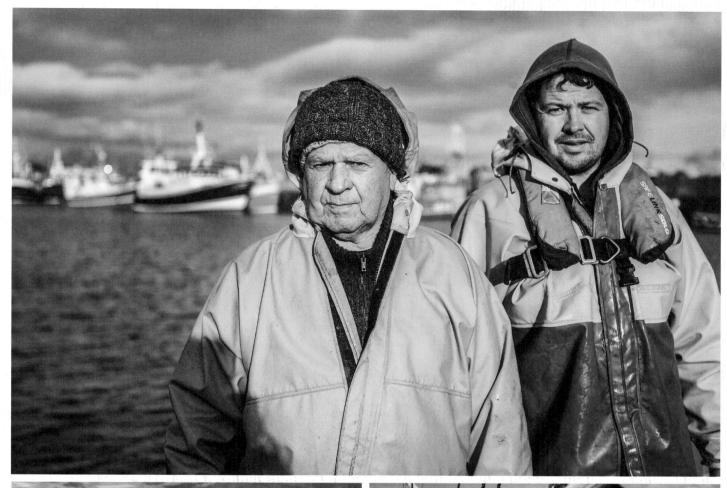

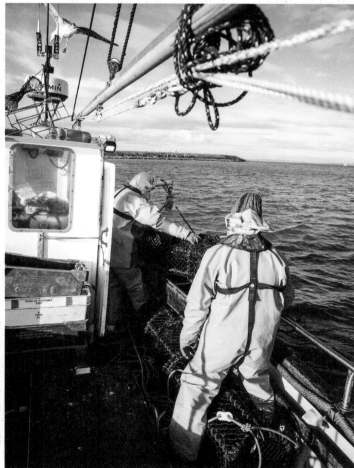

Creamy Fish Chowder

A hot, hearty chowder with plenty of fish and seafood hits the spot after a cold day at sea.

Serves 4

½ lb (200 g)	smoked white fish
1	shallot, sliced in half
1	bay leaf
2¼ cups (500 ml)	whole milk
1	onion, diced
5 oz (30 g)	butter
1	clove of garlic, minced
1	large potato, cooked and diced
5 oz (150 g)	sweet corn
15	steamed mussels
5 oz (150 g)	raw shrimp
½ lb (200 g)	pollack
1	handful of parsley, finely chopped
	Pepper
1	lemon, cut into wedges
4	slices of bread

Preparation

Add the smoked fish, shallot halves, the bay leaf, and the milk to a pot and bring to a boil, then simmer over low heat for several minutes. In a second pot, sauté the diced onion in the butter until translucent. Next add the minced garlic, diced potato, and corn, then brown slightly. Remove the smoked fish from the milk and set aside. Pour the milk through a fine sieve into the second pot. Simmer the mixture for another 20 minutes. Add the mussels, shrimp, pollack, and the smoked fish, then let stand for several minutes (do not boil!). To finish, stir in the parsley and season to taste with freshly ground pepper.

Serve with lemon wedges and a thick slice of bread.

Irish Surf & Turf

Steven's favorite dish combines two Irish delicacies on a single plate: the best beef from lush green meadows and fresh crustaceans from the depths of the Irish Sea.

Appetizer serves 4

1	clove of garlic
1	handful of mixed herbs (parsley, thyme, rosemary, oregano)
5 oz (150 g)	butter
	Salt
16	brown crab claws
1 lb (400 g)	beef steak (such as rump steak)

Preparation

Finely mince the garlic and herbs, mix with the butter, and salt to taste (you can make this the day before or you can prepare and freeze a larger amount). Heat water in a pot to 160°F (70°C), then poach the crab claws for 6 to 7 minutes. Fry the steaks in a pan until the desired degree of doneness is reached. Depending on the thickness, for a medium steak sear over high heat for 1 to 2 minutes per side and then let rest in an oven preheated to 175°F (80°C) for another 8 to 10 minutes.

Afterwards, slice the steak and arrange on a plate with the crab claws, then drizzle the melted herb butter over everything.

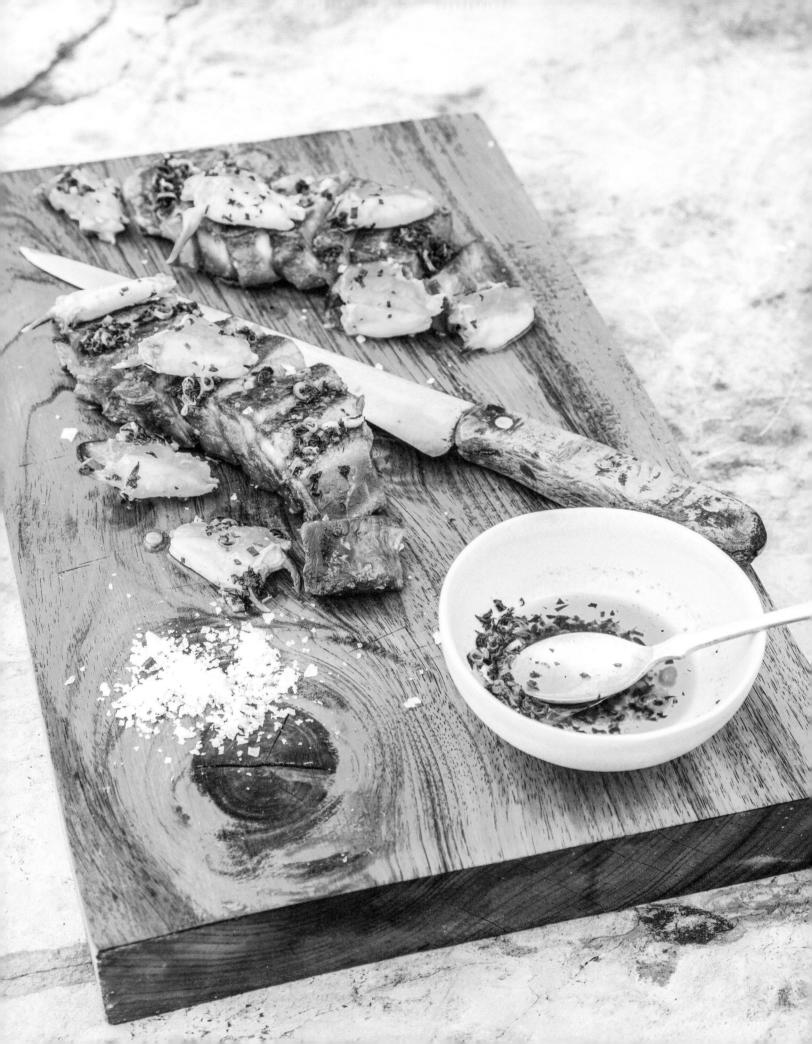

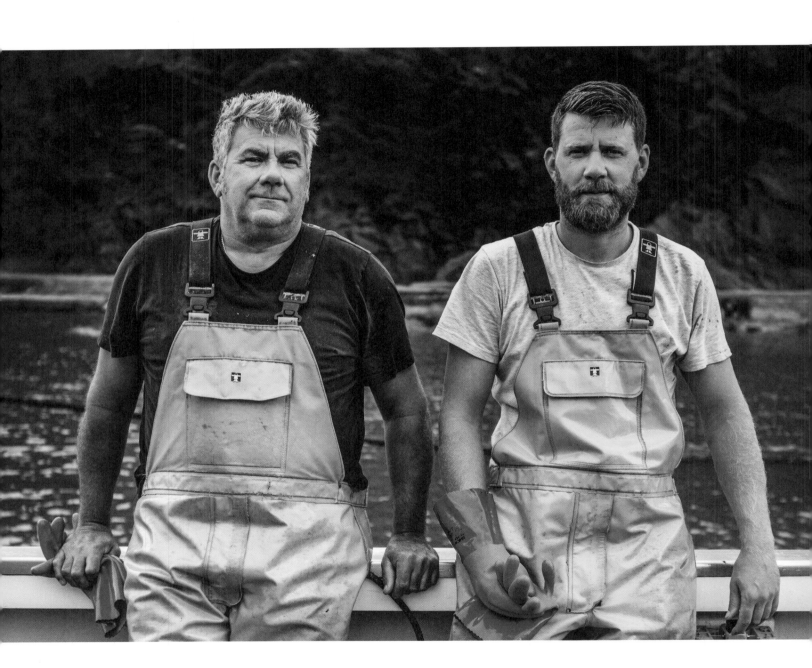

Tom & Jeremy Brown

Port Isaac, England

In the typical British morning mist, the *Freespirit 2* leaves the harbor and heads out toward the waves. Tom and Jeremy have a long day ahead of them. A storm front is coming in from the west, and this is their last trip before the boat takes shelter for a few days in the protective harbor of Port Isaac on Cornwall's north coast. Unfortunately, the two fishermen don't earn any income from a boat in port. That's why it is that much more important to have a good catch today to help bridge the time until they can go out again.

Nevertheless, Tom and Jeremy remain calm. Their lines with crab traps are located about 3 miles (4.8 kilometers) off the coast, so they have time to take a break in the warm cabin before reaching their destination. While the double-hulled boat plows through the incoming swells, the two fishermen have breakfast. After two cups of tea and catching up on the latest family gossip, the first line with its yellow signal buoy has drawn into sight. Jeremy slows down and, despite the turbulent sea, stops precisely where he needs to. Tom is able to easily pull the buoy on board using the grappling hook, and then the work begins: They shift the motor to idle, turn up the radio, and each goes to his position.

Father and son are perfectly attuned to each other: While Jeremy retrieves the traps from the water, empties the catch onto the sorting table, and rebaits the traps, Tom is responsible for quality control. When it comes to selecting crabs, he is extremely meticulous. The family runs its own crustacean shop in the harbor, and only top-quality goods make it to the sales counter. They have a reputation to maintain, because according to Tom and Jeremy, the crab meat from their waters is among the best in the world. Their customers on shore appear to agree with them, because their crabs are the absolute bestsellers in Port Isaac. To ensure that this remains the case, Tom meticulously examines every crab after it is caught and gives it a squeeze.

WITH AN EXPERIENCED GRIP, HE CAREFULLY CHECKS THE CLAWS AND SHELL OF THE CREATURES. WHEN THEY ARE NICE AND FIRM ON THE OUTSIDE, THEY ARE FILLED WITH JUICY, WHITE MEAT ON THE INSIDE.

The lucky crabs that don't meet this high standard are tossed overboard in a high arc, back to freedom.

Although the quality of the catch from the first line is good, the quantity leaves much to be desired. In rain and wind, the two work on a piece-rate basis. While Tom is still stowing the crabs in the fish crates, Jeremy heads back to the wheel, shifts to full throttle, and the *Freespirit 2* battles through the waves at full speed to the next line—there is still a lot to do before they can call it a day. Ten hours and twelve lines later, the crates on deck are full to the brim. Thanks to the last line just below the famous cliffs of Tintagel, the crates are now filled with so many crabs, that Tom and Jeremy have enough to ride out the break caused by the incoming storm. Exhausted but satisfied, they can finally head home.

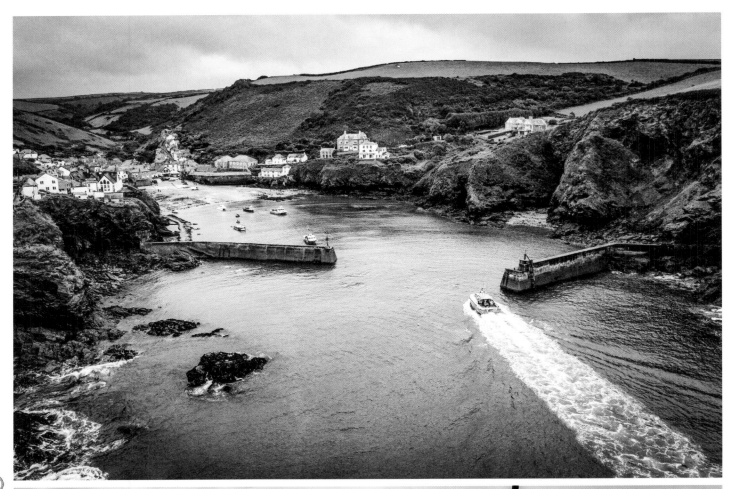

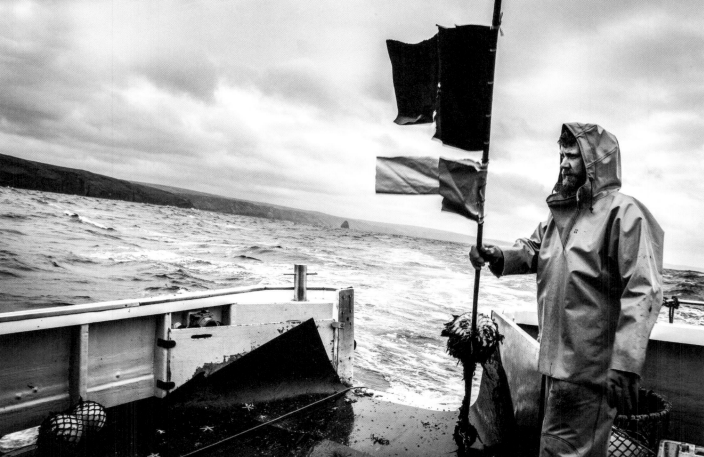

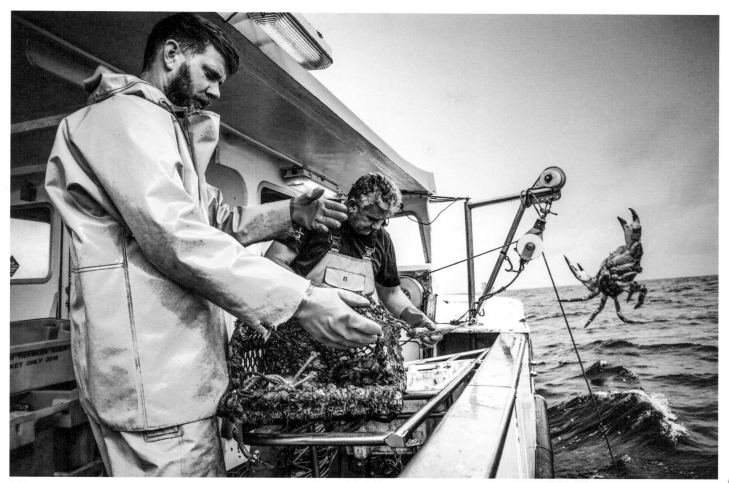

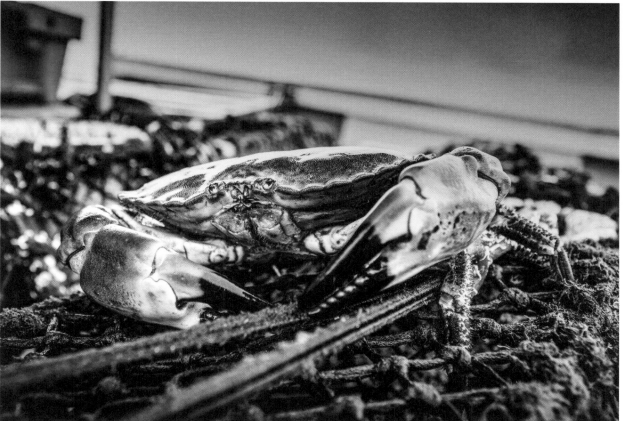

THE FAMILY RUNS ITS OWN CRUSTACEAN SHOP IN THE HARBOR, AND ONLY
TOP-QUALITY GOODS MAKE IT TO THE SALES COUNTER.

CRAB MEAT SANDWICHES

It takes some work and the right tool to get at the delicious meat of a brown crab. In the end, the effort makes the meat that much more delicious.

116

SERVES 4

1	large brown crab
	Salt
1 tsp	mayonnaise
½ tsp	tomato paste
1 tsp	mustard
1	lemon
	Black pepper
1 Tbsp each	parsley, dill, and chives, finely chopped
1 Tbsp	cornichons, finely diced
2 tsp	olive oil
8	slices of sourdough bread
	Butter

PREPARATION

Cook the crab in an ample amount of salted water for 15 to 20 minutes. Afterwards, let cool before removing the meat. Mix together the soft, brown meat from the body of the crab with mayonnaise, tomato paste, mustard, the juice from half a lemon, and pepper to form a creamy paste. In a separate bowl, combine the firm, white meat with the herbs, cornichons, the remaining lemon juice, and olive oil. Spread 4 slices of bread first with butter, then with the paste. Distribute the crab meat onto the bread slices and then top each of the sandwiches with the remaining slices of bread.

ABOUT THE INGREDIENTS:

How to properly break down a **brown crab**: After breaking off the claws and legs, use the back of a knife or a hammer to carefully crack them, then meticulously separate the meat from the pieces of shell. Use a knife to lever open the crab's top shell. Remove the brown meat with a spoon, then scrape the white meat out of the joints with a crab fork. If you still feel unsure of how to do this, simply watch one of the many videos about breaking down a crab available on the Internet.

FISH & CHIPS

Tom and Jeremy are not really big fish eaters, and they can muster very little enthusiasm for their precious crustaceans on their own plates. When they are in the mood for fish, however, they prefer the British classic: Fish & chips.

SERVES 4

	High-quality vegetable oil
2¼ lb (1 kg)	potatoes, julienned
4	fish fillets (about 7 oz/200 g each, ideally cod, pollack, or another white fish)
1½ cups (200 g)	flour for the beer batter and flour for dredging
	Salt, pepper
1 tsp	baking soda
1¼ cup (300 ml)	beer
1	lemon, cut into wedges
	Malt vinegar

PREPARATION

In a deep fryer, heat an ample amount of vegetable oil to 375°F (190°C) and pre-fry the potatoes for about three minutes, then spread the fries out on paper towels to drain and set aside. Carefully dredge the fish fillets in an ample amount of flour. Measure 1½ cups (200 g) of flour, salt, pepper, and baking soda into a bowl. Slowly stir in the beer to form a thick batter. One after the other, dip the fish fillets into the beer batter, then gently place them directly into the fryer. Depending on the thickness of the fillets, fry them at 325°F (160°C) for 6 to 10 minutes until they are golden brown. Afterwards, keep them warm in an oven. Turn the fryer back up to 375°F (190°C) and finish frying the potatoes until they are crispy and golden brown.

Drain the finished French fries on paper towels and sprinkle with salt. Remove the fish fillets from the oven and arrange with the French fries on large plates (or an old newspaper) and serve with lemon wedges and malt vinegar.

Tip: Instead of a deep fryer, you can also use a large pot or a wok. It is important that the fish fillets can float freely in the oil.

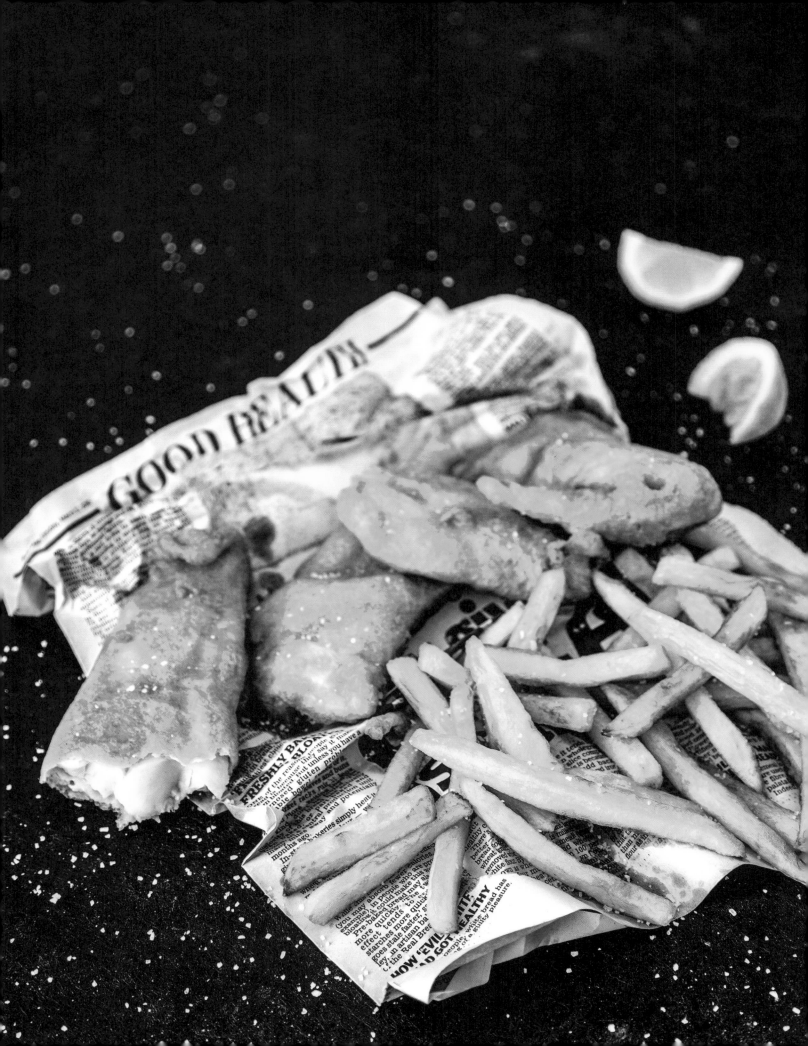

MARTIN HECHABE OSA

Zumaia, Basque Country (Spain)

Martin can survey his fishing grounds from his own garden. His farm is located right at the edge of steep cliffs, situated high above the unique rock formations for which this incredibly beautiful stretch of Basque coastline is known. Here, on the shores of the Atlantic, you encounter a spectacular sight: 60 million years of geological history, laid out like an open book. Over a long period of time, a huge piece of the earth's crust has jutted up here; horizontally, the various geological eras are now laid out in parallel next to each other.

During the days around the full moon and the new moon, the tidal range is so immense that the ocean recedes hundreds of meters at low tide, exposing the primeval layers of rock that emerge from the water like the ridges on a dragon's back. Between the individual millennia, long channels have formed with numerous puddles and pools. This is the ideal habitat for Martin's favorite food—octopus. Today, one day after the full moon, the conditions are perfect. Two hours before low tide, he begins his descent to the sea. As always, he has packed his two kakuas—the traditional Basque octopus hooks.

As soon as he reaches the water's edge, the down-to-earth Basque switches to hunting mode. With a keen eye, he scans the countless small pools between the jagged rock lines as he nimbly scrambles over the smooth stones. Here and there he uses his hook to unerringly poke into a crack. Each time, the metal pole disappears deep into the rock. He has been hunting in this area since he was a child. He knows the rough labyrinth of rocks like the back of his hand, and he knows exactly where the best cavities are located. Even after he lights a cigarillo after the first few meters, he continues on over the sharp-edged rocks and, with a sure step, traverses the tidal pools overgrown with algae. Then he suddenly strikes out. He triumphantly pulls a lively octopus from a crevice in the rock. The octopus defends itself in vain: As soon as it emerges from the water, Martin skillfully grabs it and removes it from the hook. After scrutinizing it briefly, Martin gives his head a quick shake and returns the ornery creature to the water.

THERE ARE FEWER AND FEWER OCTOPUSES IN THE ROCKS OFF ZUMAIA. NOW YOU CAN ONLY CATCH ONE PER DAY, AND MARTIN HAS BECOME PICKY. HE USED TO CATCH NUMEROUS OCTOPUSES AND EARNED DECENT MONEY ON THE SIDE BY SELLING THEM.

Although those times of abundance are long gone, Martin can still rely on his keen senses while hunting for his own modest needs. It doesn't take long until he has the next candidate in his sights, one that this time offers little resistance. For the experienced Basque, this is a sure indication that this specimen is much too small. The search continues. He heads for one of his secret spots and hits the bullseye. The octopus squirms violently and increases Martin's anticipation. Rightly so: After an extensive wrestling match, he brings out a magnificent specimen and takes hold of it with a strong grip. This time the catch is not returned to the water and instead goes straight into Martin's backpack, where it accompanies him on his way home, back up high on the cliffs.

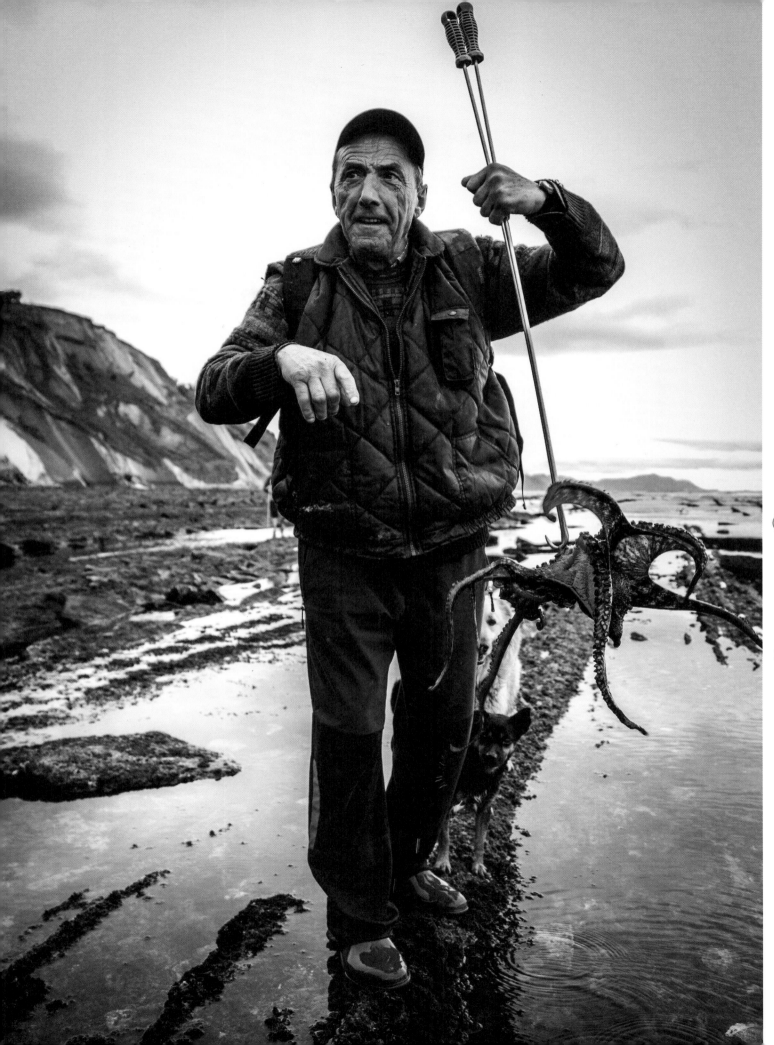

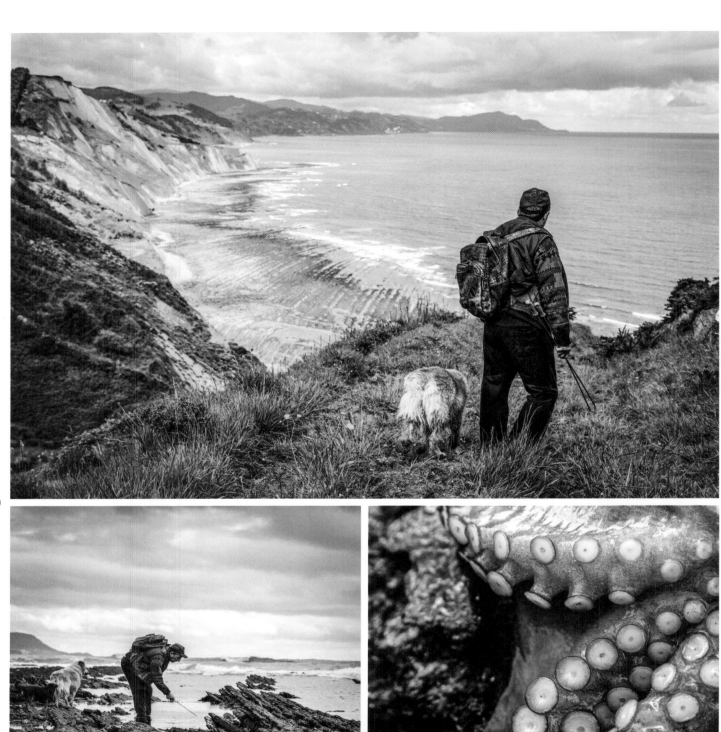

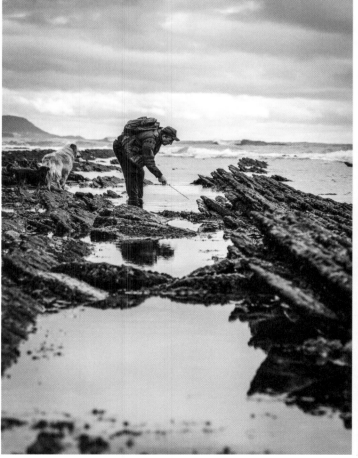

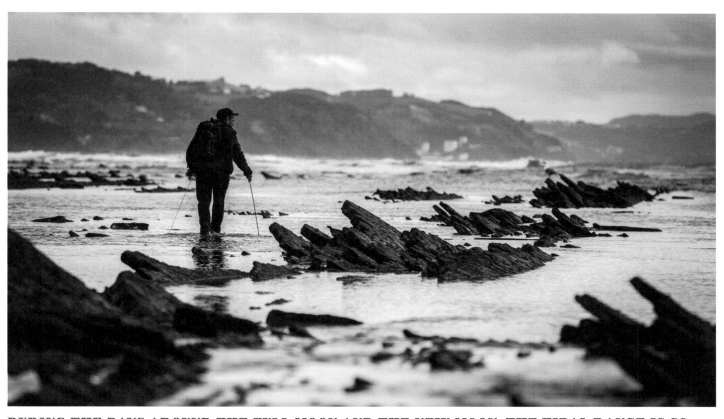

DURING THE DAYS AROUND THE FULL MOON AND THE NEW MOON, THE TIDAL RANGE IS SO IMMENSE THAT THE OCEAN RECEDES HUNDREDS OF METERS AT LOW TIDE, EXPOSING THE PRIMEVAL LAYERS OF ROCK LIKE THE RIDGES ON A DRAGON'S BACK.

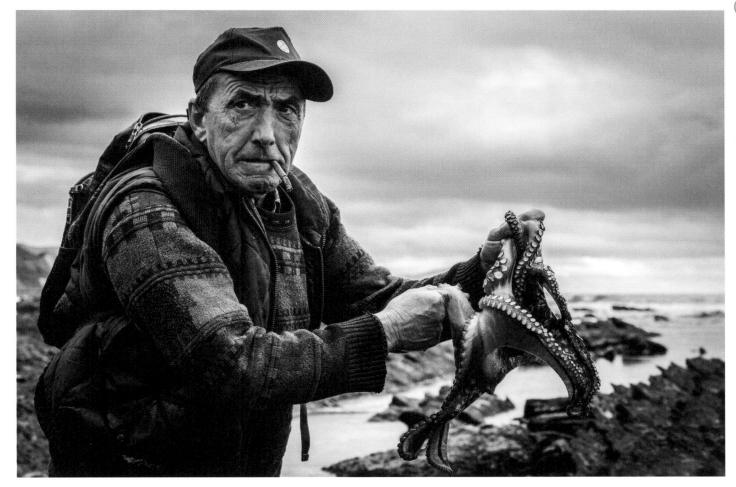

OCTOPUS SALAD

There are different variations of octopus salad on many coasts. This is how it is prepared on a Basque cliff:

SERVES 4

2	red bell pepper, finely diced
½	green bell pepper, finely diced
2 Tbsp	olive oil
1 tsp	paprika (sweet)
	Coarse salt
1	splash of white vinegar
1	whole octopus (about 2¼ lb/1 kg), cooked
2	green onions, finely sliced
	Pepper
	Bread

PREPARATION

Add the diced bell peppers, olive oil, paprika, a pinch of salt, and the vinegar to a bowl. Cut the octopus into bite-sized pieces and add to the bowl. Mix in the green onions, season with salt and pepper, and serve the finished octopus salad with some bread.

ABOUT THE INGREDIENTS:
There are many different ways to cook **octopus**. Martin first adds about 2 quarts (2 liters) of water to a pot along with a bay leaf and two whole cloves of garlic, then he brings it to a boil. Next, he briefly dips the octopus into the water several times with the tentacles dangling down until the arms have rolled up nicely. Martin then lowers the entire octopus into the pot (it is fine if the head remains above water), closes the lid, and cooks it for 20 minutes.

FRIED OCTOPUS
WITH POTATO-PARSNIP PUREE

When Martin prepares his favorite dish, he doesn't need to go to the supermarket. He grows potatoes and parsnips in his own garden, and he catches the octopus himself, fresh from the Atlantic.

SERVES 4

17 oz (500 g)	parsnips, peeled and diced
17 oz (500 g)	potatoes (floury), peeled and diced
1 tsp	granulated vegetable bouillon
1 Tbsp	butter
	Salt, pepper
1	pinch of nutmeg, freshly grated
1	whole octopus (about 2¼ lb/1 kg), freshly cooked
	Olive oil

PREPARATION

Add the parsnips and potatoes to separate pots along with the vegetable bouillon and cook until just tender. Afterwards, drain the pots but be sure to reserve some of the stock.

Mash the parsnips and potatoes in a large pot. Add in the butter and some of the reserved stock until the puree reaches the desired consistency. Season to taste with salt, pepper, and nutmeg.

Cut off the individual arms of the octopus, cut the head into quarters, and quickly sear everything in olive oil over high heat. Serve together with the potato-parsnip puree.

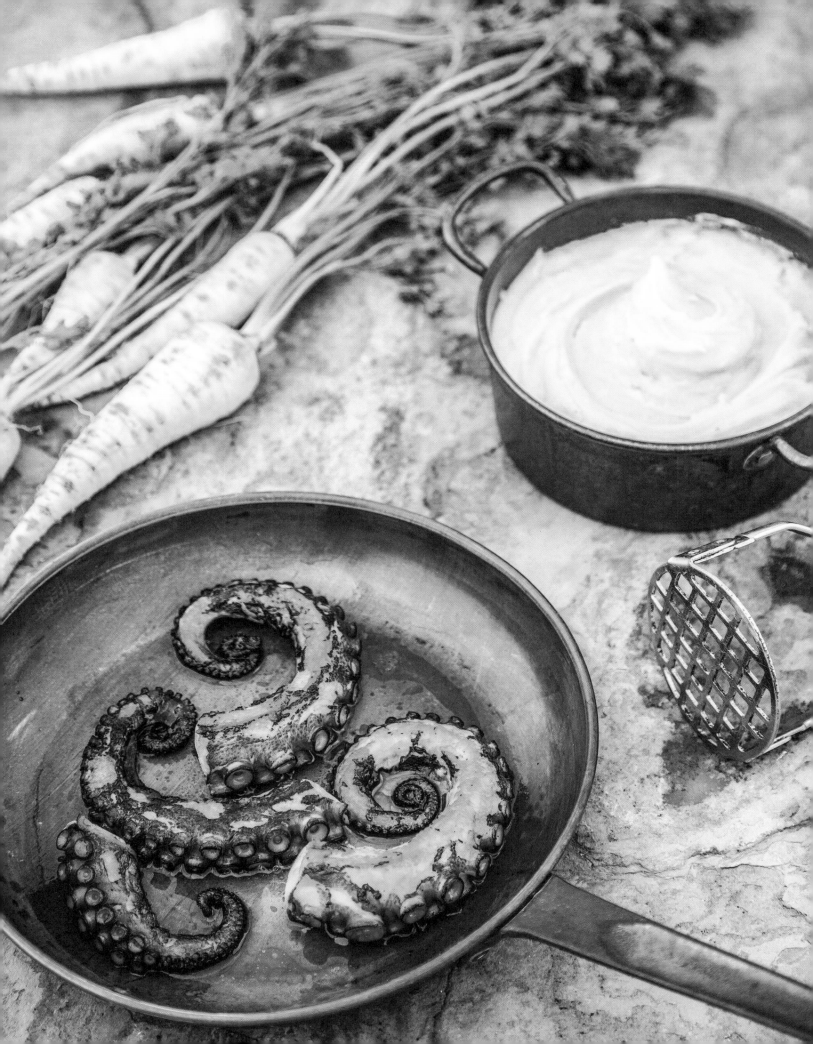

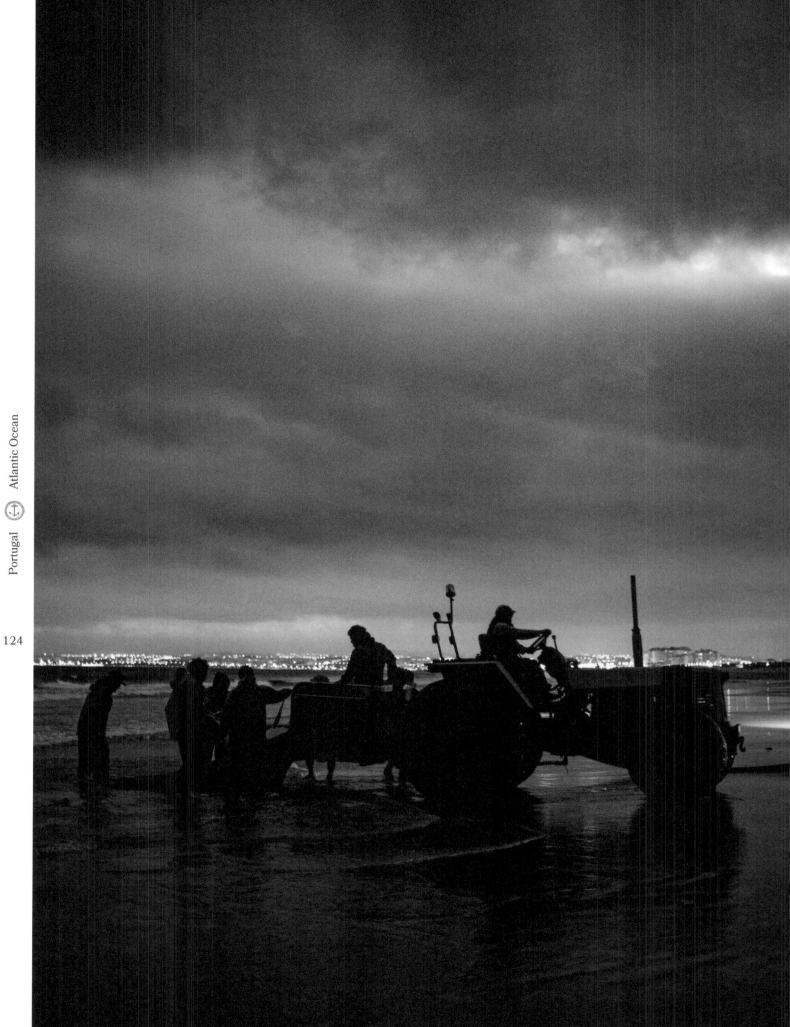

124

MIGUEL SILVA

Costa da Caparica, Portugal

Miguel and his crew have been on their feet since sundown. The long night shift was so successful that by the break of day tall stacks of bright orange fish crates stand in the fine sand of Costa da Caparica—according to long-standing Portuguese custom, the fishermen cast their nets from the beach. As always, they end up with a wide range of different fish, and glistening mackerel, bass, bream, calamari, and cuttlefish are already waiting to be picked up. But one last haul is about to join them.

THE FISHERMEN HAVE PULLED IN THEIR NETS SIX TIMES ALREADY TONIGHT, AND MIGUEL NOW URGES HIS PEOPLE ON DOWN THE HOME STRETCH.

Although he is still relatively young, his pleasant mix of natural authority and a friendly manner have earned him the respect and affection of his crew. The giant of a sailor orchestrates a team of 16—mostly men and a few women—three tractors, and one boat in an effort to induce this part of the Atlantic to give up its treasures. The ragtag band of sailors is in fine spirits, and although they have a long, hard night behind them, they joke and kid around during their short breakfast break before getting right back to work. After all, setting the net requires their complete concentration.

They begin by towing the boat into ankle-deep water with a tractor and then pulling together to maneuver it by hand into deeper water. After directing the crew's efforts from his perch on the tractor, Miguel then climbs nimbly on board and issues commands from the helm as the departing boat pitches and tosses. Once the vessel has reached waters of a sufficient depth, the captain flips down the outboard, starts the engine, and skillfully maneuvers the *Neptuno* over the incoming waves. After passing the dangerous breakers, Miguel and his crew head one mile out to sea in order to set their net at a depth of 100 feet (30 meters) before turning back toward shore.

Now that the trap has been put in place, the crew use motor-driven winches to slowly haul in the ends of the net, which are fastened to the tractors with long ropes, until the tapered mesh appears on the beach. The final feet of net are retrieved by hand, and the fishermen combine forces to land the bulging fishing gear and to empty its contents onto a huge plastic tarp. Miguel's crew member Eduarda then discreetly takes charge as they collect the fish, which are now thrashing about. With the lists of customer orders in her head, she organizes the loading of the prepared plastic crates. The petite woman is the focus of attention as the different types of fish are sorted, and the seamen await her instructions. Eduarda not only maintains the necessary overview, but she also has an especially practiced eye: She has worked in the traditional fishing business on Caparica Beach since the age of eight, taking time off only after her children were born. Now that her kids are grown and have left home, the cheerful Portuguese woman has been back in the thick of things for the past several years.

Once the last fish of the day has landed in the right crate, both hunters and hunted leave the beach in the tractor, ready at long last to call it a day. After all, even though they enjoy their backbreaking work and are proud of their traditional fishing practices, Miguel, Eduarda, and the rest of the crew look forward to some hours of hard-earned sleep after such a long night.

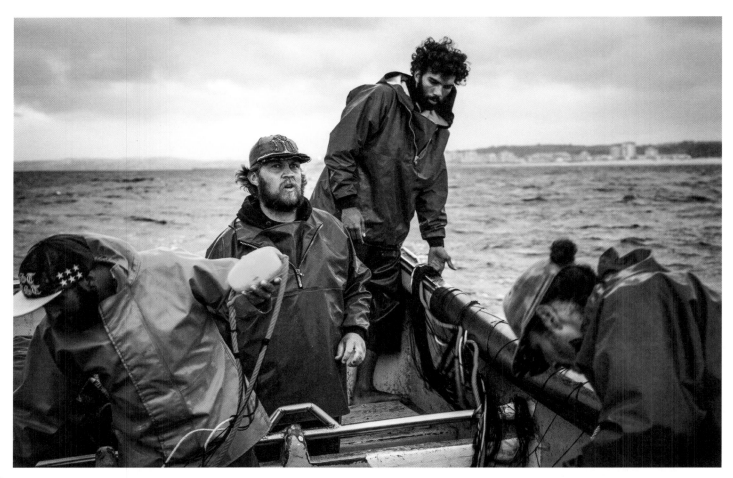

AFTER DIRECTING THE CREW'S EFFORTS FROM HIS PERCH ON THE TRACTOR, MIGUEL
THEN CLIMBS NIMBLY ON BOARD AND ISSUES COMMANDS FROM THE HELM AS THE
DEPARTING BOAT PITCHES AND TOSSES.

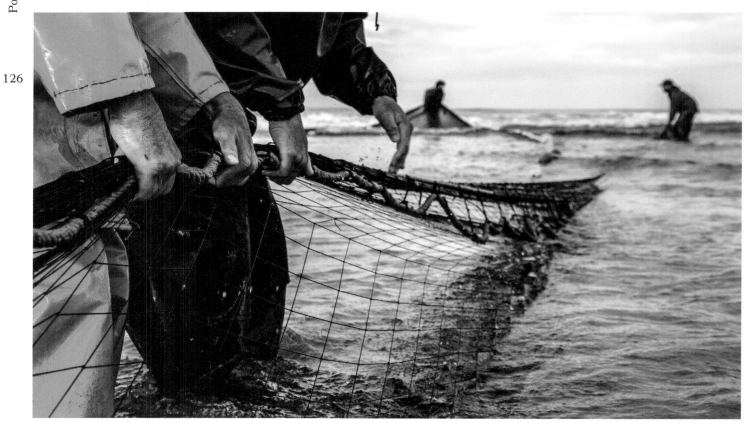

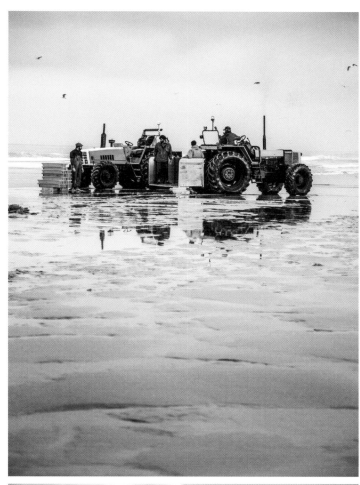

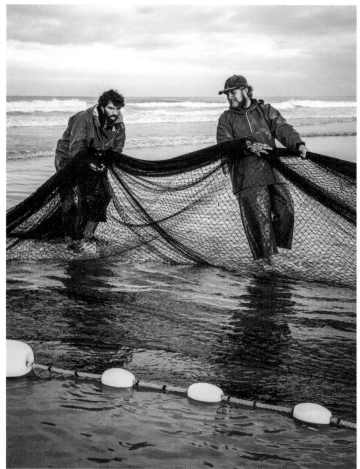

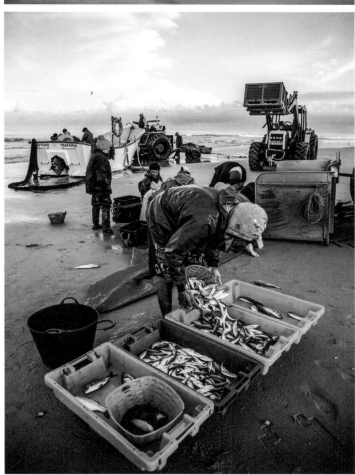

SARDINHAS ALIMADAS

Marinated, pickled sardines, served cold: a wonderfully refreshing summer dish from sunny southern Portugal.

SERVES 4

2¼ lb (1 kg)	sardines or small jack crevale
	Coarse salt
	Olive oil
	Juice of one lemon
5	cloves of garlic, thinly sliced
1	bunch of coriander or parsley, chopped
	Bread

PREPARATION

Gut the sardines, remove the heads and layer the fish with a generous amount of coarse salt in a container with a tight-fitting lid. Refrigerate for at least 24 hours.

On the day you plan to serve the dish, first rinse the sardines thoroughly with clear water. Bring a pot of water to boil and cook the sardines until done, 4 to 5 minutes. Fill a bowl with cold water and carefully remove any remaining skin and the backbones with your fingers.

Sprinkle the sardine fillets with olive oil, lemon juice, and garlic, garnish with herbs, and serve with bread.

128

CATAPLANA

This Portuguese fish stew takes its name from the eponymous clam-shaped, copper pan in which the dish is usually prepared. If you don't have a cataplana on hand, you can also use a pot or a deep-sided sauté pan with a tight-fitting lid.

SERVES 4

2 tsp (10 ml)	olive oil
1	onion, sliced into rings
2	large potatoes, peeled and sliced
2	cloves of garlic, slightly crushed
1	large tomato, sliced
1	bell pepper, cut into strips
1	small bunch of coriander
5 oz (150 ml)	white wine
1 Tbsp	tomato paste
	Salt, pepper
2¼ lb (1 kg)	fish, any type
	Bread

PREPARATION

Grease the cataplana with a small amount of olive oil, then layer the onions, potatoes, garlic, tomato, bell pepper, and coriander in the pan. Mix the white wine with the rest of the olive oil and tomato paste, season with salt and pepper, and pour the mixture over the layered vegetables.

Cover the cataplana with a tight-fitting lid and cook everything over medium heat for around 20 minutes. Meanwhile, clean the fish, cut it into pieces, season with salt, and once the initial 20-minute cooking time is up, add to the bubbling broth.

Tightly cover the pan again and simmer for another 5 to 10 minutes. Serve hot with bread.

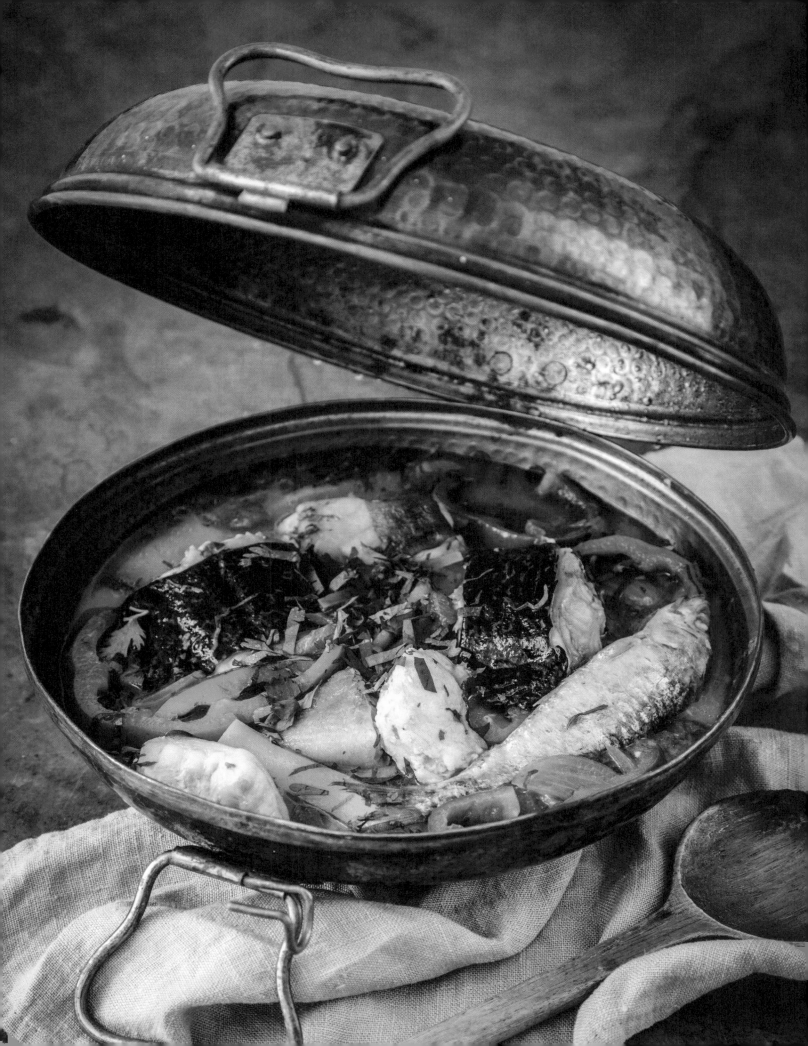

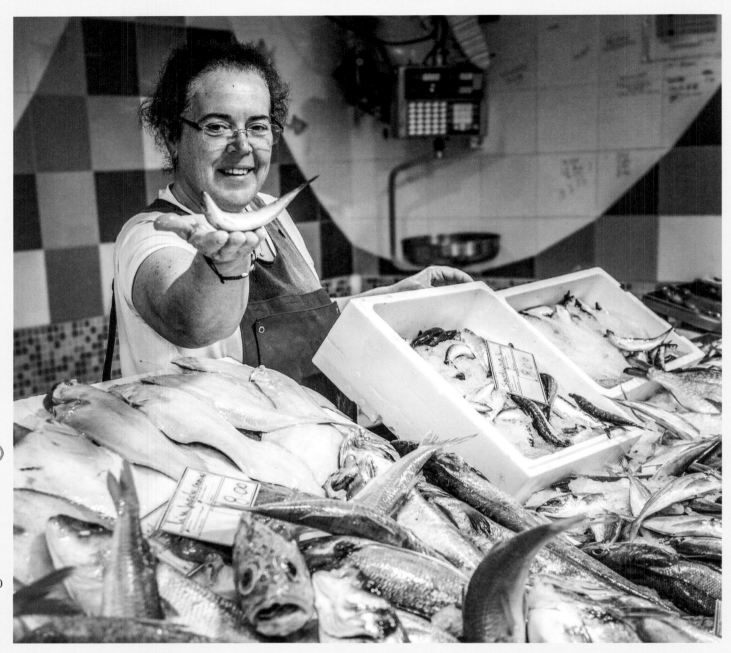

Tips for Buying Fish

Ana is a female fisherman who runs her own fish stand at the market in
Costa da Caparica in southwestern Portugal. She also is a passionate seafood cook.
She knows exactly what to look for when it comes to buying fish and shares her advice
on how food connoisseurs can land the best deals at the fish market.

Loyalty pays off, because regular customers naturally receive especially good service. Like with all other kinds of food, it's worth establishing and maintaining a good relationship with an experienced fishmonger. If possible, always buy locally and in season. Not only is this the responsible thing to do, and in keeping with the times, but it also means that you get the freshest fish on offer.

Be flexible: Always check out the market display before deciding which fish to prepare at home. Make your selection from whatever the fishmonger has available that day. Do not be afraid to ask questions, inspect the goods with care, and smell the fish. Also, go right ahead and touch it.

First impressions — The fish should glisten and be covered by a clear film. It should never smell "fishy"; the scent should be neutral or even slightly briny.

Eyes — They should be nice and clear and never look milky or cloudy.

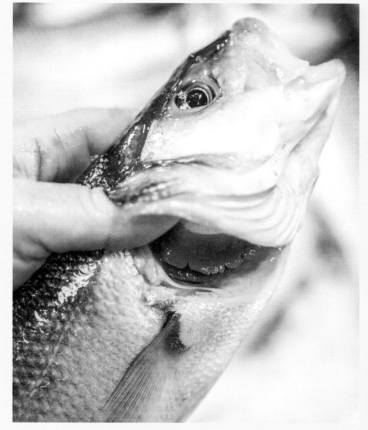

Gills — The gills of a fresh fish are dark red and moist. Brownish discoloration and a dull film are signs that the fish isn't as fresh as it should be.

Consistency — When you hold up a freshly caught fish, it should hang straight and firm. Once the muscles begin to decompose, the fish becomes soft and limp. When you press down lightly with your fingers, the skin should immediately bounce back and not leave any depressions.

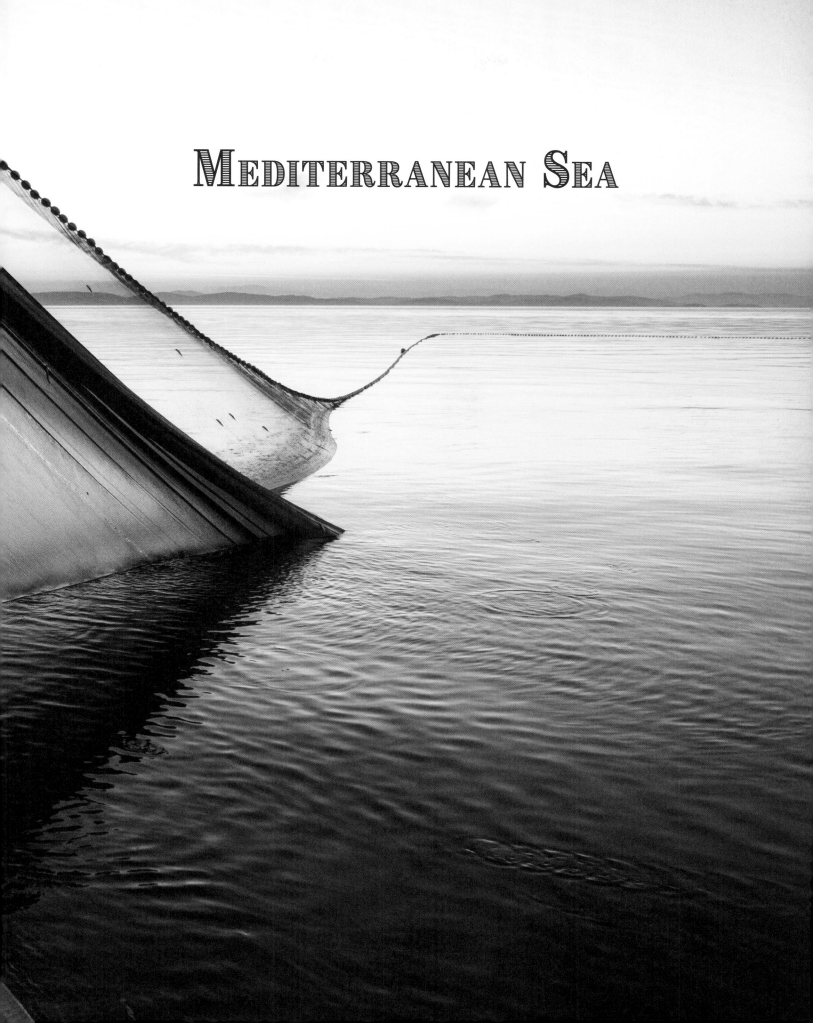

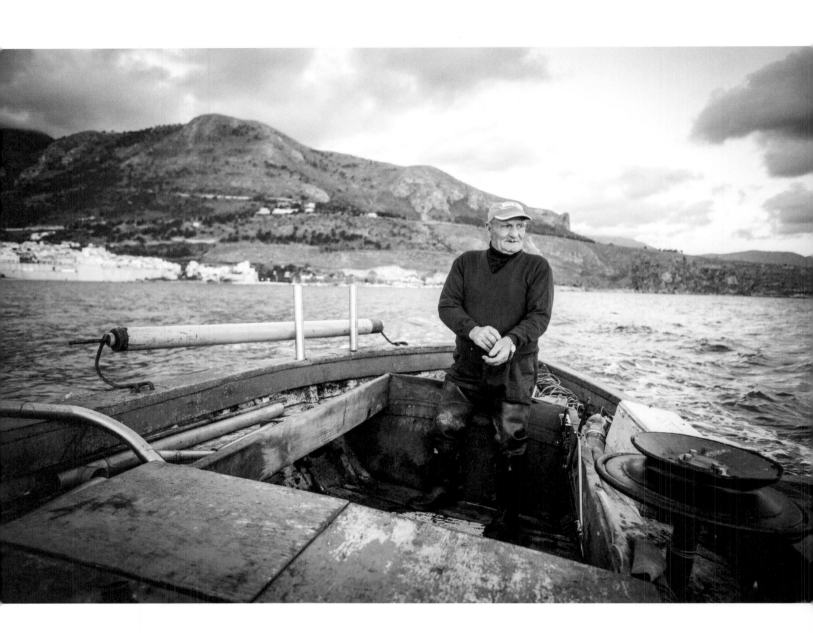

ANTONIO RUSSO

Castellammare del Golfo, Sicily

Italian fishermen are actually not allowed to bring guests on board. But Antonio Russo doesn't worry about any rules set in the distant city of Brussels. "Of course! My pleasure! We'll head out at six in the morning," he replies when asked if he would welcome company. At daybreak, he arrives right on time at the port of Castellammare del Golfo: The old fisherman slowly descends the stairs from the village and trudges toward the quay wall. At the jetty, he slips down to his boat with astonishing agility and deftly casts off the lines. He starts the motor by hand, and after two hesitant coughs the old diesel engine gets going. Satisfied, Antonio lights a cigarette, and as the boat passes the harbor wall, the old Sicilian has transformed into an upright sailor, standing at the helm with a proud chest and smoking with relish.

Antonio is 83 years old and still heads out to sea every day. Yet he plans to stop when winter rolls around again. He loves his work, but it's starting to become a bit difficult, and fishing isn't what it used to be.

AS A YOUNG MAN, ANTONIO WORKED IN TUNA FISHING. EVERY YEAR, THE TURQUOISE-BLUE WATERS AROUND CASTELLAMMARE WOULD TEEM WITH LARGE SCHOOLS OF SPLENDID TUNA.

On the way to their spawning grounds in the eastern Mediterranean, they would swim directly past the northwestern coast of Sicily. There they were eagerly awaited, because they brought work and prosperity to the coastal villages. Like his forebearers, Antonio also worked at the tuna station in the neighboring village. He was one of the strongest men on his boat and, while fishing, he would always stand in the most important spot to haul the gigantic fish, which could weigh as much as 660 pounds (300 kilos), on board at just the right moment. Antonio witnessed firsthand the golden age of tuna fishing. The reality today is quite different. In the Mediterranean, the number of tuna has sharply declined, and they are rarely as large as they were back then. The old fishing stations have been closed and are falling into ruins. Antonio now catches fish that are often smaller than his hands.

The shrinking numbers are also noticeable this morning. Antonio smokes, grumbling as he untangles the net to inspect his meager haul. But then—a ray of hope. Some cuttlefish have landed in the net. He eyes the ink-spitting creatures with obvious delight, sends a few words of thanks upwards, and sets the mollusk aside in a separate pail. It is to take home. In the afternoon, Antonio can look forward to his wife preparing his favorite dish, "Linguine al Sepia." Angela, the love of his life, is another reason why he wants to give up fishing. She does tend to worry about her tobacco-loving sea wolf when he is alone out at sea without a radio or telephone. In the village every morning she walks to the overlook and keeps a close eye on Antonio as he maneuvers his boat out of the harbor. When he returns, she is already waiting for him so she can sell the fish to her regular customers directly from the jetty. They are all tremendous fish experts and initially examine the haul with a critical eye—only to buy up all of the day's catch, as usual. Finally, Antonio and Angela work together to clean the net. Afterwards, they head home to enjoy a well-deserved meal with the fresh cuttlefish.

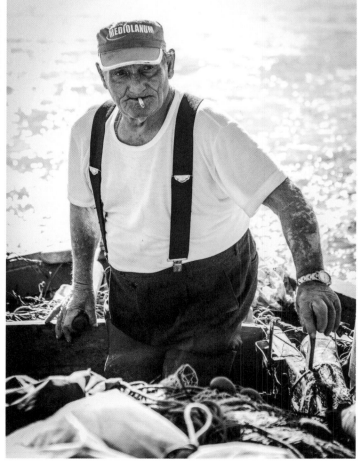

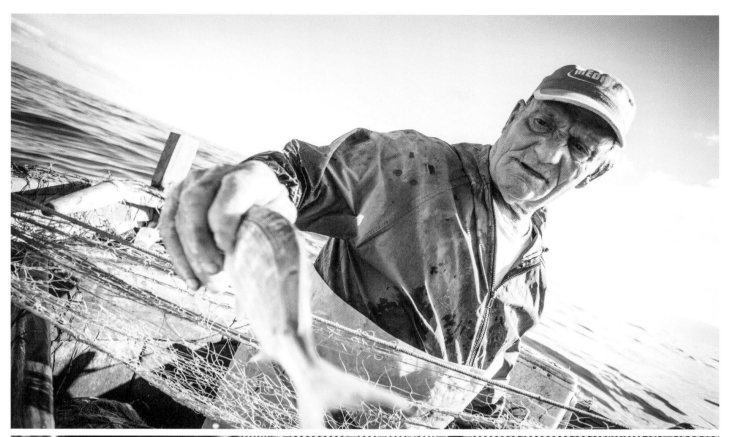

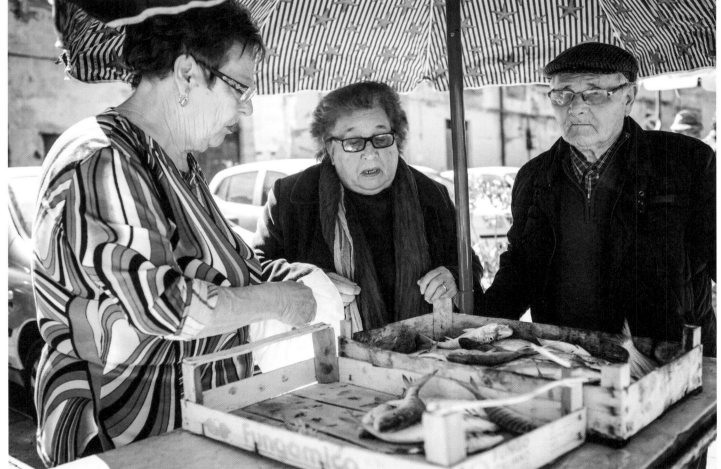

ANGELAS CUSTOMERS ARE ALL TREMENDOUS FISH EXPERTS AND INITIALLY EXAMINE
THE HAUL WITH A CRITICAL EYE—ONLY TO BUY UP ALL OF THE DAY'S CATCH, AS USUAL.

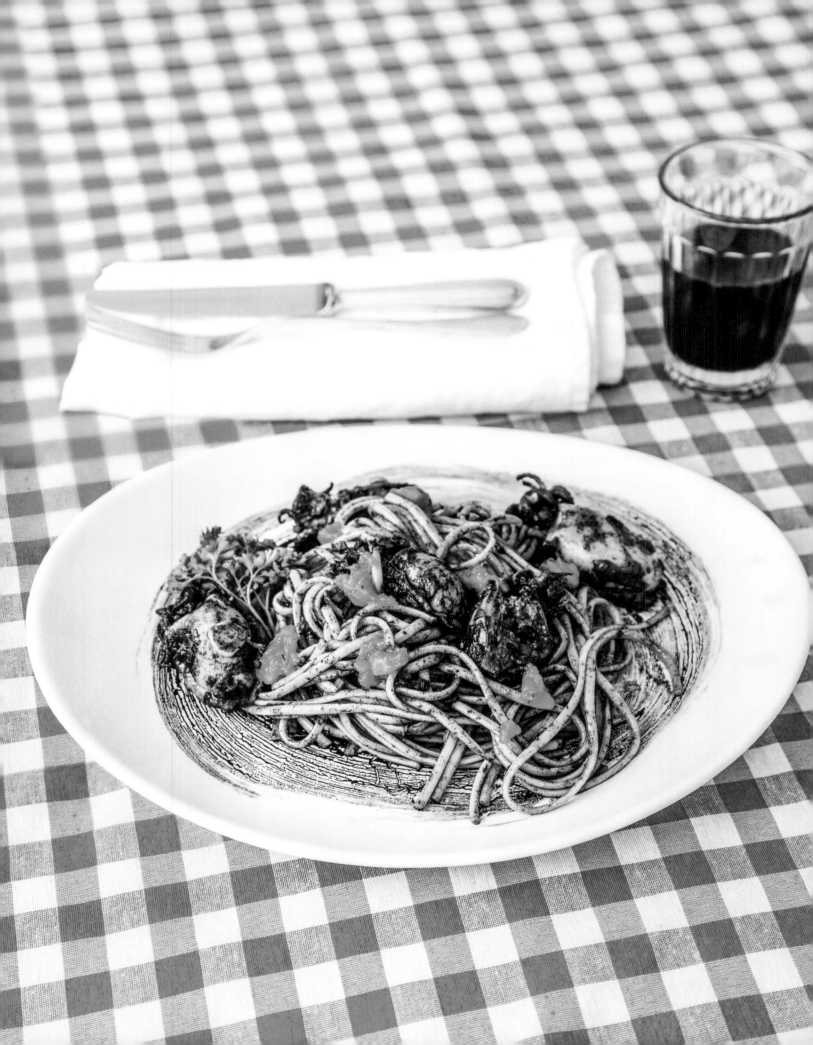

Linguine with Cuttlefish in Ink

Angela, the wife of the fisherman and herself a fishmonger, does not eat fish. But she does prepare it for her Antonio, and after all these years his favorite dish is her absolute specialty.

Serves 4

18 oz (500 g)	linguine
2	small cuttlefish or squid, gutted and cleaned
2	cloves of garlic, minced
1	onion, finely diced
	Olive oil
1	can of strained tomatoes
2	packets of cuttlefish ink
	Pepperoncini

Preparation

Cook the pasta in boiling salted water until al dente.

Cut the cleaned cuttlefish into bite-sized pieces. Sauté the garlic and chopped onion in olive oil, add in the cuttlefish pieces, then cover it all with the strained tomatoes and stir once.

Simmer for 3 to 5 minutes over medium heat, depending on the thickness of the cuttlefish pieces.

Stir the cuttlefish ink and pepperoncini into the sauce. Add the cooked pasta, mix thoroughly, and then serve.

Tip: With pasta dishes, the sauce should always be finished before the pasta.

Fritto di Pesce

This dish is simple but delicious. Since this recipe can be used to prepare any type of small fish, fishermen have always turned to it as a delicious way to enjoy their bycatch and any other unsold fish.

Serves 4

1¾ lb (800 g)	small, whole fish (any kind)
	Flour
	Olive oil
2	lemons

Preparation

Coat the whole fish in flour and fry in plenty of olive oil until golden brown. Drain briefly on paper towels, then serve hot and greasy on a large plate.

Drizzled with plenty of lemon juice right before eating, they are best eaten with your fingers.

Tip: In the case of larger fish, such as sardines, nibble the fillets carefully off the bones. Smaller fish such as sprats can be eaten whole, including the heads.

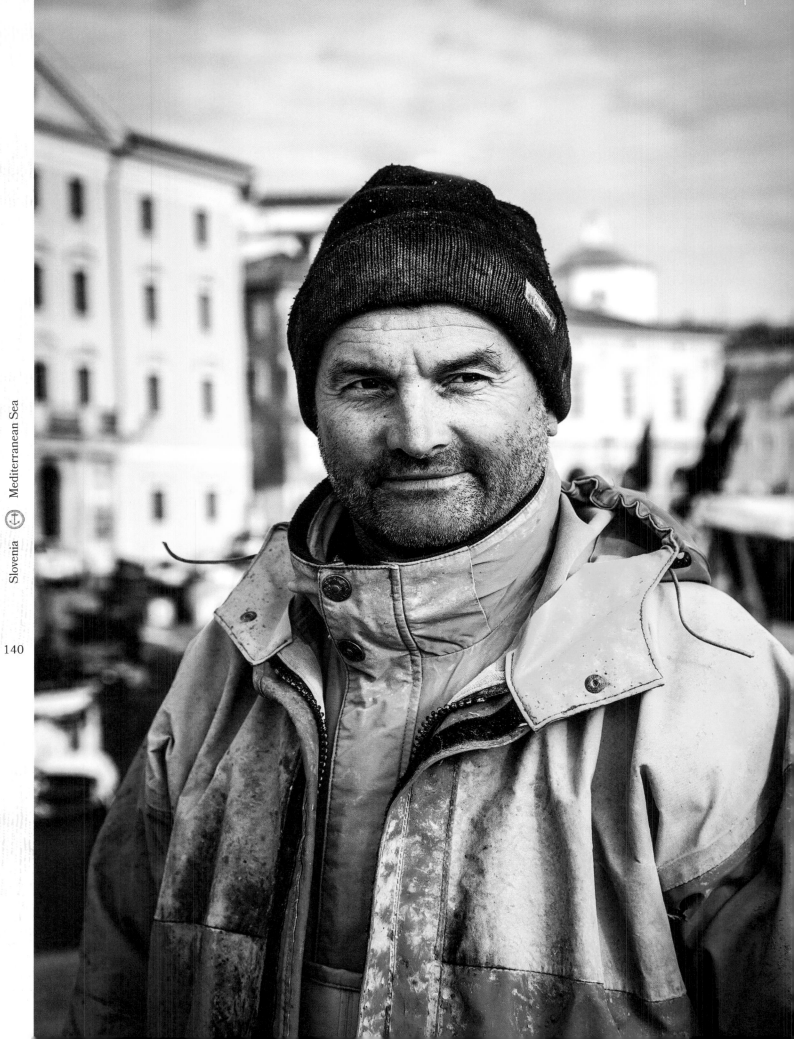

ROK DOMNIK

Piran, Slovenia

Rok Domnik is not actually a professional. Framed against the backdrop of the medieval city of Piran, as he hauls in his net, he explains that fishing is just his passion. In fact, the Slovenian has a number of irons in the fire when it comes to work: He owns a restaurant, works as a chef, and is an experienced programmer. He studied programming, and although he turned his back on the job despite a successful career, he still uses his computer know-how today. He programmed his own reservation and payment system for his restaurant, which makes his work easier, especially in high season during the summer. The 54-year-old skillfully combines his various activities and knowledge, and he happened upon fishing in a roundabout—yet lucrative—way.

Because he was looking for a new challenge and tourism was booming in his hometown, ten years ago he and his wife bought a former excursion steamer named *Podlanica*. In the harbor of Piran, the two opened a unique restaurant on the old boat, which is located adjacent to the moored fishing boats and thus at the perfect spot to purchase freshly caught fish.

Yet Rok has always been a good businessman, and since he has always enjoyed going out to sea, it didn't take long for him to decide to catch his own fish. No sooner said than done: He bought himself a small boat, got his fishing license, and tried his luck at sea. With success. His restaurant has now become so popular, that Rok has to supplement his own catch by buying additional fish from his colleagues on the jetty in the summer. Unfortunately, it is impossible to synchronize the streams of fish and tourists on the Adriatic coast of Slovenia. In the hot months when crowds of tourists arrive in the popular port city known for its Venetian architecture, there are relatively few fish in the crystal-clear waters.

THE BEST FISHING IS NOW TO BE HAD IN THE WINTER, WHEN SCHOOLS OF FISH FROM THE LAGOONS SWIM OUT INTO THE ADRIATIC SEA AND ALONG THE COAST CLOSE TO SHORE. RIGHT WHEN THE RESTAURANT IS CLOSED, PLACED IN DRY DOCK, AND BEING SPRUCED UP FOR THE NEXT SEASON.

But more than anything else, Rok is a passionate fisherman, which is why he heads out to sea every day even in the wintertime. Today the first fishing gear is directly in front of the beacons along the old harbor wall. When it comes to water quality, the Adriatic coast of Slovenia is currently one of the forerunners in Europe. Rok regularly sets one of his nets right next to the port entrance: The fish teem here along the shore in the shallows, and they automatically land in the stretched net.

On this particular morning, quite a few mullets have ended up in the net, much to the delight of the versatile restauranteur. Because another one of his many talents is cooking: Rok is an excellent chef. And it is also something he enjoys. Now, in the winter, he always keeps part of his catch to experiment with in his own kitchen, and he works on refining dishes for the coming season. At the top of his list: new mullet recipes.

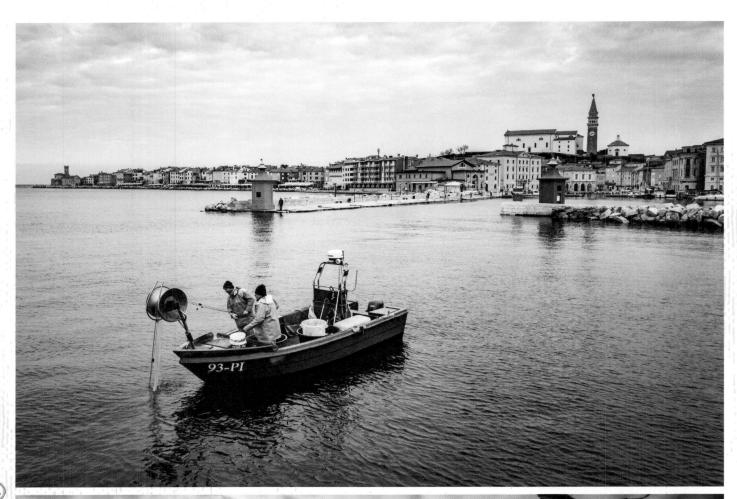

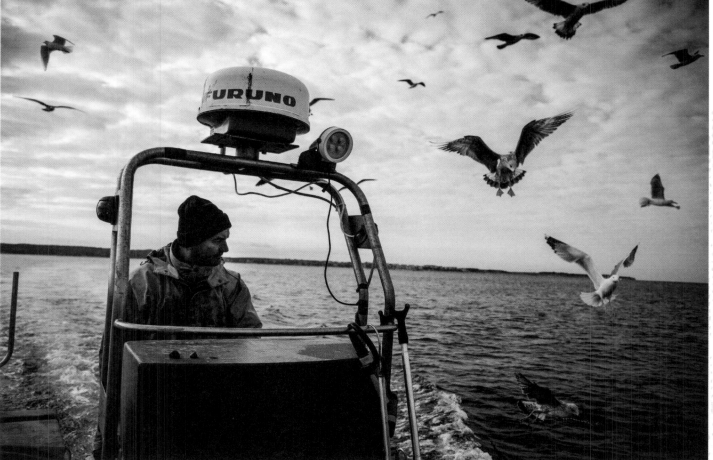

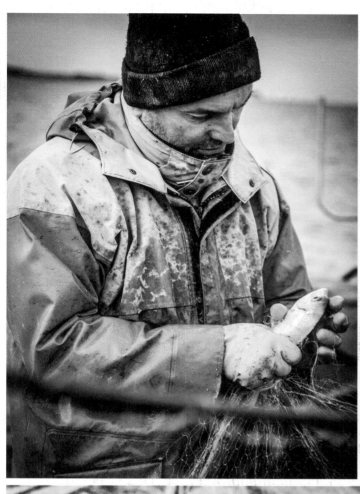

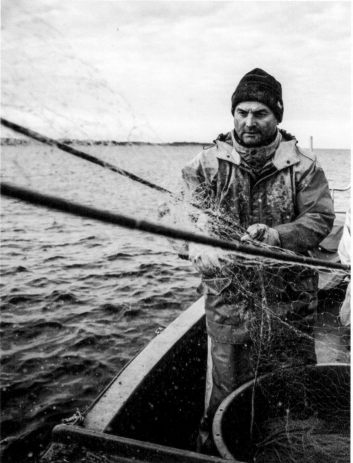

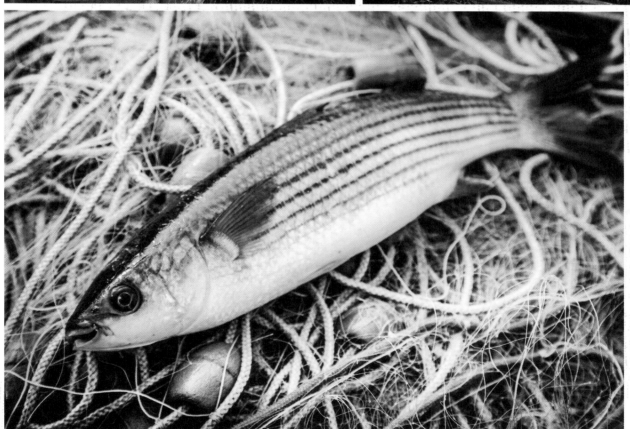

ON THIS PARTICULAR MORNING, QUITE A FEW MULLETS HAVE ENDED UP IN THE
NET, MUCH TO THE DELIGHT OF THE VERSATILE RESTAURANTEUR.

Mullet Carpaccio

Mullet has a particularly firm flesh and is well suited for raw fish dishes. This is a basic recipe that can be varied as desired by adding some spiciness, for instance, or with sesame oil, soy sauce, and grated ginger for an Asian flair.

Serves 4

11 oz (300 g)		mullet fillet
		Olive oil
	1	lemon
		Salt, pepper
	1	green onion

Preparation

Cut the mullet fillet into very thin slices.
(*Tip:* If you put the mullet in the freezer for a little while, the fillet will be much easier to slice.)

Fan out the fish slices on a large plate, then drizzle with some high-quality olive oil and a bit of lemon juice. Finish off by seasoning with salt and pepper and sprinkle with the thinly sliced green onion.

144

Mullet Fillets with Beer Vanilla Sauce

Mullet is often underestimated as a fish for eating and tends to be inexpensive as a result. It is important to get the right variety of mullet. There is very little visible difference between the varieties, so get it from a fishmonger you trust.

Serves 4

2¼ lb (1 kg)		potatoes, cooked
		Olive oil
	1	whole mullet, filleted and portioned
		Butter
	½	vanilla bean
	1	bottle of dark beer
		Salt, pepper
	1	bunch of fennel fronds

Preparation

Slice the cooked potatoes and fry them in a frying pan with olive oil. In a second pan, fry the mullet fillets in some butter over medium heat.

About three minutes before the fish is done, add the vanilla bean half (cut into three pieces about ⅓ inch or 1 cm in length each) to the melted butter in the pan. Wait until the fragrance of the vanilla develops, then deglaze the pan with the beer.

Simmer briefly and season to taste with salt and pepper. Arrange the fish fillets on the fried potatoes, garnish with the fennel, and finish by pouring the sauce over the artfully presented food.

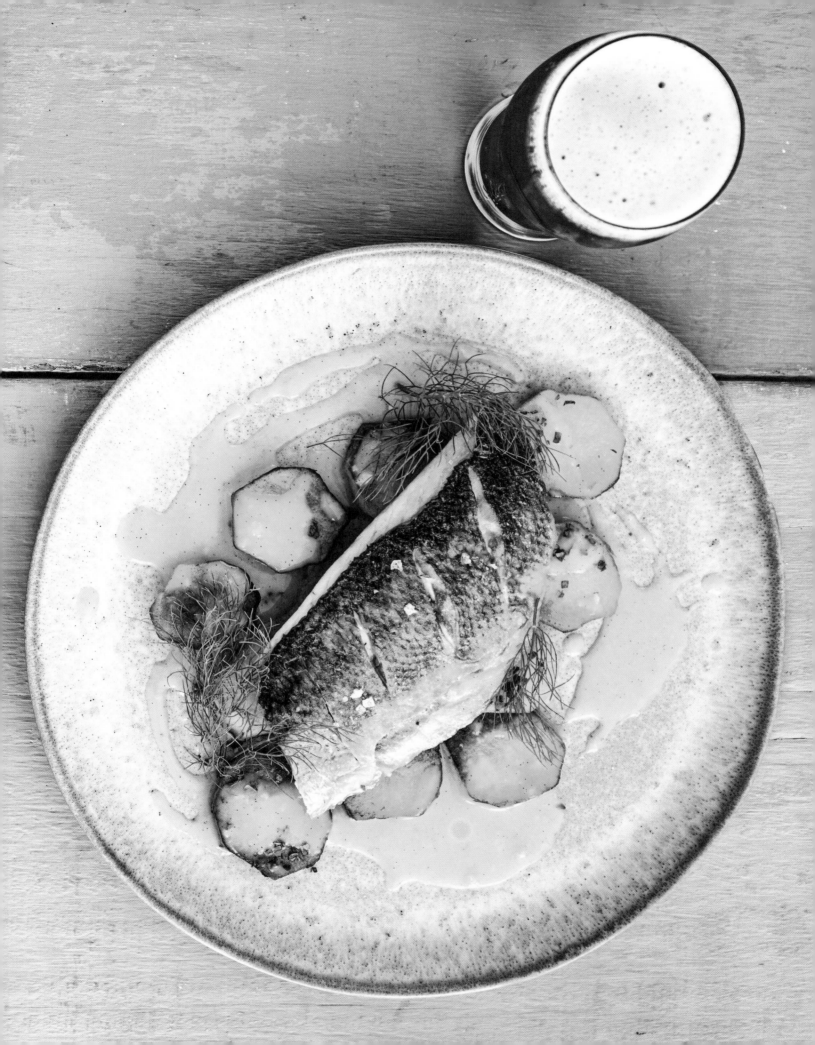

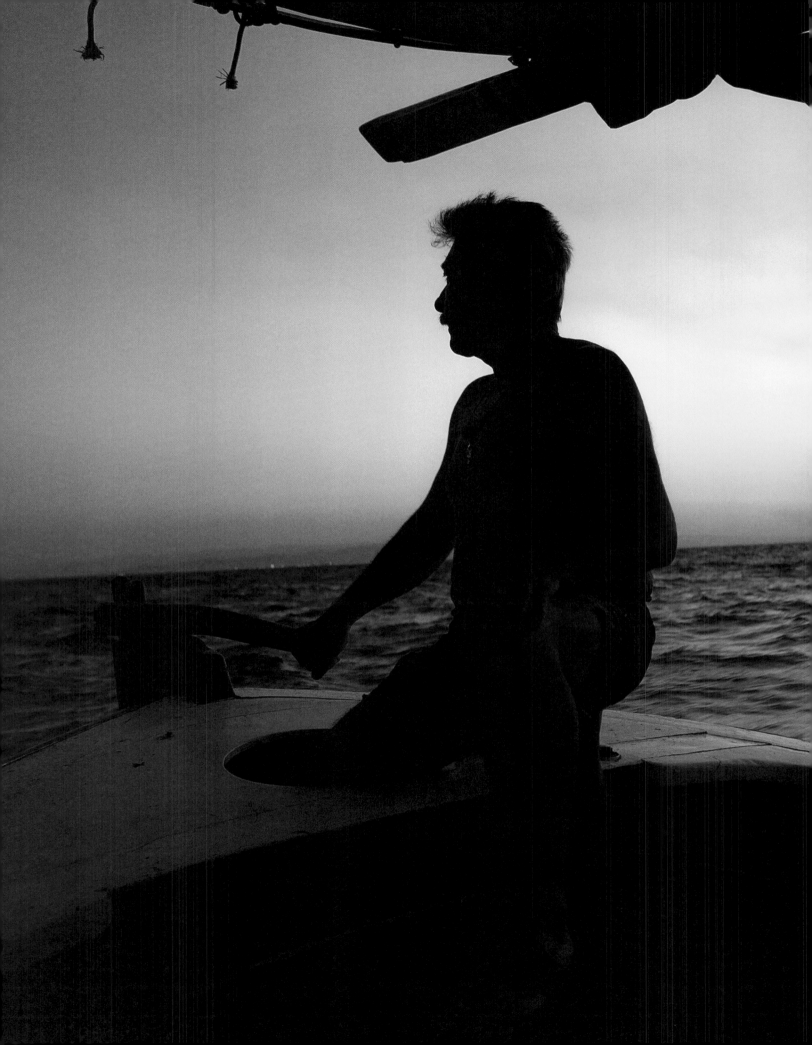

 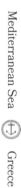

147

STAVROS KOUTSOUKOS

Aegina, Greece

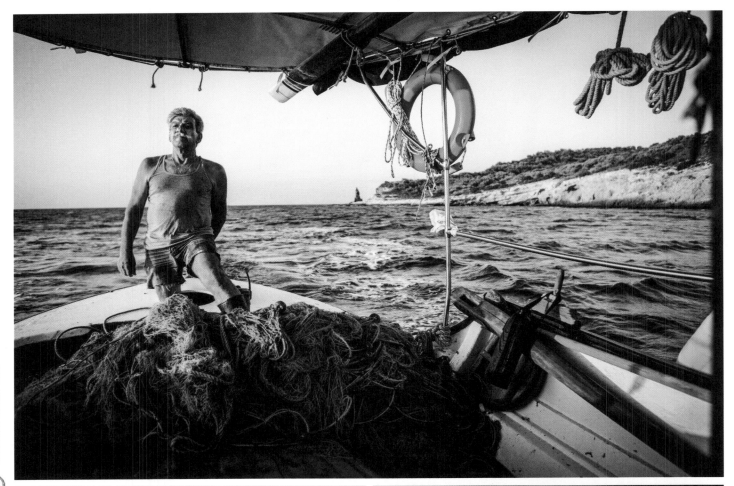

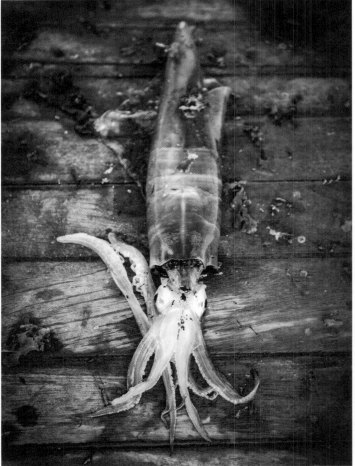

Before daybreak, the *Agios Nikolaos* chugs out of the small harbor of Vagia as the rising sun colors the sky a soft pink. At the rear of the small wooden boat, Stavros Koutsoukos has the tiller firmly in hand. He is heading for the reefs at the northeastern tip of Aegina. The night before, he had cast his nets in familiar fishing grounds that have been passed down from generation to generation. There his father had once shown him the submarine hills where marine life clusters at fairly shallow depths. Stavros practically grew up on the fishing boat: Even as a child he would head out to sea with his father, learning from him not only how to navigate, but above all the art of fishing.

When tourism was booming, however, business was better on shore. After holding down various jobs in the culinary industry, Stavros opened his own bar in Souvala, a village close to Vagia, which he operated for many years with great commitment and success. The island in the Saronic Gulf has always attracted Greek tourists. Thanks to its proximity to the capital, many residents of Athens in particular owned a vacation home here. They would regularly take the ferry over and spend several days enjoying the idyllic island life—and giving the economy a healthy boost in the process. But at some point, the rush to Aegina began to die down, and visitors to the island—and hence to Stavros' pub—declined sharply. Since the financial crisis, Greek guests have become ever more infrequent, and the few vacationers who do come to the island have become more frugal.

To make matters worse, the area is now attracting visitors with bad intentions: At night, poachers from the port city of Piraeus arrive on speed boats to plunder the fishing grounds of the local fishermen. Armed with oxygen tanks, harpoons, and lamps, they can clear out an entire submarine mountain in a single night. The sea life is attracted to the light, which means that a single boat can quickly capture between 30 to 40 large fish before disappearing once again into the darkness. This method of fishing is highly illegal, but at the same time it is brutally effective and all too tempting given the economically strained situation.

These are not easy conditions for the fishermen of Aegina. Nevertheless, Stavros looks forward to his daily outings, because his true vocation is and will always remain his work at sea.

"YOU ARE BORN A FISHERMAN," ANNOUNCES THE GREEK PROUDLY. "MASTERING THE CRAFT, STEERING A BOAT—THESE ARE ALL THINGS THAT YOU CAN LEARN, BUT YOU CAN'T MAKE A GOOD CATCH WITH THESE SKILLS. IT IS JUST AS IMPORTANT TO DEVELOP AN INSTINCT FOR THE SEA SO YOU CAN FIND THE FISH— AND CATCH THEM."

Thanks to his skill and his familiarity with the area, even in these difficult times Stavros does not return to shore empty-handed. Today he has a few rays, gilthead bream, and some of his beloved squid in tow. Later he sells most of them to the villagers. Only the squid does he immediately set aside: He will take them home himself and fry them up that same evening.

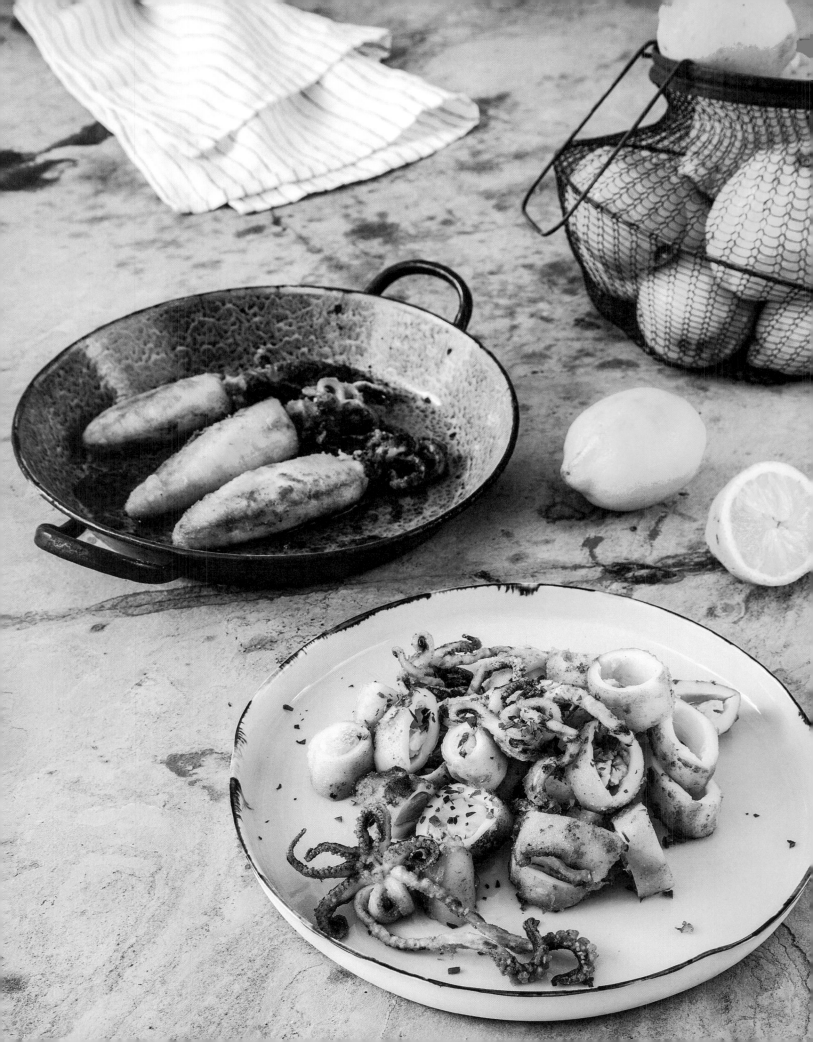

Stavros' Calamari

Once you've sampled Stravros' calamari, you'll wonder how anyone could ever sink so low as to think that frozen calamari rings with various types of mayonnaise sauce is good.

Serves 4

1¾ lb (800 g)	medium-sized squid
	Flour
	Olive oil
2	lemons
	White bread

Preparation

Clean the calamari, coat in flour, and fry in an ample amount of olive oil over high heat for about 4 minutes until golden brown on both sides.

Afterwards, cut into bite-sized pieces, squeeze the lemons over them, add a bit of the juices from the pan, and mix well.

Don't forget: Use a piece of white bread to soak up the delicious juices in your plate!

Kakavia Fish Soup

Kakavia is a traditional soup made by Greek fishermen at sea. In the past, boats did not have refrigerators on board, so the list of ingredients had to be kept simple.

Serves 4

1 cup	olive oil
3½ cups (800 ml)	water
1–2	onions depending on the size, quartered
	Salt, pepper
2¼ lb (1 kg)	cleaned fish
1	lemon

Preparation

Add the oil, water, quartered onions, salt, and pepper to a pot. Bring to a boil and then simmer for 5 minutes. Add the fish and then simmer for another 10 minutes over low heat.

Remove the pot from the stove, then add the juice from the squeezed lemon and let stand for 5 minutes—done!

Tip: Kakavia is prepared in a variety of ways in Greece. Stavros' recipe is the puristic, original version. Depending on what is available, feel free to create your own variations of this fish soup to suit your taste by adding seafood, tomatoes, garlic, carrots, or chopped parsley.

SENAD HADŽIHALILOVIĆ
Biograd, Croatia

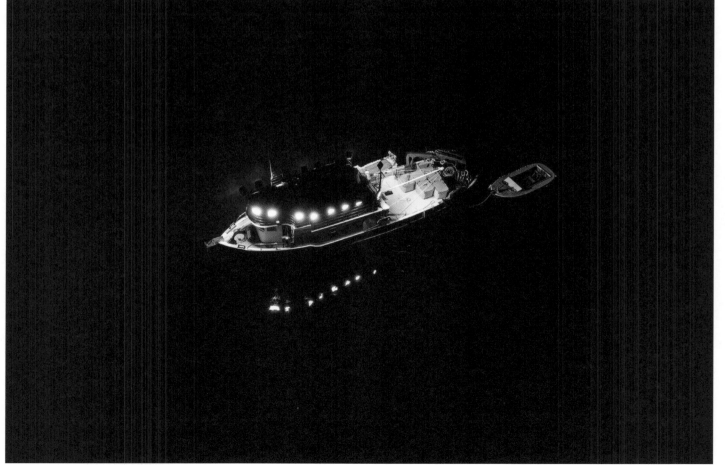

The darkness of night descends over the deep blue Adriatic as the *Mormora* zigzags through water that is as smooth as glass. Part of the crew is already asleep below deck, but Captain Senad Hadžihalilović is still wide awake on the bridge, gazing intently at all his many monitors. He continues to change course suddenly, over and over again. Using sonar and a depth finder, he is looking specifically for a large school of sardines so he can anchor overhead and use the boat's spotlights to attract even more fish. The brawny sailor shoulders a tremendous amount of responsibility: He alone decides where to fish. His entire crew works on commission.

Along with an entire fleet of fishing boats, Senad set sail in the evening from Biograd. Nearly all the other boats have already found their spot for the night and anchored. One ship after another turns on its spotlights. Seen from aboard the *Mormora,* they look like a string of fairy lights shining in the distance. It is a beautiful sight that only spurs on the restless Senad. Once again, he changes direction and steers the boat to the west. And yet even here the large school remains elusive. At some point he simply has to settle for what he can find. He drops anchor to the ocean floor 260 feet (80 meters) below, and on board the *Mormora* the spotlights are switched on as well. All around the boat, spotlights as bright as day illuminate the glistening water. Senad is now finally able to retire to his berth as well. The youngest sailor, still somewhat sleepy, takes over the night watch.

AT FOUR O'CLOCK IN THE MORNING, THE SHIP'S BELL JOLTS EVERYONE OUT OF THEIR SLEEP. NUMEROUS FISH FLASH IN THE BRIGHT WATER.

Yet the sparkling surface reveals little about the total number of fish that may be underneath the boat. After his first glance at the sonar, the captain remains skeptical at first. Nevertheless, it is time to get to work. Two men climb into the dinghy equipped with spotlights. While they slowly row away, Senad switches off the lights on the *Mormora* and shuts down the machines. Suddenly it is completely dark on board. The crucial moment of today's trip is upon them. On the pitch-black deck, the cigarettes of the concentrated crew glow, moving up and down every second. It is so quiet, that you can almost hear the soft crackling of the red embers.

Then everything starts happening very quickly. The crew members rowing the dinghy give the go-ahead. The second dinghy heads out at full throttle, engine roaring, dragging the huge net behind. It drives in a large circle around the small rowboat to close the trap. Every second is precious, because a steel cable has to be used to draw shut this loophole, similar to a funnel, to prevent the fish from escaping downwards. The catch is finally in the net and the hectic pace is over. For the crew, however, the most strenuous part of the work is about to begin. The net is slowly pulled together and brought on board using a crane winch. Four men stand under the dripping wet crane to ensure that the meshes of the net, which weigh tons, collapse properly. As the net circle with the yellow buoys closes ever tighter, the fish become increasingly panicked and search in vain for an escape route, almost making the surface of the water boil with their efforts.

Only now will it become clear whether the yield is large enough: An oversized bucket is used to hoist the shimmering silver fish onto the deck. The captain is responsible for bringing the catch safely on board. Senad confidently handles the bucket while also directing the distribution of the masses of fish.

In the light of the rising sun, the huge tubs fill with several tons of sardines and anchovies—an average result which makes itself clearly evident in the atmosphere on board. Now it all depends on the current price in the harbor. While the crew starts sorting the fish, Senad is already on the phone with the fish dealers on shore. Halfway back to the coast, they receive a relieving message: A tuna farm will buy the entire catch for a top price, giving the *Mormora* a successful night after all.

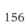

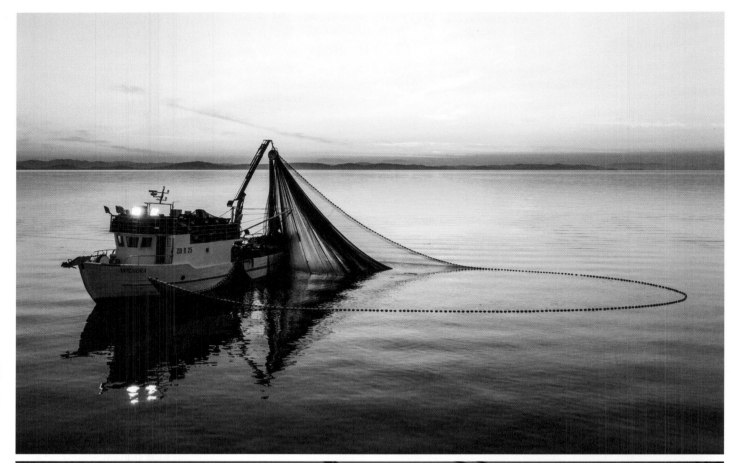

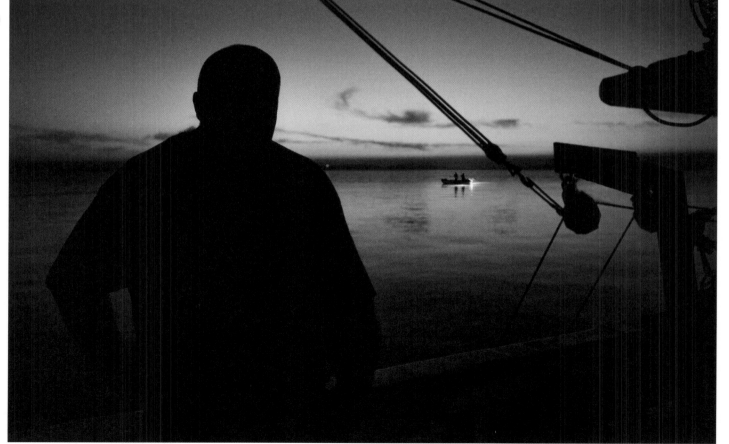

SUDDENLY IT IS COMPLETELY DARK ON BOARD. THE CRUCIAL MOMENT OF TODAY'S TRIP IS UPON THEM.

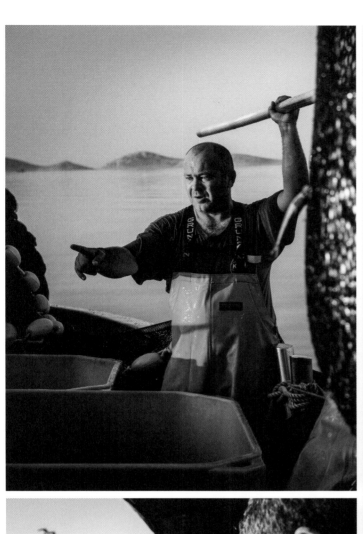
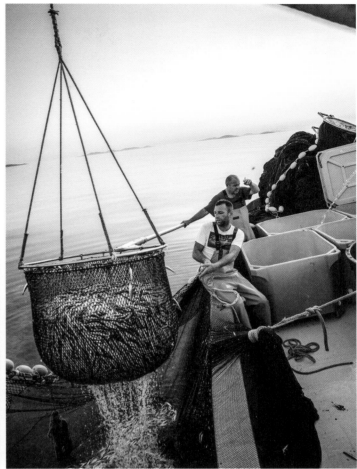

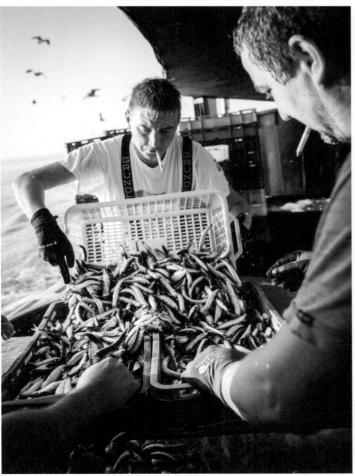
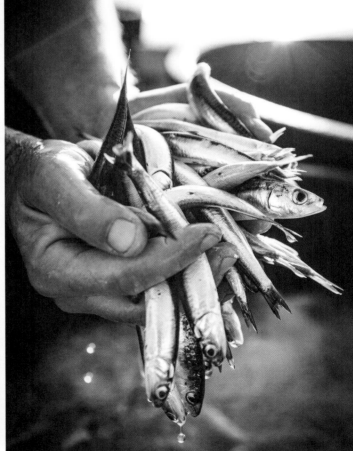

CROATIAN FISHERMAN'S BREAKFAST

When the crew from the Mormora returns to harbor after a strenuous night, the first thing on the agenda is a hearty meal. Freshly caught, of course!

SERVES 4

2¼ lb (1 kg)	potatoes, peeled
	Salt
6	cloves of garlic, minced
	Oil
1 tsp	parsley, chopped
2	onions, diced
2¼ lb (1 kg)	anchovies
	Pepper
	Ajvar

PREPARATION

Cook the potatoes in salted water for about 20 minutes. Next, sauté two cloves of garlic in some oil, then mash with the cooked potatoes, the parsley, and a pinch of salt to form a puree.

Fry the onions in some oil in a pot, then add the remaining garlic and continue to sauté briefly before adding the whole fish to the pot. Fill the pot with water until the fish are just covered. Season with pepper and simmer over low heat for 4 to 5 minutes.

Drain the water and serve the fish, onions, and garlic along with the mashed potatoes and Ajvar.

GRILLED FISH

Pure pleasure from the Adriatic: A fresh fish doesn't need many ingredients to taste delicious.

SERVES 4

1	whole sea bass (about 2¼ lb/1 kg) or other fish of your choice, cleaned
	Cooking twine
1	small bunch each of parsley, thyme, and rosemary
	Olive oil
	Juice from 1 lemon
	Coarse salt

PREPARATION

Wash the fish and pat dry. Using a piece of the cooking twine, tie some of the herbs together to form a small brush. Finely chop the remaining herbs and mix with the olive oil and lemon juice.

Using the herbal brush, apply the herbed oil to both the inside and outside of the fish. Grill the fish over medium heat for about 5 minutes per side until brown and crispy, taking care to sprinkle with coarse salt and brush with the herbed oil each time you turn it.

ABOUT THE INGREDIENTS:
A grill basket is ideal for **grilling fish** because it makes it very easy to flip them. The cooking time varies depending on the thickness of the fish. The back fin is a good indicator: If you can pull it off easily, the fish is done. With large fish, do not forget the head—it has some of the best pieces.

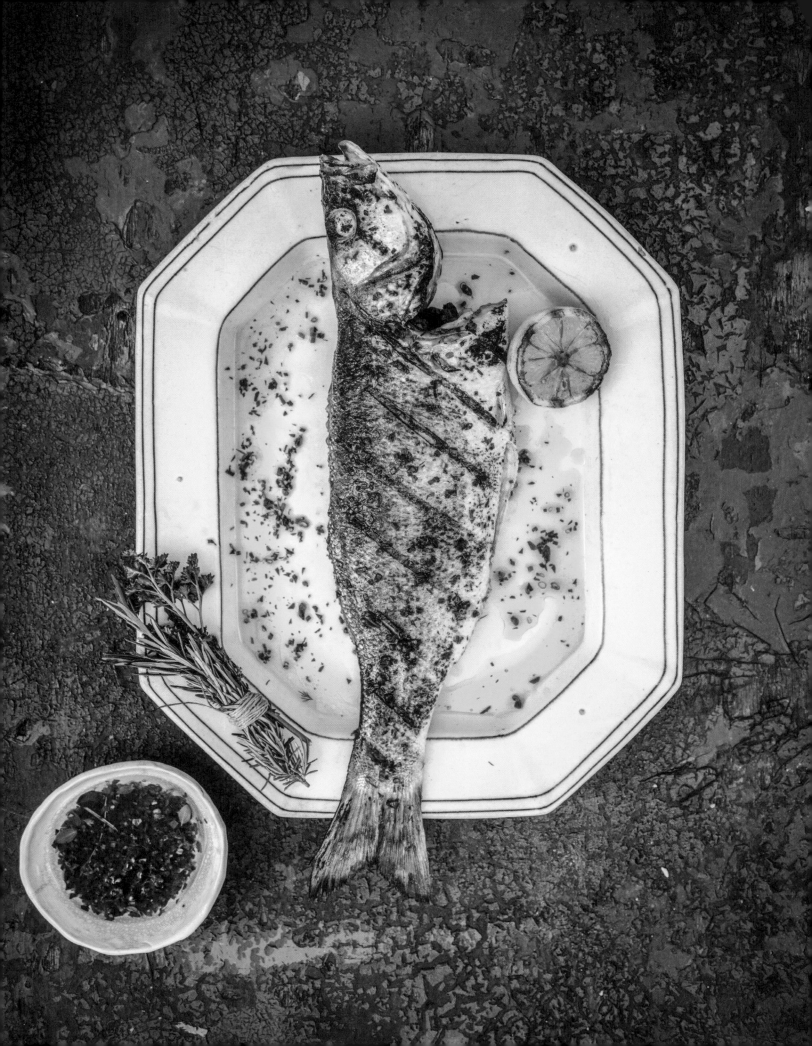

Massimo Tagliopietro

Burano, Italy

In the early morning hours, an idyllic tranquility reigns on the colorful island situated in the northern part of the Venetian lagoon. Only the fishermen and seagulls are awake as nighttime slowly draws to a close. Massimo Tagliopietro considers this to be the most beautiful time of day. He always gets up a bit early so he can start off the morning with a cigarette and espresso outside his front door. As he climbs into his boat and heads toward the lagoon accompanied by the quiet hum of the four-stroke engine, the sky brightens and the island city slowly comes to life.

Burano has changed dramatically in recent years, and mass tourism is becoming increasingly noticeable here as well. For a long time, the small fishing island remained largely undiscovered in the shadow of its famous neighbors. Yet in the age of the Internet, the number of visitors is now steadily growing. Every day hordes of tourists from nearby Venice come to explore and photograph the picturesque and colorful houses along the narrow streets and alleyways. Armed with selfie sticks and the latest camera technology, they line the banks of the narrow canals in the heart of Burano. People pose everywhere until they manage to get the shot they want—and sometimes that can take quite some time. While the day-trippers stand in a line on the most beautiful bridges for a souvenir photo, unimpressed locals glide by in their boats underneath on their way to work.

MOST FISHERMEN IN BURANO NOW EARN THEIR LIVING BY CULTIVATING CLAMS. IT IS PROFITABLE WORK AND PROVIDES THEM WITH A REGULAR WORK DAY, EVEN IF CLAMMING HAS MORE IN COMMON WITH HARVESTING THAN FISHING.

Clamming doesn't interest Massimo in the least. He follows the rhythm of nature. After all, he is intimately familiar with every nook and cranny of the lagoon and knows precisely where he needs to fish during each season of the year. Due to the shallow depth, the water temperature can vary significantly depending on the season, and the inhabitants of the underwater world change along with it. The charismatic fisherman is happy to see a tremendously high level of biodiversity throughout the year. The Italian has been studying the migratory behavior of fish since his childhood. He is well-versed in a wide variety of fishing methods and has an extensive collection of traps, nets, and hook lines. He always tailors his choice of fishing gear and location to match each season as well as the type of fish.

Today he will be fishing in the shallow waters along the shore close to the open sea. The lagoons along the Italian coast serve as a nursery for the fish of the Adriatic, and at the moment a large number of juvenile fish populate the supposedly safe areas close to shore. Apart from traditional fishing, aquaculture also enjoys a long tradition here. Massimo catches a few small fish specimens every spring to sell to the fish farms on the neighboring island.

For this he often works with a colleague. They gently pull a small, fine-meshed net through the knee-deep water to round up the nimble, sparkling fry. Once they have collected a manageable school in front of the net, they bring the ends of the net together to trap the fish. Afterwards, they simply have to sort them. Although the tiny fry all look the same to a layman, Massimo has an experienced eye and rapidly sorts them into different buckets. This time there are quite a few mullets as well as a good number of gilthead bream—just as Massimo likes it. Not only are they extremely valuable, but when mature they are his personal favorites when it comes to fish.

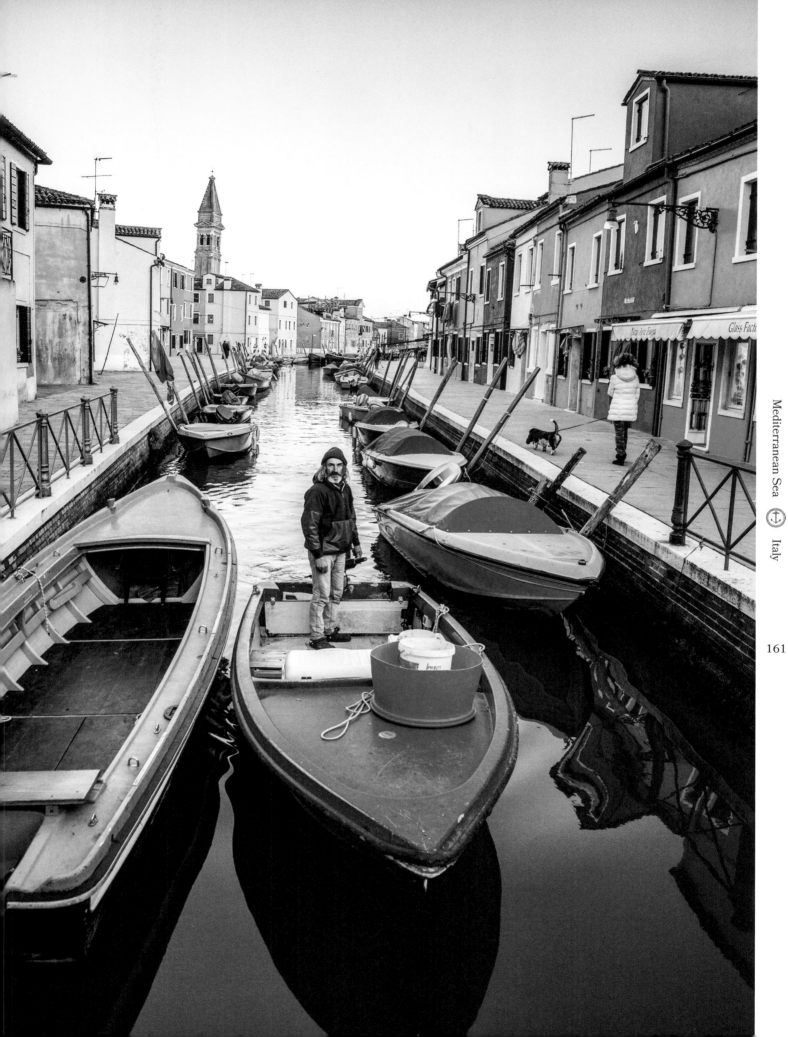

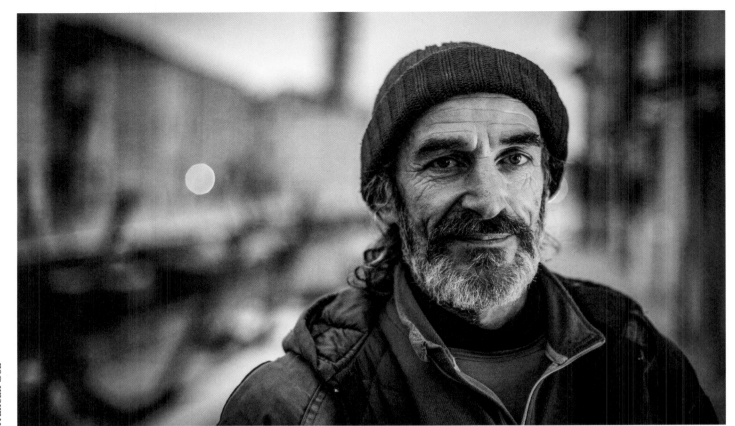

162

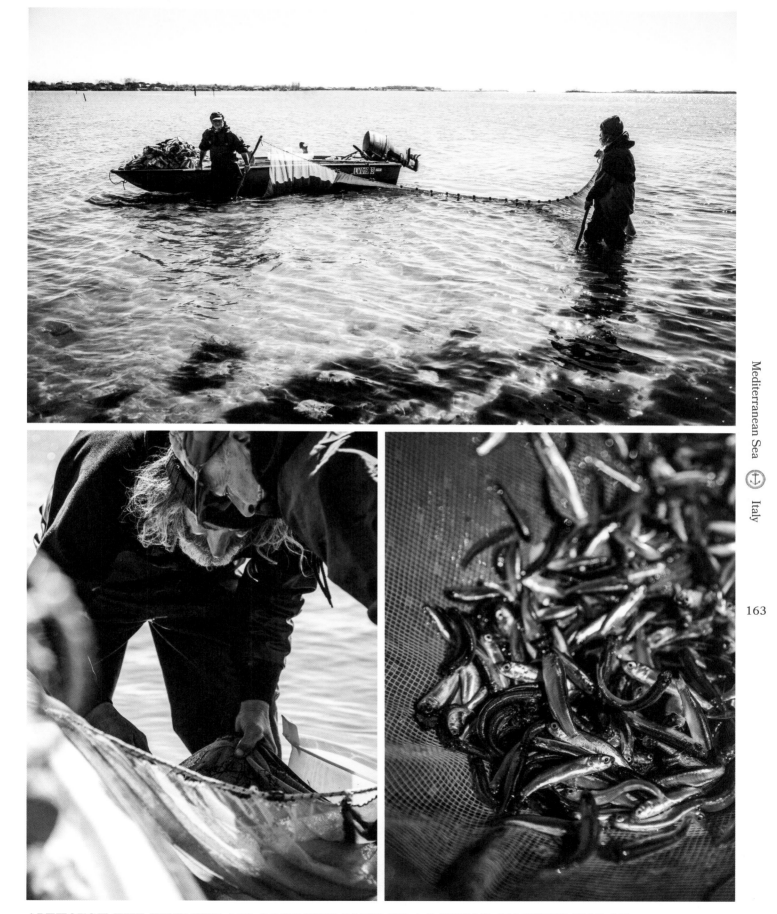

ALTHOUGH THE TINY FRY ALL LOOK THE SAME TO A LAYMAN, MASSIMO HAS AN EXPERIENCED EYE AND RAPIDLY SORTS THEM INTO DIFFERENT BUCKETS.

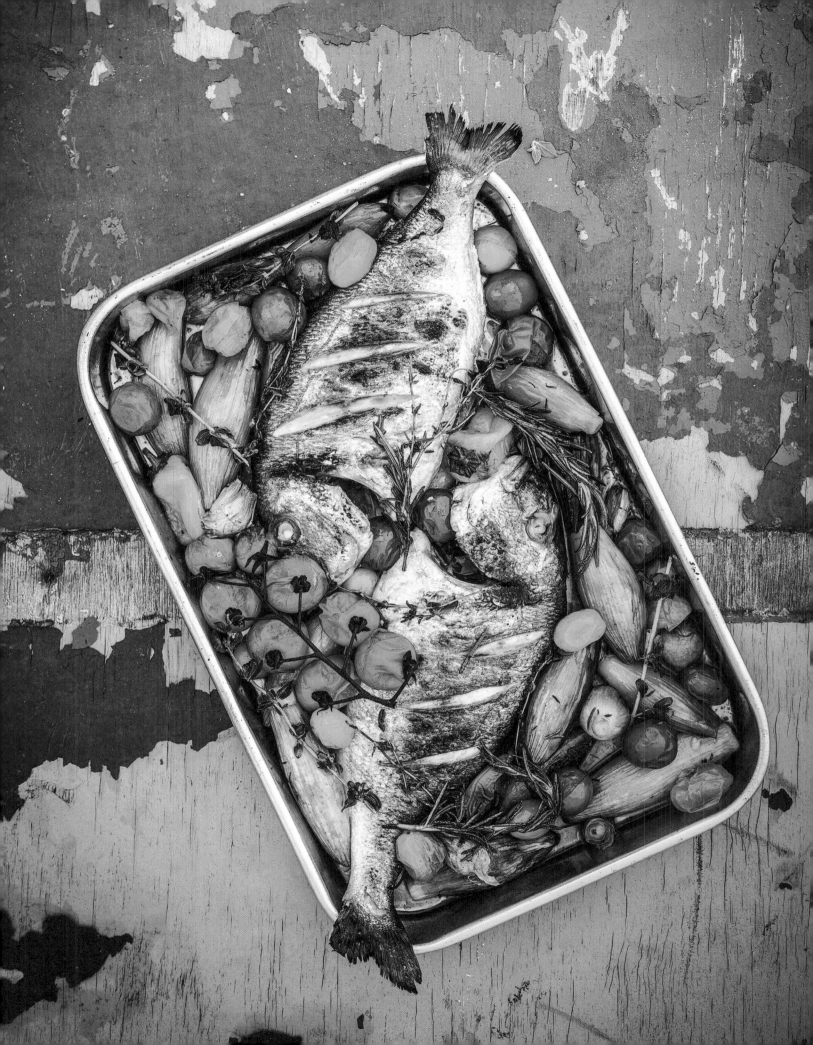

Oven-baked Gilthead Bream with Vegetables

Massimo is not just enthusiastic about catching all kinds of marine life, he also loves to eat them. When it comes to fish, gilthead bream with its particularly tender meat is his favorite.

Serves 4

4	kitchen-ready gilthead bream (gutted, scaled, cleaned)
	Salt, pepper
	Thyme
	Rosemary
	Oregano
1	lemon, sliced
	Olive oil
4	cloves of garlic
1 lb (500 g)	cherry tomatoes
10 oz (300 g)	shallots, peeled and cut in half
1	loaf of ciabatta bread

Preparation

Season the fish with salt and pepper, then stuff each with the herbs (preferably fresh) and one slice of lemon.

In a large, ovenproof pan, briefly brown the fish on both sides in some olive oil. Add the garlic, cherry tomatoes, and shallot halves to the pan, then place in a preheated oven (350°F/180°C) and bake until done, about 15 to 20 minutes.

Set the pan on the table. Serve a portion of fish on each plate. Everyone can help themselves to the vegetables and dip their bread into the delicious broth in the pan.

Spaghetti Vongole

One of the classics from the lagoon. Feel free to vary this recipe however you like by using other mussels or mollusks, or even crustaceans. Various vegetables, such as zucchini or green asparagus, also go nicely with this dish.

Serves 4

14 oz (400 g)	spaghetti
	Salt
2¼ lb (1 kg)	fresh clams
	Olive oil
1	dried peperoncino, finely chopped
4	cloves of garlic, minced
1	small bunch of chopped parsley leaves
1	handful of cherry tomatoes, quartered
7 oz (200 ml)	dry white wine
	Freshly ground pepper
	Bread

Preparation

Cook the pasta in plenty of salted water until al dente.

Check the clams and sort out any that have already opened. Thoroughly wash the remaining clams.

Add plenty of olive oil to a large, deep pan and sauté the peperoncino, garlic, one third of the parsley leaves, and the tomatoes. Once the garlic has taken on a bit of color, add the clams and quickly pour in the white wine to deglaze the pan. Mix everything well, then put the lid on and simmer, stirring occasionally, to ensure that the clams are heated evenly. After 5 minutes, all the clams should have opened. Sort out any of the clams that remain firmly closed.

Drain the cooked pasta and add it directly to the pan. Add in a splash of olive oil and the remaining parsley and season with pepper. Mix everything thoroughly, then let it sit for a minute or two to allow the flavors to blend. Serve with some bread.

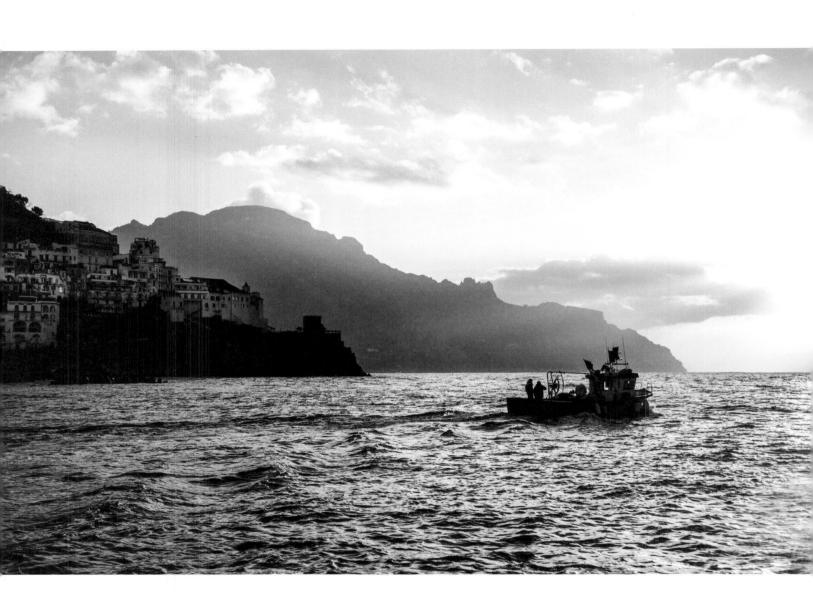

Mario & Valentino Esposito

Amalfi, Italy

With its steep, sun-kissed coastline, breathtakingly beautiful fishing villages, and fragrant lemon groves, the Amalfi Coast is a dream destination for many visitors and the absolute highlight of a trip along Italy's Mediterranean coast. Still, even though these lovely clichés are perfectly true, at the moment they have very little in common with Valentino and Mario Esposito's everyday experience. For days now, tremendous waves have been hammering the harbor wall in Amalfi, and before that a storm raged, with one downpour following hard on the heels of another. In the past week, the father and son had no opportunity to take out their fishing boat a single time. But yesterday they set their nets in heavy swells, and today they can finally bring in the catch and earn some money.

As the sky clears, the clouds at least seem to be cooperating, and the *Irsilia Maria* heads out into the Gulf of Salerno in a blaze of morning sunshine. The colorful ship was named after the women in the family, paying homage to the Esposito grandmothers, sisters, mothers, and wives. And yet the strong family bond is also apparent elsewhere, as a nearly identical ship owned by Valentino's brother is berthed at the next mooring. For the past 250 years, the Espositos have been fishing along the Amalfi coastline, whose steep cliffs form a dramatic backdrop, and the family has long been a fixture of the fishing community in the small port town. The previous day, they were the only ones to venture out onto the turbulent sea in their two bright yellow boats. All other vessels bobbed about on the swells, safely moored in the sheltered harbor. The Espositos are masters of their trade and know how to read the fickle moods of the sea.

Valentino and his brother have been fishing since they were children, and their knowledge of the marine world and its creatures was handed down to them from their father. Mario is carrying on the family tradition with pride and passion.

HE'S BEEN PART OF THE CREW EVER SINCE HE FINISHED SCHOOL AND IS NOW AN EXCELLENT FISHERMAN AND HELMSMAN. HE LOVES HIS JOB AND THE SENSE OF FREEDOM HE GETS WHILE OUT AT SEA. "THIS IS OUR FAMILY BUSINESS," THE AMALFI NATIVE REMARKS WITH PRIDE.

Unfortunately, the deep blue waters, once teeming with fish, now yield ever smaller catches, so, nowadays, when summer comes around, he changes boats and work attire: As the captain of a passenger ship, he transports tourists from one attraction to the next. These tourists are an easier catch and earn him a steadier income than does the uncertain fishing trade, as is once again apparent from today's events. After hauling his nets on board from a depth of 820 feet (250 meters) at a distance of two nautical miles out of town, Mario counts only a couple of hake, some gilthead bream, and one bright red perch. Nevertheless, the weather is showing signs of improvement and the forecasts for the next few days are entirely positive, so he immediately sets his fishing gear again with his father's assistance. Who knows, maybe he'll have better luck the next morning.

Back in port, someone is waiting for the Espositos: Meowing loudly, the harbor cat prowls the jetty while the two men immediately carry their catch to the local fishmonger, where they deliver the precious bounty they have hauled up from the depths of the Tyrrhenian Sea and exchange it for hard cash. The father and son are not going to get rich today, but at least the weather-induced break in their work routine is finally over. They stop to grab a quick espresso in their favorite bar next door before heading home to their family—just as it should be.

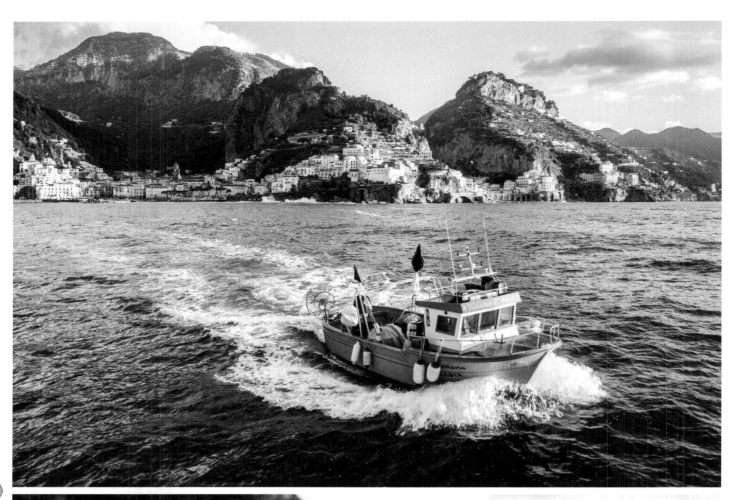

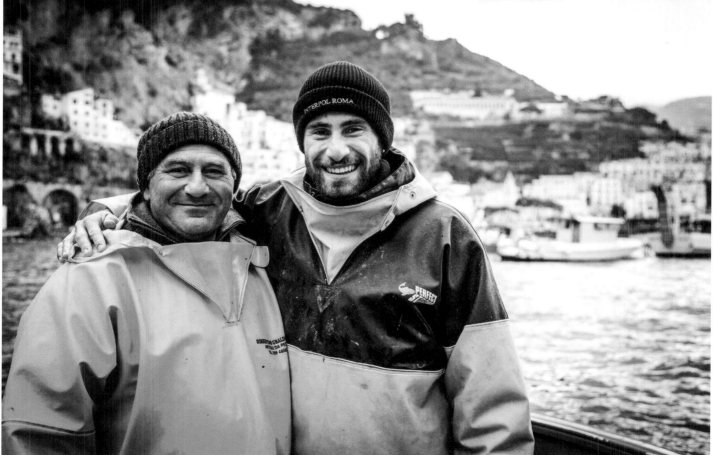

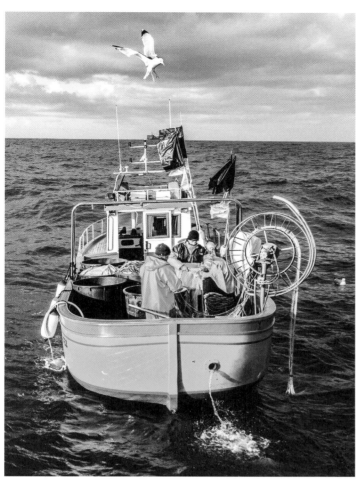

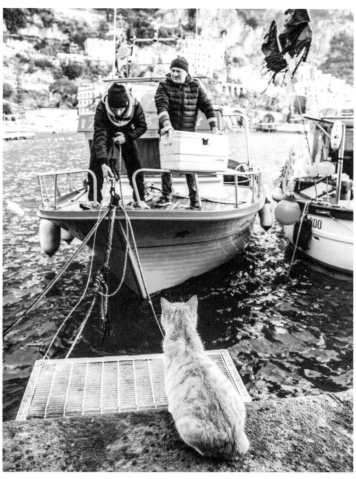

AFTER HAULING HIS NETS ON BOARD FROM A DEPTH OF 820 FEET (250 METERS) AT A
DISTANCE OF TWO NAUTICAL MILES OUT OF TOWN, MARIO COUNTS ONLY A COUPLE OF HAKE,
SOME GILTHEAD BREAM, AND ONE BRIGHT RED PERCH.

169

PASTA DONNA CLELIA

An aromatic winter dish from the Amalfi coast: Local walnuts, a few anchovies pickled last summer—even in periods of scarcity, it was always possible to find the basic ingredients for this dish.

SERVES 4

17 oz (500 g)	spaghetti
	Salt
¼ lb (100 g)	shelled walnuts, coarsely chopped
2	cloves of garlic, minced
1	peperoncino, finely chopped
	Olive oil
10	pickled anchovy fillets, coarsely chopped
	Pepper
	Parmesan cheese, to taste

PREPARATION

Cook the pasta in salted water until al dente. Sauté the walnuts, garlic, and peperoncino in olive oil, then add the anchovies and two or three tablespoons of pasta water to the pan.

After draining the pasta, add it to the sauce and season to taste with salt and pepper. Stir the pasta in the pan for about two minutes over medium heat.

Enjoy as you like, with or without parmesan cheese.

NEAPOLITAN CALAMARI STEW

A hearty Mediterranean stew that is quick and easy to prepare. When you come home hungry from the sea, this stew really hits the spot.

SERVES 4

2¼ lb (1 kg)	potatoes
1¾ lb (800 g)	small squid, cleaned
	Olive oil
2	cloves of garlic, thinly sliced
1	can of peeled tomatoes
	Salt
	Peperoncini

PREPARATION

Cut the potatoes into small cubes and fry in a pan.

In a second pan, sear the squid in some olive oil, add the garlic and sauté briefly, then pour the peeled tomatoes into the pan. Season to taste with salt and peperoncini. Add the fried potatoes, then simmer for another 5 minutes over medium heat.

Tip: If you like, feel free to add a handful of chopped parsley to the tomato sauce while cooking.

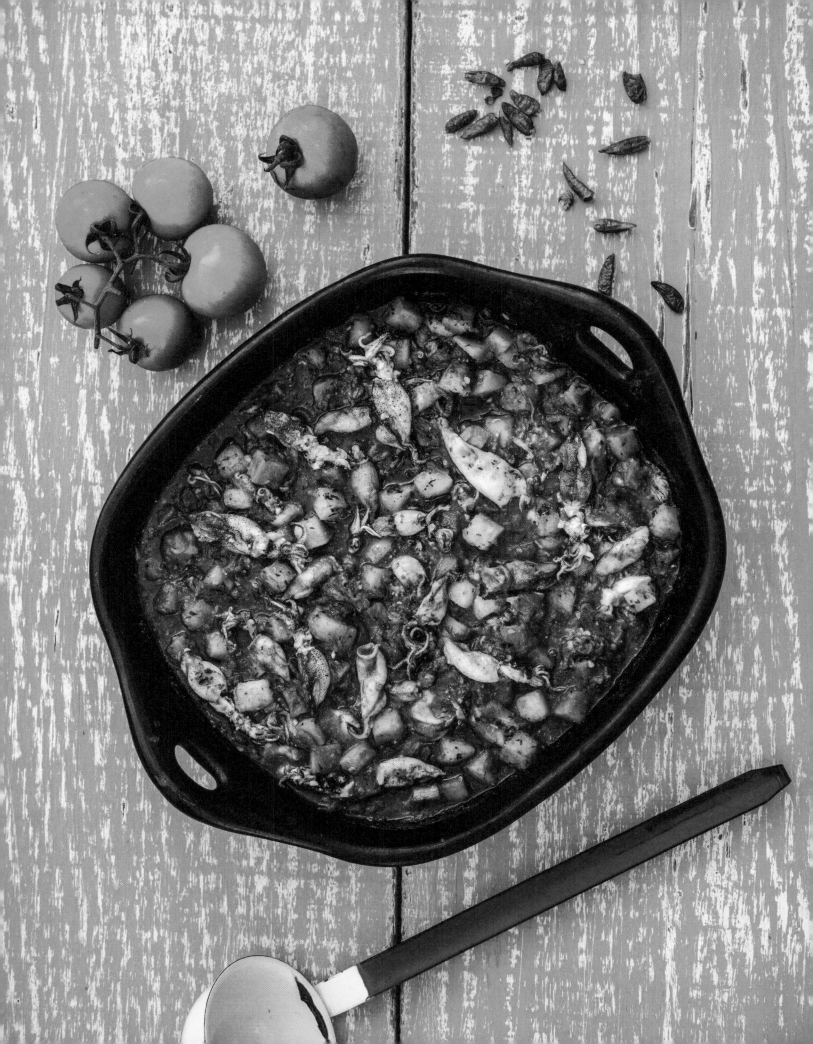

ANGÉLIQUE COLFORT

Cavalaire, France

Angélique Colfort loves the ocean. Although the woman with the haunting gaze grew up in northern France far from the sea, she felt herself drawn to the shore at a young age. Since the first time she took her first breath of salty sea air during a family vacation, she has been filled with a yearning for the deep blue of the sea. Right after completing school, she moved to the Mediterranean. After working as a professional diver and as a deckhand on passenger ships, she found her dream job in fishing. Seven years ago, she bought a wooden boat from an old fisherman, and today the traditional vessel is her livelihood. She has lovingly restored the over-sixty-year-old boat and installed a new motor. The name *Finistère* is the only thing she has not changed. After all, it's a part of the boat. "You can't just suddenly start referring to Pierre as Pascal," remarks the Frenchwoman.

As on most days, she and her trusty companion leave the harbor bright and early to gather in her nets in the picturesque bay of Cavalaire. She has already emptied the first two nets before the sun rises. The fact that the nets are only moderately full does not dampen Angélique's mood. "This is reward enough," she says as rays of sunshine illuminate the purple clouds in the east. Given that the past few days have been windy and cold, she appreciates the gentle waves of the Côte d'Azur and the week's first warming rays of sunshine that much more.

Angélique is a female fisherman through and through. She enjoys her independence as much as she does the constant variety: "Pulling the net on board and seeing what treasures the ocean holds is exciting every time." Even on vacation she searches out local colleagues and goes out fishing with them. Fishermen in other countries are always happy to meet kindred spirits, and a female fisherman is naturally a special highlight. Sometimes the men can scarcely believe that a woman goes out to sea, and Angélique has to show them photos on her cell phone to convince the last doubters.

Even in her home port it has not always been easy as a woman among sea wolves, but she is now respected by most and even admired to a degree by some. This is due in part to her courage and her determination, because she started fishing during difficult times.

IN THE MEDITERRANEAN, MANY FISH POPULATIONS ARE CONSIDERED TO BE OVERFISHED, AND IT IS BECOMING INCREASINGLY DIFFICULT TO EARN MONEY AT LARGE FISH MARKETS WITH SMALL BOATS.

But the fishermen of Cavalaire have found a solution: For some years now, they have stopped selling their catch to dealers and have been selling it themselves instead. They have set up a small sales stand right next to the jetty where customers now wait for them every morning.

The quality of the freshly caught seafood is far better than what is found at the fish counters in the supermarket even though the variety is limited. The early bird gets the worm... and can purchase whatever the sea has yielded on that particular day. Angélique enjoys the bustling atmosphere after her early start to the day. Many customers are regulars. They know each other, and there's always time for a short chat or culinary advice while Angélique cleans the fish. Angélique loves to cook, so she regularly shares the best fish recipes with her customers.

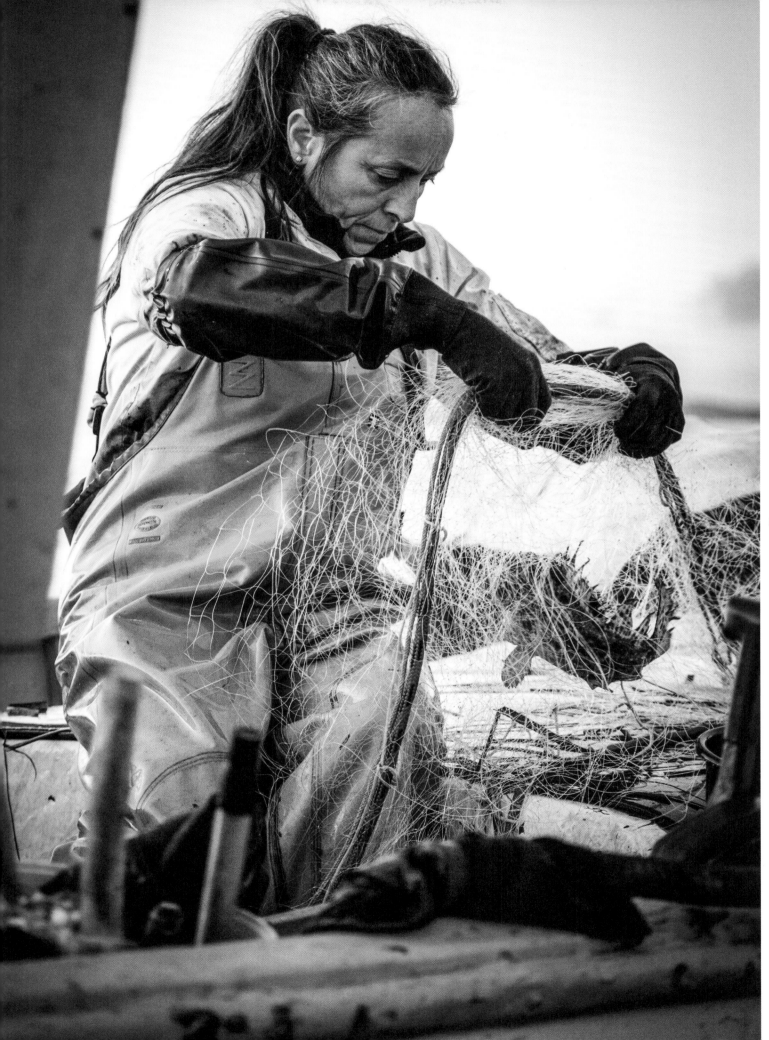

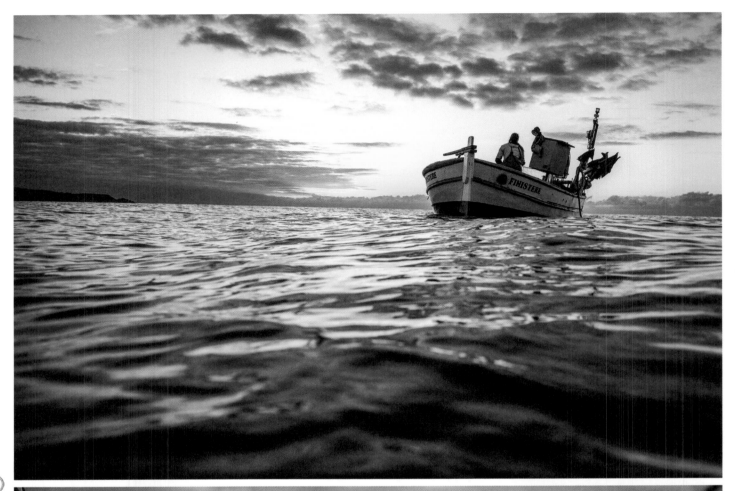

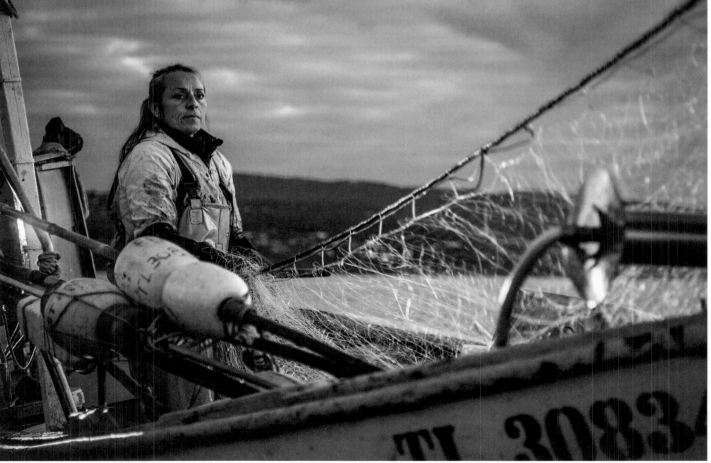

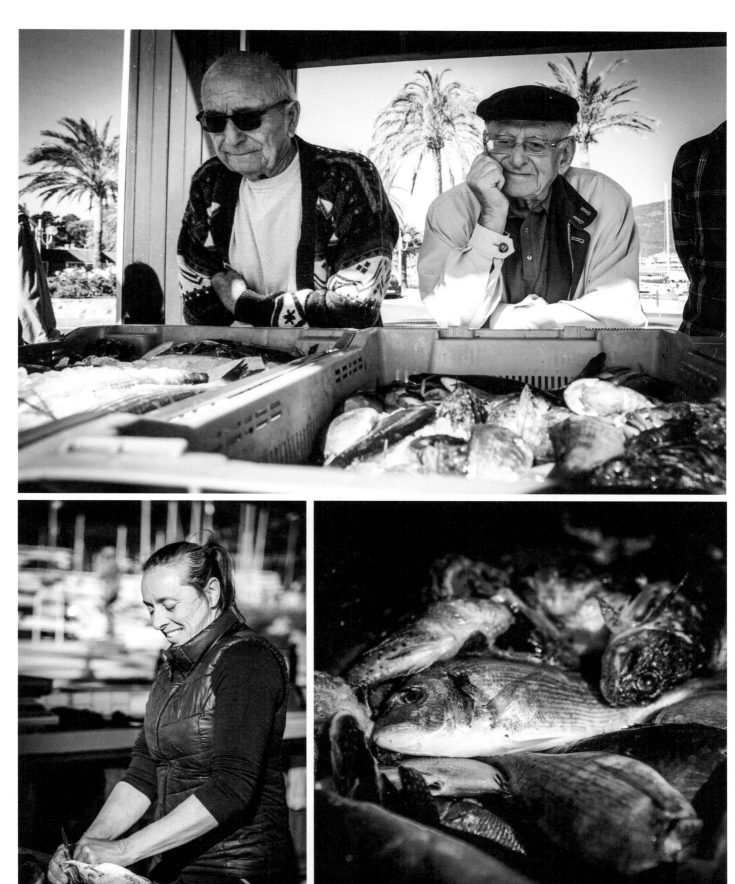

ANGÉLIQUE LOVES TO COOK, SO SHE REGULARLY SHARES THE BEST FISH RECIPES
WITH HER CUSTOMERS.

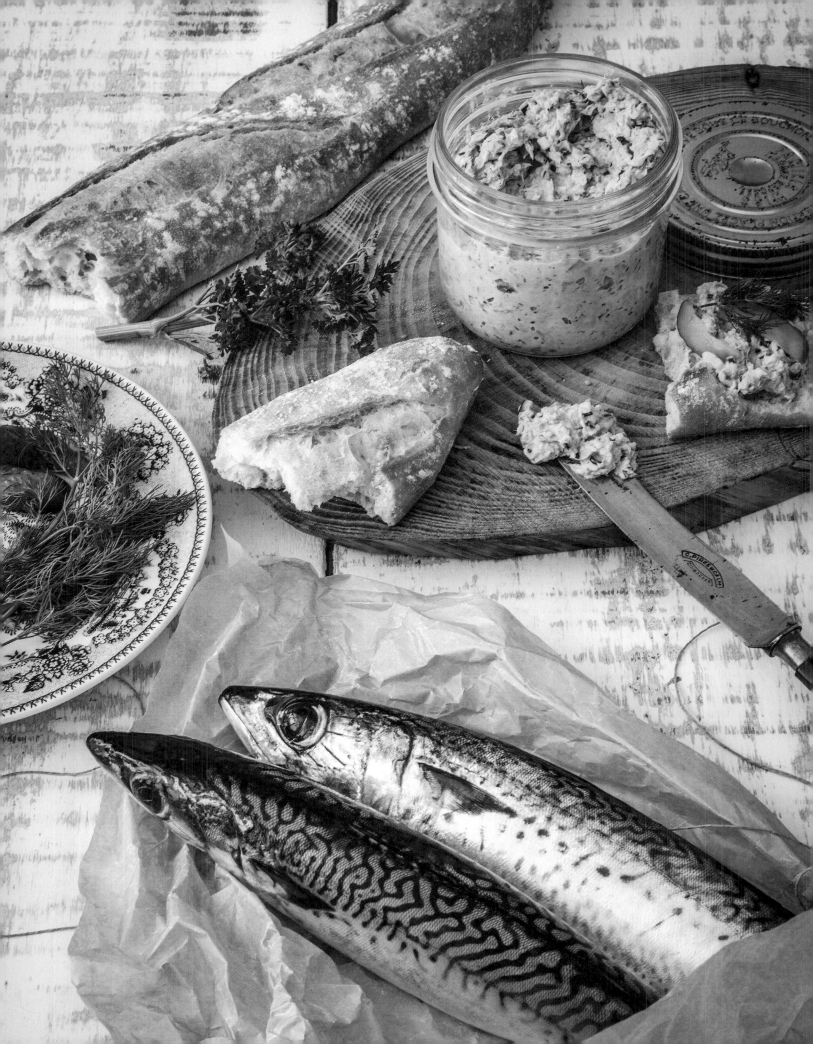

Mackerel Rillettes

Best if prepared 1 to 2 days in advance.

SERVES 4

2	large, whole mackerel (about 2¼ lb/1 kg)
	Olive oil
About 10	black peppercorns
1	bay leaf
1–2	sprigs of tarragon
3½ oz (100 g)	gherkins
3½ oz (100 g)	zucchini
3½ oz (100 g)	shallots
3½ oz (100 g)	yellow bell pepper
1¾ oz (50 g)	dried tomatoes
	Colorful pepper
2 Tbsp	mayonnaise
	Optionally dill, mint, parsley, or chives

PREPARATION

Clean the mackerel, then put the whole fish in a pot with water and some olive oil, the peppercorns, the bay leaf, and the sprigs of tarragon, then simmer for 10 minutes. Afterwards, remove the mackerel from the pot and set aside to cool. Pour the broth through a sieve and set aside about ½ cup of the strained broth. While the fish is simmering, cut the vegetables into a very small dice.

Once the mackerel are cool, remove the skin and use your fingers to remove all the flesh from the bones. Add to a large bowl along with the diced vegetables and mix with the ½ cup of reserved broth. Season the rillettes to taste with the colorful pepper (and some mild chili powder if desired), then cover and refrigerate overnight. The next day, mix the mayonnaise into the rillettes. Ideally refrigerate the rillettes for another 12 to 24 hours to allow the flavors to develop, then serve with a fresh baguette.

Depending on the season and personal preferences, feel free to add different herbs. In the summer, for example, Angélique always prepares her rillettes with a little fresh chopped mint, which gives the dish a summery, aromatic flavor.

Gilthead Bream Tartar

This is a simple, summery recipe that you can easily amend with additional ingredients, such as chili peppers, avocados, bell peppers, or celery.

SERVES 4

2	gilthead bream fillets, cut into a fine dice
3	green onions, finely chopped
1 tsp	chopped parsley
	Juice from 1 lemon
	Olive oil
	Salt, pepper

PREPARATION

Mix together all the ingredients in a bowl along with the lemon juice. Add a drizzle of olive oil and then season to taste with salt and pepper.

Chill the tartar for 15 minutes. This can be served as an appetizer or as a light main course. In the latter case, serve with a simple salad and a fresh baguette.

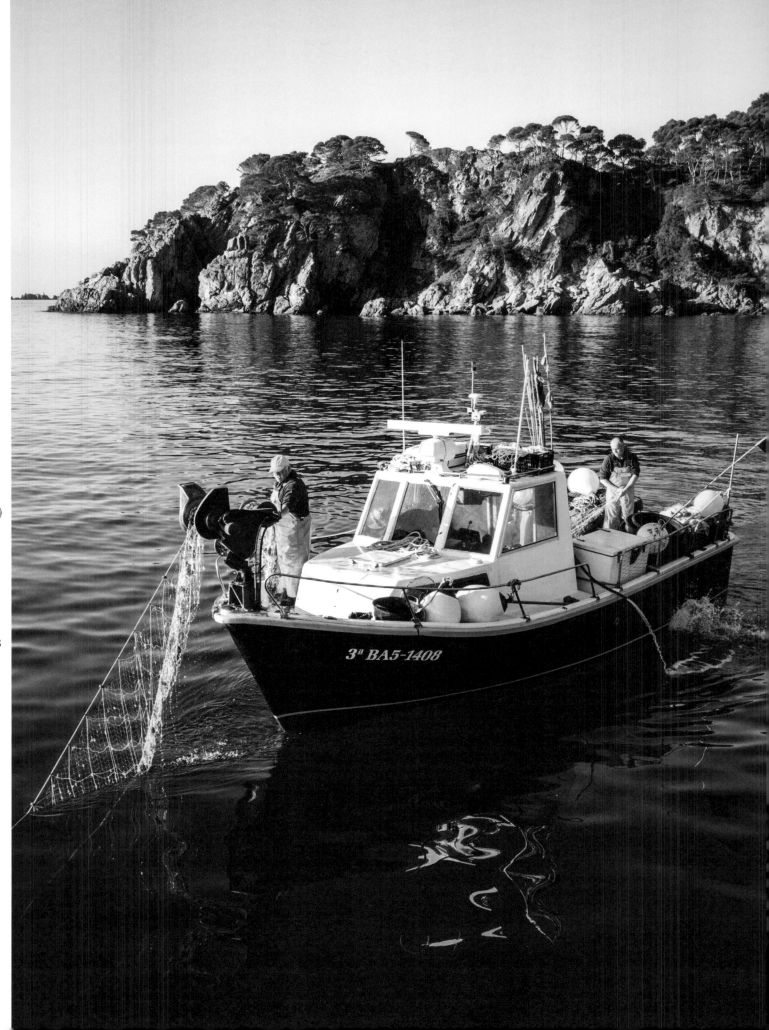

Jordi & Salvadore Besson Cassellas

Costa Brava, Spain

Costa Brava is one of the best fishing grounds along the Spanish Mediterranean coast. Great variations in the depth of the ocean floor and a continuous supply of minerals from the nearby French river deltas create vast biodiversity in this underwater world, so that fishermen can enjoy an excellent livelihood. Long before mass tourism turned the bucolic region into a world-famous vacation spot, most of the local residents made a good living from the sea and its precious aquatic creatures. Like many others, Jordi and Salvadore's family has subsisted on fishing for many generations, although the two men could soon be the last two fishermen in the Besson Cassellas clan.

The brothers have been going out to sea since a very young age, and they learned how to fish from their father long ago. This practice has now become a thing of the past. Fishing along the Spanish Mediterranean coast is strictly regulated. According to one regulation, only members of a fishing vessel's crew are allowed on board, which means that fishermen cannot take along any friends, tourists, or even their own children.

THE TIGHT NETWORK OF RULES AND DECLINING FISH STOCKS HAVE MADE IT HARDER TO TEACH THE NEXT GENERATION OF FISHERMEN THE ROPES OR GENERATE ANY ENTHUSIASM FOR A LIFE AT SEA, AND SO THE NUMBER OF SMALL FISHING BOATS OWNED BY COASTAL VILLAGERS IS SHRINKING ALL THE TIME.

"We are now the youngest fishermen along this stretch of coast," Jordi and Salvadore report with a regretful smile as they haul in the night's catch. The previous evening, they had cast their nets right off the picturesque rocky coast with its characteristic pine forests. The two brothers make an excellent team, and there is a decent amount of fish on this sunny morning, so they head back to port.

The *Tau* is currently moored in the Llafranc marina, but later in the summer it will find a berth in Tamariu Bay, right at the family's doorstep. In the modern marina, the fishing vessel stands out against the sailboats and yachts, and it also mirrors the social change that has come to Costa Brava. Very few locals can afford to buy their own homes anymore in the region's premium real estate market. Many houses have been turned into vacation rentals, and they are unoccupied most of the time. As a result, the number of year-round residents in the villages continues to decline, while the population explodes in high season. Once the tourists have arrived, there is sometimes too much activity even on the sea, although Jordi and Salvadore are still enjoying the quiet atmosphere of the off-season.

After loading their catch and cleaning the nets, the two Catalans set off to sell their fish. This part of their job has also gotten more complicated. The type and number of fish must be meticulously documented, and the catch can be sold only in nearby Palamós. This town has a famous fishing port with a great many large trawlers and an auction hall, where the traders are already waiting for the day's haul. It would certainly be more lucrative to sell to customers directly, especially in the summertime when all the tourists are around, but direct sales are also forbidden. Nor are the fishermen allowed to give away as much as a single fish, and they are even strictly limited to two pounds (one kilo) per person for their personal use. In the end, Jordi and Salvadore take only four fish home to their families. Nevertheless, these glistening gilthead bream, pandoras, and one brightly colored dentex are the finest specimens they have caught today.

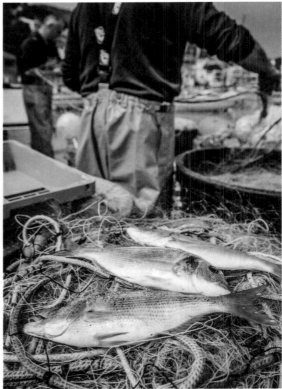

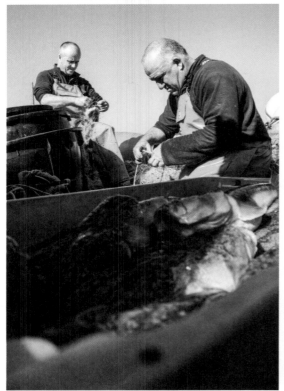

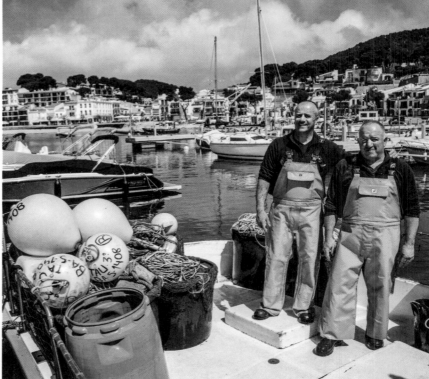

IN THE MODERN MARINA, THE FISHING VESSEL STANDS OUT AGAINST THE SAILBOATS
AND YACHTS, AND IT ALSO MIRRORS THE SOCIAL CHANGE THAT HAS COME TO
COSTA BRAVA.

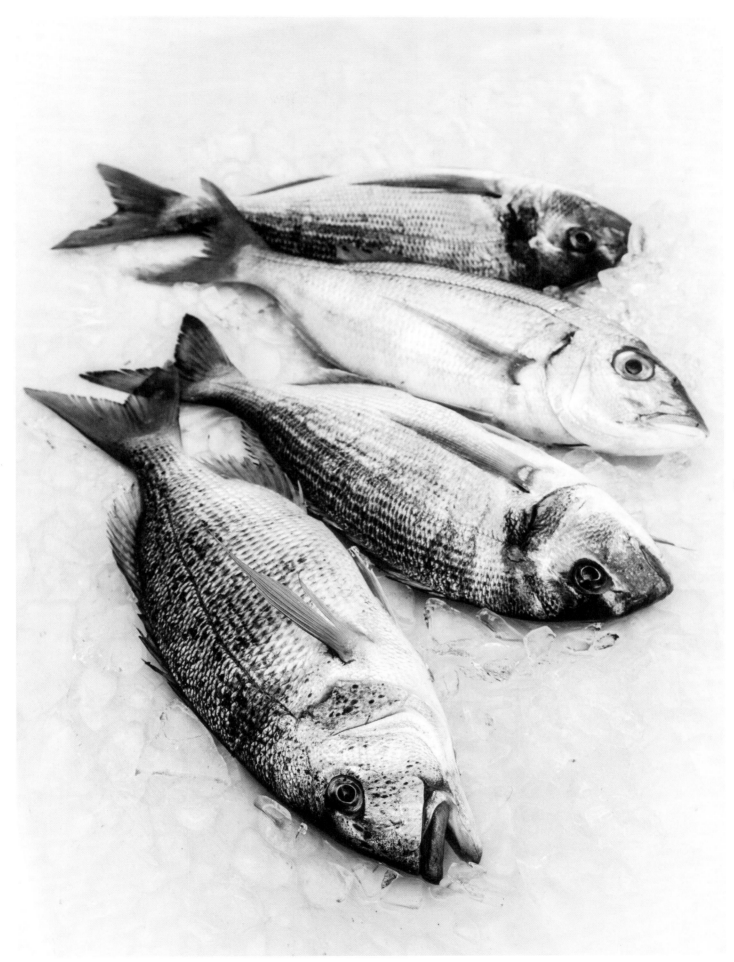

Gambas a la Plancha

When fishermen eat their prawns, they first remove and suck the head, then they suck the prawn (with the shell still on), and finally they remove the shell and eat the meat. The shell and the juices have most of the flavor.

Serves 4

	Olive oil
2¼ lb (1 kg)	raw whole prawns, with the head and shell
	Cloves of garlic, to taste
	Coarse sea salt
2	lemons

Preparation

Heat olive oil in the largest pan you have or on a plancha grill. Fry the prawns with a few slightly crushed cloves of garlic in the hot oil for 2 to 3 minutes per side.

After turning the prawns, sprinkle liberally with coarse sea salt. Shortly before they are done cooking, squeeze plenty of lemon juice over the prawns. Finally, give them a final toss in the pan.

Tip: Depending on the size of the pan, you may need to fry the prawns in several stages. Be sure to only ever fry one layer at a time to ensure that each prawn gets the full heat.

182

Catalan Fish Stew

"Suquet," the traditional stew of Catalan fishermen, is the basis for this dish. Feel free to vary your choice of fish and shellfish as you like, depending on what is fresh and seasonally available.

Serves 4

1	onion, chopped
14 oz (400 g)	potatoes, peeled and cut into generous 1 inch (3 cm) cubes
	Olive oil
4	cloves of garlic, minced
1	can of strained tomatoes
	Paprika powder (sweet)
	Salt, pepper
½ lb (250 g)	fish fillets, cut into bite-sized pieces
½ lb (250 g)	shellfish and mussels, your choice

Preparation

In a large, deep pan, sauté the chopped onion and potatoes in some olive oil. Add the garlic and sauté briefly before pouring in the strained tomatoes. Stir, then simmer for 10 minutes.

Pour in a cup of water and add a generous pinch of paprika. Use a hand blender to puree everything in the pot, then season to taste with salt and pepper.

Put the pot back on the stove, then add the fish and shellfish to the soup. Cover and simmer over low heat for about 4 minutes until the fish is done and the mussels have opened.

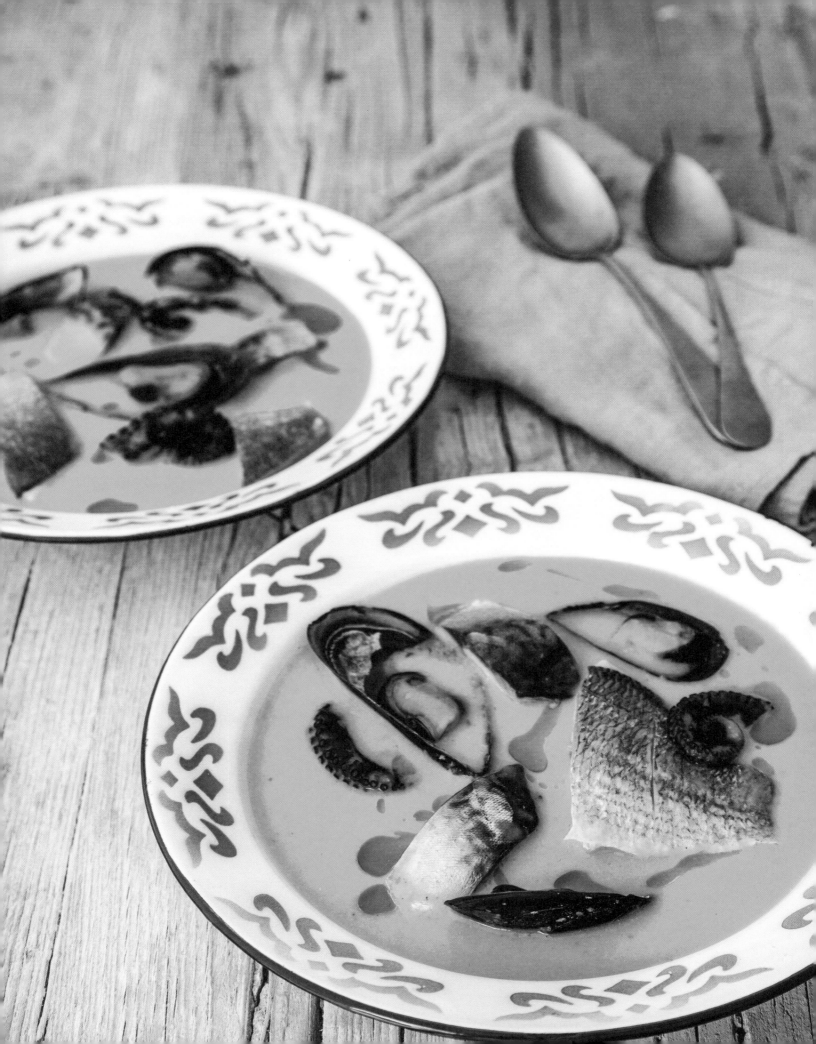

Index

A

Anchovies
- → Croatian Fisherman's Breakfast | 158
- → Pasta Donna Clelia | 170

Appetizers
- → Fried Whiting | 67
- → Gilthead Bream Tartar | 177
- → Irish Surf & Turf | 110
- → Mackerel Rillettes | 177
- → Matjes Herring Tartar | 15
- → Mullet Carpaccio | 144
- → Norway Lobster with Bacon | 33
- → Pickled Fried Herring | 52
- → Shrimp Croquettes | 20
- → Smoked Fish with Cream Cheese | 52

Arnfinnur's Fish Cakes | 81

Arugula
- → Fried Whiting | 67

B

Bacon
- → Norway Lobster with Bacon | 33

Baked Dishes
- → Oven-Baked Gilthead Bream with Vegetables | 165
- → Red Mullet | 87
- → Salmon au Gratin with Potatoes and Spinach | 40

Baked Sole with Buttered Potatoes and Broccoli | 15

Beef Steak
- → Irish Surf & Turf | 110

Beer
- → Fish & Chips | 116
- → Mullet Fillets with Beer Vanilla Sauce | 144

Beets
- → Labskaus | 27

Bismarck Herring
- → Labskaus | 27

Brown Crab
- → Crab Meat Sandwiches | 116
- → Irish Surf & Turf | 110

C

Catalan Fish Stew | 182
Cataplana | 128

Catfish
- → Storceag (Sturgeon Soup) | 72

Clams
- → Spaghetti Vongole | 165

Cod
- → Arnfinnur's Fish Cakes | 81
- → Faroese Fish Soup | 81
- → Fish & Chips | 116
- → Fiskefrikadeller | 40
- → Pannfisch with Potatoes | 92
- → Plokkfiskur | 92
- → Scottish Marinated Fish | 33

Crab Cakes with Aioli Dip | 104

Crab Claws
- → Irish Surf & Turf | 110

Crab Meat Sandwiches | 116
Creamy Fish Chowder | 110
Croatian Fisherman's Breakfast | 158
Cured Salmon | 46

Cuttlefish
- → Linguine with Cuttlefish in Ink | 139
- → Sepia à l'armoricaine | 87

D

Deep-Fried Fish
- → Fish & Chips | 116
- → Fried Whiting | 67
- → Fritto di Pesce | 139
- → Shrimp Croquettes | 20

E

Eggs
- → Crab Cakes with Aioli Dip | 104
- → Fried Herring with Young Potatoes | 58
- → Fried Whiting | 67
- → Labskaus | 27
- → North Sea Shrimp with Scrambled Eggs and Green Asparagus | 20
- → Pannfisch with Potatoes | 92
- → Shrimp Croquettes | 20
- → Storceag (Sturgeon Soup) | 72

F

Faroese Fish Soup | 81
Fish Stock | 46
Fish & Chips | 116
Fish Stew with Lemon and Tomato | 67
Fiskefrikadeller | 40
Fried Herring with Young Potatoes | 58
Fried Octopus
with Potato-Parsnip Puree | 122
Fried Whiting | 67
Fritto di Pesce | 139

G

Gambas a la Plancha | 182
Gilthead Bream
→ Oven-baked Gilthead Bream
with Vegetables | 165
→ Gilthead Bream Tartar | 177
Gilthead Bream Tartar | 177
Green Asparagus
→ Mackerel Pembrokeshire Style | 104
→ North Sea Shrimp
with Scrambled Eggs and Green Asparagus | 20
→ Spaghetti Vongole | 165
Grilled Fish | 158
Grilled Fish
→ Gambas a la Plancha | 182
→ Grilled Fish | 158
→ Grilled Herbed Herring with Polenta | 72
Grilled Herbed Herring with Polenta | 72

H

Halibut
→ Plokkfiskur | 92
Herring
→ Fried Herring with Young Potatoes | 58
→ Grilled Herbed Herring with Polenta | 72
→ Labskaus | 27
→ Matjes Herring Tartar | 15
→ Smoked Fish with Cream Cheese | 52
→ Pickled Fried Herring | 52
→ Scottish Marinated Fish | 33

I

Irish Surf & Turf | 110

J

Jack Crevale
→ Sardinhas Alimadas | 128

K

Kakavia Fish Soup | 151

L

Labskaus | 27
Lamb
→ Arnfinnur's Fish Cakes | 81
Linguine with Cuttlefish in Ink | 139

M

Mackerel
→ Mackerel Pembrokeshire Style | 104
→ Mackerel Rillettes | 177
→ Scottish Marinated Fish | 33
Mackerel Pembrokeshire Style | 104
Mackerel Rillettes | 177
Marinated Fish
→ Pickled Fried Herring | 52
→ Sardinhas Alimadas | 128
→ Scottish Marinated Fish | 33
Marsh Samphire
→ Mackerel Pembrokeshire Style | 104
Matjes
→ Labskaus | 27
→ Matjes Herring Tartar | 15
Matjes Herring Tartar | 15
Meat & Seafood
→ Arnfinnur's Fish Cakes | 81
→ Irish Surf & Turf | 110
→ Labskaus | 27
→ Norway Lobster with Bacon | 33
Mullet
→ Mullet Carpaccio | 144
→ Mullet Fillets with Beer Vanilla Sauce | 144
Mullet Carpaccio | 144
Mullet Fillets with Beer Vanilla Sauce | 144
Mussels | 98
Mussels
→ Catalan Fish Stew | 182
→ Creamy Fish Chowder | 110
→ Mussels | 98
→ Spaghetti Vongole | 165

N

Neapolitan Calamari Stew | 170
North Sea Shrimp
with Scrambled Eggs and Green Asparagus | 20
Norway Lobster
→ Norway Lobster with Bacon | 33
Norway Lobster with Bacon | 33

O

Octopus
→ Fried Octopus
with Potato-Parsnip Puree | 122
→ Octopus Salad | 122
Octopus Salad | 122
Oven-Baked Gilthead Bream
with Vegetables | 165

P

Pan-Fried Fish
→ Baked Sole with Buttered
Potatoes and Broccoli | 15
→ Fried herring with Young Potatoes | 58
→ Fried Octopus
with potato-parsnip puree | 122
→ Mackerel Pembrokeshire Style | 104
→ Mullet Fillets with Beer Vanilla Sauce | 144
→ Pannfisch with Potatoes | 92
→ Swordfish Steaks | 98
Pannfisch with Potatoes | 92
Parsnips
→ Fried Octopus
with Potato-Parsnip Puree | 122
Pasta Dishes
→ Linguine with Cuttlefish in Ink | 139
→ Pasta Donna Clelia | 170
→ Spaghetti Vongole | 165
Pasta Donna Clelia | 170
Pickled Fried Herring | 52
Pimientos
→ Swordfish Steaks | 98
Plokkfiskur | 92
Pollack
→ Creamy Fish Chowder | 110
→ Fish & Chips | 116
Potato Cucumber Salad with Smoked Eel | 27
Potato Leek Soup with Fried Salmon | 58
Potatoes
→ Arnfinnur's Fish Cakes | 81
→ Baked Sole with Buttered Potatoes
and Broccoli | 15
→ Catalan Fish Stew | 182
→ Cataplana | 128
→ Creamy Fish Chowder | 110
→ Croatian Fisherman's Breakfast | 158

→ Fish & Chips | 116
→ Fiskefrikadeller | 40
→ Fried Herring with Young Potatoes | 58
→ Fried Octopus with Potato-Parsnip Puree | 122
→ Labskaus | 27
→ Mackerel Pembrokeshire Style | 104
→ Matjes Herring Tartar | 15
→ Mullet Fillets with Beer Vanilla Sauce | 144
→ Neapolitan Calamari Stew | 170
→ Pannfisch with Potatoes | 92
→ Pickled Fried Herring | 52
→ Plokkfiskur | 92
→ Potato Cucumber Salad with Smoked Eel | 27
→ Potato Leek Soup with Fried Salmon | 58
→ Red Mullet | 87
→ Salmon au Gratin
with Potatoes and Spinach | 40
→ Storceag (Sturgeon Soup) | 72
Prawns
→ Gambas a la Plancha | 182

R

Red Mullet | 87
Rice
→ Sepia à l'armoricaine | 87
Rollmops
→ Labskaus | 27

S

Salads
→ Octopus Salad | 122
→ Potato Cucumber Salad with Smoked Eel | 27
Salmon
→ Cured Salmon | 46
→ Potato Leek Soup with Fried Salmon | 58
→ Salmon au Gratin
with Potatoes and Spinach | 40
→ Scottish Marinated Fish | 33
→ Smoked Fish with Cream Cheese | 52
Salmon au Gratin
with Potatoes and Spinach | 40
Sardinhas Alimadas | 128
Sardine
→ Fritto di Pesce | 139
→ Sardinhas Alimadas | 128
Scottish Marinated Fish | 33
Sea Bass
→ Fish Stew with Lemon and Tomato | 67
→ Grilled Fish | 158
Sepia à l'armoricaine | 87
Shrimp
→ Creamy Fish Chowder | 110
→ North Sea Shrimp with Scrambled Eggs
and Green Asparagus | 20
→ Shrimp Croquettes | 20
Shrimp Croquettes | 20

Smoked Eel
→ Potato Cucumber Salad
 with Smoked Eel | 27
→ Smoked Fish with Cream Cheese | 52
Smoked Fish with Cream Cheese | 52
Sole
→ Baked Sole with Buttered Potatoes
 and Broccoli | 15
Soups & Stews
→ Catalan Fish Stew | 182
→ Cataplana | 128
→ Creamy Fish Chowder | 110
→ Faroese Fish Soup | 81
→ Fish Stew with Lemon and Tomato | 67
→ Kakavia Fish Soup | 151
→ Neapolitan Calamari Stew | 170
→ Plokkfiskur | 92
→ Potato Leek Soup with Fried Salmon | 58
→ Storceag (Sturgeon Soup) | 72
Spaghetti Vongole | 165
Spider Crab
→ Crab Cakes with Aioli Dip | 104
Spinach
→ Salmon au Gratin
 with Potatoes and Spinach | 40
Sprats
→ Smoked Fish with Cream Cheese | 52
Squid
→ Linguine with Cuttlefish in Ink | 139
→ Neapolitan Calamari Stew | 170
→ Stavros' Calamari | 151
Stavros' Calamari | 151
Storceag (Sturgeon Soup) | 72
Sturgeon
→ Storceag (Sturgeon Soup) | 72
Swordfish
→ Swordfish Steaks | 98
Swordfish Steaks | 98

W

Walnuts
→ Pasta Donna Clelia | 170
White Fish
→ Crab Cakes with Aioli Dip | 104
→ Creamy Fish Chowder | 110
→ Fish & Chips | 116
Whiting
→ Fried Whiting | 67

Z

Zucchini
→ Mackerel Rillettes | 177
→ Spaghetti Vongole | 165

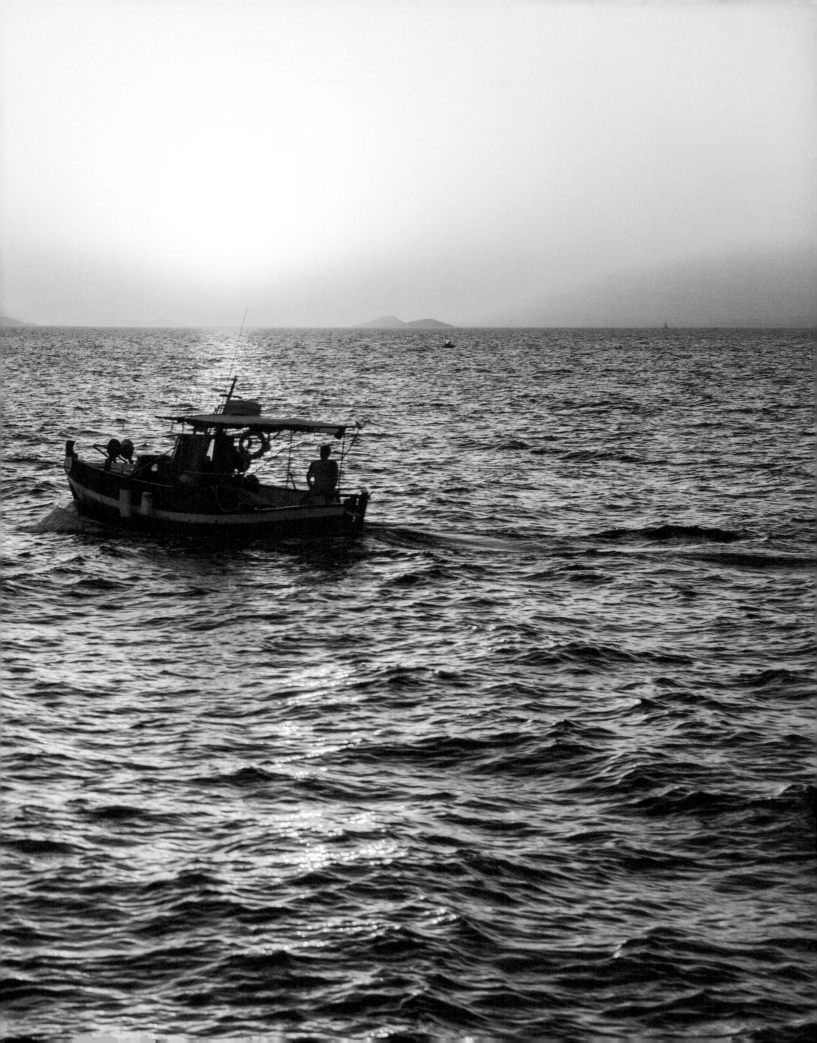

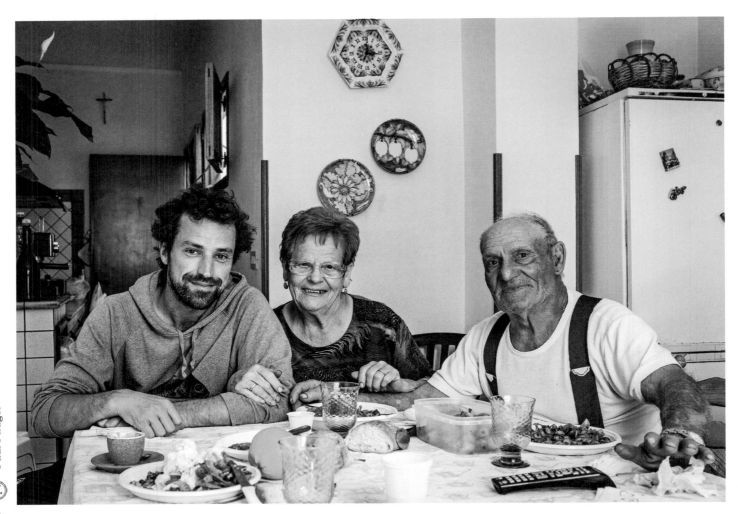

ABOUT THE AUTHOR

Paul Pflüger was born in Mainz, far from the sea. From an early age, however, he has been fascinated by the sea and its diverse inhabitants, both above and below the water. After finishing school, he was drawn to the coast. After pursuing jobs in Bremen, Hamburg, and Biarritz, he now commutes between Lisbon and Paris, where he works as a cameraman. Apart from his career, Pflüger has always been passionate about photography, food, and travel. While traveling in foreign lands, he enjoys wandering around and, with a curious eye, exploring what he discovers along the way—the cuisines and culinary specialties of each country have always been a starting point for him. Whether in restaurants, at markets, or with locals at home: Meals are wonderful opportunities to use all your senses to discover the culture of a cook and to spend time getting to know others at the table. Because Pflüger's affinity for the sea also influenced his travels, it goes without saying that he frequently ate fish during these encounters. After enjoying yet another culinary discovery in pleasant company during one of his trips, Pflüger came up with the idea for this book—and an entirely new journey began.

THANK YOU

I am immensely grateful to the people in this book. I would like to thank them for their trust, their hospitality, as well as for the fact that we also always returned to harbor safe and sound. Dank je wel! Danke! Thank you! Tack! Dziękuję! Paldies! Teşekkür! Mulţumesc! Merci! Takk! Diolch! Eskerrik Asko! Obrigado! Grazie! Hvala! ευχαριστώ! Gràcies!

On shore, I would like to thank Elodie in particular for her patience and her understanding. I would like to thank my family for their support throughout my life. I would like to thank my friends—for their friendship as well as for the countless ways they've inspired me, both large and small. I would also like to extend my heartfelt thanks to all the wonderful people I met along the way. They helped me get to know their homeland in a way that touched me deeply. Massi, Salvatore, Ines, Krzysztof, Herfinn, Alise, the Leclèv family, the Brennan family, Mircea, Razvan, Tanja, and Patrick are just the tip of the iceberg when it comes to the hospitality extended to me. Although, unfortunately, I do not know them all by name, I would like to mention the countless fleeting encounters in cafés and harbor pubs that also helped to make this journey so unique. The beautiful images of the dishes were made possible by Frederico's culinary skills, experience, and passion. Sofia gave us amazing support during this process, including with her delicious desserts. Obrigado!

Without Antje, Nadja, Lars, and the entire Literarische Agentur Kossack team, I would probably still be happily traveling—and this book would not exist. They fully supported my idea from the very beginning and later helped bring it to fruition in the big, wide world of publishing. Thank you for your confidence! At teNeues I would like to thank Christina in particular for the excellent teamwork, Bernhard for the implementation of the project, and the rest of the team for their patience. And finally, my thanks to all the fish who modeled for this book—though not always voluntarily.

IMPRINT

© 2018 teNeues Media GmbH & Co. KG, Kempen
Photographs & texts © 2018 Paul Pflüger
All rights reserved.

Food styling by Freddy Guerreiro
www.freddyguerreiro.com
Translation by WeSwitch Languages GmbH & Co. KG
Editorial coordination: Christina Reuter
Copyediting by Christina Reuter
Proofreading by Christina Reuter, Sabine Egetemeir
Creative Director: Martin Graf
Design & Layout: Robin John Berwing
Production: Nele Jansen
Color separation: Robin Alexander Hopp

ISBN 978-3-96171-150-5

Library of Congress Number: 2018904685

Printed in Italy

Bibliographic information published by
the Deutsche Nationalbibliothek
The Deutsche Nationalbibliothek lists this
publication in the Deutsche Nationalbibliografie;
detailed bibliographic data are available on the
Internet at http://dnb.dnb.de.

Published by teNeues Publishing Group

teNeues Media GmbH & Co. KG
Am Selder 37, 47906 Kempen, Germany
Phone: +49-(0)2152-916-0
Fax: +49-(0)2152-916-111
E-mail: books@teneues.com

Press department: Andrea Rehn
Phone: +49-(0)2152-916-202
E-mail: arehn@teneues.com

Munich Office
Pilotystrasse 4
80538 Munich, Germany
Phone: +49-(0)89-443-8889-62
E-mail: bkellner@teneues.com

Berlin Office
Kohlfurter Strasse 41–43
10999 Berlin, Germany
Phone: +49-(0)30-4195-3526-23
E-mail: ajasper@teneues.com

teNeues Publishing Company
350 7th Avenue, Suite 301
New York, NY 10001, USA
Phone: +1-212-627-9090
Fax: +1-212-627-9511

teNeues Publishing UK Ltd.
12 Ferndene Road, London SE24 0AQ, UK
Phone: +44-(0)20-3542-8997

teNeues France S.A.R.L.
39, rue des Billets
18250 Henrichemont, France
Phone: +33-(0)2-4826-9348
Fax: +33-(0)1-7072-3482

WWW.TENEUES.COM

MIX
Paper from
responsible sources
FSC® C016466
www.fsc.org

teNeues Publishing Group
Kempen
Berlin
London
Munich
New York
Paris

teNeues